Photography
Essentials

by Mark Jenkinson

ALPHA

A member of Penguin Group (USA) Inc.

ALPHA BOOKS

Published by the Penguin Group

Penguin Group (USA) Inc., 375 Hudson Street, New York, New York 10014, USA

Penguin Group (Canada), 90 Eglinton Avenue East, Suite 700, Toronto, Ontario M4P 2Y3, Canada (a division of Pearson Penguin Canada Inc.)

Penguin Books Ltd., 80 Strand, London WC2R 0RL, England

Penguin Ireland, 25 St. Stephen's Green, Dublin 2, Ireland (a division of Penguin Books Ltd.)

Penguin Group (Australia), 250 Camberwell Road, Camberwell, Victoria 3124, Australia (a division of Pearson Australia Group Pty. Ltd.)

Penguin Books India Pvt. Ltd., 11 Community Centre, Panchsheel Park, New Delhi—110 017, India

Penguin Group (NZ), 67 Apollo Drive, Rosedale, North Shore, Auckland 1311, New Zealand (a division of Pearson New Zealand Ltd.)

Penguin Books (South Africa) (Pty.) Ltd., 24 Sturdee Avenue, Rosebank, Johannesburg 2196, South Africa

Penguin Books Ltd., Registered Offices: 80 Strand, London WC2R 0RL, England

International Standard Book Number: 978-1-59257-752-1
Library of Congress Catalog Card Number: 2007941479

10 09 08 8 7 6 5 4 3 2 1

Interpretation of the printing code: The rightmost number of the first series of numbers is the year of the book's printing; the rightmost number of the second series of numbers is the number of the book's printing. For example, a printing code of 08-1 shows that the first printing occurred in 2008.

Printed in the United States of America

Note: This publication contains the opinions and ideas of its author. It is intended to provide helpful and informative material on the subject matter covered. It is sold with the understanding that the author and publisher are not engaged in rendering professional services in the book. If the reader requires personal assistance or advice, a competent professional should be consulted.

The author and publisher specifically disclaim any responsibility for any liability, loss, or risk, personal or otherwise, which is incurred as a consequence, directly or indirectly, of the use and application of any of the contents of this book.

Most Alpha books are available at special quantity discounts for bulk purchases for sales promotions, premiums, fund-raising, or educational use. Special books, or book excerpts, can also be created to fit specific needs.

For details, write: Special Markets, Alpha Books, 375 Hudson Street, New York, NY 10014.

Publisher:	Marie Butler-Knight	Senior Production Editor:	Janette Lynn
Editorial Director:	Mike Sanders	Copy Editor:	Lisanne V. Jensen
Senior Managing Editor:	Billy Fields	Cover/Book Designer:	William Thomas
Acquisitions Editor:	Michele Wells	Indexer:	Tonya Heard
Development Editor:	Susan Zingraf	Proofreader:	Mary Hunt

For Ceci and Eli

Contents at a Glance

Contents

Introduction

"The illiterate of the future will be ignorant of camera and pen alike." —Lazlo Moholoy-Nagy

When the artist/photographer Moholoy-Nagy made that statement in the early 1930s, cameras were bulky, heavy, and expensive things. Using them required special training, and developing and printing one's own photographs required a purpose-built, dedicated darkroom and even more special training. Surely it seemed impossible that in the future everyone would own many different cameras (in the form of camera phones, video cameras, point-and-shoots, and SLRs) and carry them as personal effects the way we carry keys and wear watches. It probably seemed equally unlikely that we would have the ability to print photos with a keystroke at the comfort of our desks in broad daylight. Yet, in the modern world, photography is as accessible and easy as reading and writing. It's a skill and a technology that we take for granted.

As a teacher at a (very expensive) major university, I am often asked by anxious parents whether four-plus years of formal training is still necessary for photographers in this day and age. On some levels the answer is no; it was never necessary to have formal training to learn photography as a craft. But we have always been able to learn the craft of photography through reading, practice, and/or apprenticeship.

So in many ways, photography is easier than it's ever been—but somehow it seems harder. Why is that?

There is much more to know now than there ever was in the past. There are more cameras, different types of cameras, more printing options, and many more essential skills in the form of photo editing and web presentation. More equipment is also necessary in the form of lighting and computer options.

What might be more important is that we live in a time when Moholy-Nagy's prediction has become a fact of life. We live in a world of images—a world that has put tools in the hands of school children that just a few years ago were inaccessible to all but the highest-paid professionals. Photography is no longer a craft; it has become a language—a language that enriches all of our lives and

is as much a necessity to modern life as the ability to read and write. Digital photography and our image-rich environment have also raised the bar for what we expect and what excites us visually. Creating good photography, and being a good photographer, are harder than ever.

This book is designed with two purposes in mind. The first is to guide you through learning and using your own camera. Although there are many photo books that do this (and a lot of them are very good), I have tried to look at some of the common tools and techniques in slightly different ways in the hope that it will make you consider things from a different perspective. I hope that this book will offer food for thought, whether you have just unpacked your new camera from the box or you have been shooting for years.

The second purpose of the book is to help you think and see more creatively and decisively—to make photography matter. This is the part of photography that engages us at our very core; the part that teaches us who we are and puts us in contact with the world.

This is what can make photography an integral part of your life. It makes going to a softball game or enjoying a family vacation even more fun because there's a bigger investment and something to strive for. These are the photographs you'll cherish—the ones that go beyond being a simple recording of life's little moments and become about life itself.

I've always thought that as an art form, photography is closer to the performing arts or athletics than to painting or some of the other visual arts. The photographic act—planning, observing, reacting, thinking, feeling, embracing, sweating, laughing, acting, and participating—tie the photographer to the real and physical world. At its best, it is a transcendent moment that approaches a religious experience. I think much more about being "in the zone" than I do about composition. I question my thoughts about a subject more than I think about lenses.

Photography is a visual art because it creates a tangible piece of visual evidence—a record of the performance, both about the subject and the photographer. In many ways, good photographs are just the trophies of a game well played.

Things to Help You Out Along the Way

Throughout this book you will encounter several boxes of useful information designed to help you along your way to becoming a better photographer. These boxes include definitions of the lingo used in photography industry, tips and directions on how to become a better photographer, and cautionary tidbits on how to keep you from damaging your equipment or making photographic errors.

Acknowledgments

I have many people to thank for their help in making this book possible. First and foremost, my literary agents Janet Rosen and Sheree Bykofsky, who approached me with the project. My acquisitions editor, Michele Wells at Penguin, who took a big chance on me as a first-time author. My development editor, Susan Zingraf, who caught many of my mistakes. I also want to extend a special thank you to my (stellar and awesome) editorial assistant, Alexandra Pacheco-Garcia.

Finally, many thanks to all of my colleagues and students at New York University's Department of Photography and Imaging for their inspiration and fellowship over the years. It has been a rare privilege to have been part of such a remarkable community.

Special Thanks to the Technical Reviewer

The Complete Idiot's Guide to Photography Essentials was reviewed by an expert who double-checked the accuracy of what you'll learn here to help us ensure that this book gives you everything you need to know about photography. Special thanks are extended to Avi Gerver.

Trademarks

All terms mentioned in this book that are known to be or are suspected of being trademarks or service marks have been appropriately capitalized. Alpha Books and Penguin Group (USA) Inc. cannot attest to the accuracy of this information. Use of a term in this book should not be regarded as affecting the validity of any trademark or service mark.

Chapter 1

Getting Started: Basic Camera Equipment and Essentials

Camera 101

So you've bought a new camera. Now what? There are so many buttons, features, menus, and cords that you're wondering, "How do I just take a simple picture that will look good?" Good question. And because you're reading this book, you're headed in the right direction to learn just how to do that ... and a whole lot more. This book will help make the seemingly daunting mechanics of your camera become second nature to you and prepare you with knowledge, tips, and advice on how to skillfully capture all of your cherished moments on film.

Whether it's your baby's first steps, your vacation to the Grand Canyon, or the flowers in your backyard, learning how to use your camera to take good pictures takes knowledge and practice.

Chances are the camera you just bought or have been using is a *single-lens reflex* (SLR) camera, which is very popular today among both novice and professional photographers—so it's the basic type of camera we will explore in this book. While different brands and models of SLR cameras vary somewhat, they all have the same basic features and capabilities—so the principles covered in this book will apply across most SLR cameras.

A **single-lens reflex** (SLR) camera refers to a type of camera that uses an automatic mirror system that directs an image from the lens through the viewfinder, where the photographer can see it. The abbreviation DSLR refers to digital single-lens reflex cameras.

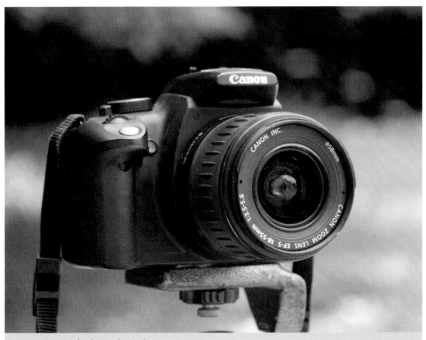

A Canon Rebel XT digital SLR camera.

Back to your camera ... it likely came as a "kit" with a moderate wide-angle to moderate telephoto zoom lens. Also it likely has autofocus and can be programmed in various ways to optimize exposures for portraits, landscapes, and sports or close-up photography. Whether it shoots 35 mm film or digital photos, the basic concepts in this book will apply to both.

If some or all of these assumptions are true for your camera, congratulations! You own an absolutely awesome piece of equipment. It's likely better than anything Henri Cartier-Bresson—a famous French photographer who is considered the father of modern photojournalism—or Ansel Adams—an American photographer best known for his photographs of the American West—ever owned. You also chose a perfect camera to own for learning the essentials of photography. Your camera is amazing. Just a few years ago, professionals were spending tens of thousands of dollars on cameras that weren't as good. The fact is, now you can take a camera out of the box, charge the battery, set the dial to P (which stands for Program), and shoot photos that can be as good as most of the photos you see in glossy magazines. Qualitatively, the only difference between you and a top professional is the brain behind the lens. A pro knows absolutely everything about his or her camera and how to get the most out of whatever he or she is shooting. Getting to know your camera and how to get the most out of it for the pictures you want to take is the purpose of this book.

To put myself in your shoes (or close to it), I bought a Nikon D40—one of the most popular D-SLRs on the market—and a camera you are likely to own. Because I normally shoot with Canon-brand cameras, using the Nikon helps me provide you with some of the similarities and differences between the two. All cameras work on the same basic principles, so if I mention something specific to the Nikon or Canon controls, you can probably be assured that your particular camera (Pentax, Olympus, and so on) has a way of doing the same thing. I will not talk about extremely specific features (for instance, the D40 has in-camera retouching options), but instead I'll focus on controlling the camera and knowing how and what to use—and when—to get the most out of your camera while you're out there shooting.

Getting to Know Your Camera

One thing that has always fascinated me about how people view photographers and photography is that they somehow think photography skills can be picked up without much—or any—practice. Concert pianists practice six hours a day or more; professional athletes also train several hours a day; and rock stars jam and "noodle" on their guitars constantly. The same goes for photographers and their cameras. But somehow people think the skills of photography can be picked up almost instantly by simply buying a new camera—and what's worse, doing so the day before a vacation, wedding, or other memorable event. That's like learning how to swing a baseball bat the day before you're scheduled to play in the World Series.

Now unless you plan to become a professional photographer, you won't need to (and likely aren't able to) practice taking pictures for six hours a day. But if you want to get better at it and make the most of your investment, you should set aside at least two hours a week to take pictures. That's two hours when you are just walking around with your camera (and this book, of course), snapping away. It can be 20 minutes a day, all on a Sunday morning, or over a couple of lunch hours during the week—whatever works for you. The point is to start taking pictures on a regular basis.

The purpose of this exercise is two-fold:

1. First, it will take some or all of the pressure off when you're in high-pressure photographic situations. You won't be figuring out how your camera works when your daughter is walking down the aisle on her wedding day. Believe me, I still sweat the big photo-ops just as much as you do. But training is what helps me, as it will you, stay cool under pressure.

2. Second, it will teach you how to *see*, and what to look for to make photographs that you will enjoy and be proud of. If you don't know what to take a picture of, just look around and find an object in your field of vision right now. A good photographer can make that object look interesting; a great photographer can make that object look fascinating. There's always a picture worth taking somewhere around you; just

pretend that your camera is a kaleidoscope and there's no limit to the possibilities. Taking that picture and trying your best to make the mundane look interesting will train you over time how to use your camera creatively.

As proof of what I'm saying, here are three photographs I shot in my office just after writing the sentence you just read.

In the course of taking just these three quick pictures, I learned four things about the brand-new Nikon camera I am using:

- It has a little light on the front of the camera that turns on automatically to assist the autofocus in low light situations (more details on this later).

- In Program mode (or "P"), it changed the ISO (which stands for International Standards Organization; I'll provide more details about that in Chapter 3) automatically to keep me from making a total blunder of a shot.

- I learned how to use the autofocus lock button (a very nice touch on this camera; you'll learn why a little later on).

- There is no *depth of field* (DOF) preview button on the Nikon D40 (more details on this later).

Now, while some or all of that information may sound foreign to you at the moment, rest assured that very soon you'll know it all. The point is, that's a lot to learn in fewer than five minutes—and tinkering around with your camera is exactly how you will learn more about it.

Anatomy of a Single-Lens Reflex Camera

Small-format SLRs are the universal choice for required equipment at every university photography department because they are remarkably capable of doing almost everything. Professionally speaking, it's the only camera I absolutely can't do without.

Pro Tip

A good photographer is constantly playing around with his or her camera, learning how to use it and manipulate it. A good photographer also makes plenty of mistakes, which is a big part of the learning process.

The most appealing attribute of all SLRs, regardless of size or format, is the fact that you are looking through the actual lens that makes the photograph. When you shoot with an SLR camera, you pretty much see what you get (and get what you see).

All SLR cameras have a few things in common: the lens, the viewing and focusing system, the focal plane shutter, and the light meter.

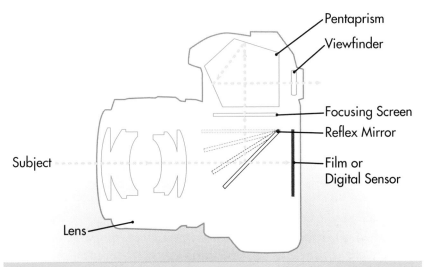

Cutaway image of an SLR camera.

The Lens

Looking at the camera from front to back, we first see the lens. Inside the lens is an adjustable diaphragm, or *aperture*, which controls the amount of light passing through the lens. Light is an essential aspect of photography, so throughout this book we will talk about it constantly and explain how to use and manipulate it.

Aperture is the opening in a camera's lens through which light passes, it can be made larger or smaller by the mechanical diaphragm, a series of overlapping blades which open and close like the iris of your eye.

The Viewing and Focusing System

Behind the lens is a movable mirror that redirects and projects the light passing through the lens onto a focusing screen. The mirror flips out of the way when you press the button to snap the picture, and it instantly flips back after the picture is taken. When the mirror flips out of the way, there is a temporary moment of

blindness for the photographer because the mirror is no longer reflecting the image so it can be seen. But it all happens so fast that the blindness is typically negligible. Under certain conditions (using very long/slow shutter speeds) can it become a little problematic.

Photosensitive

Never touch the mirror on an SLR camera. It has been positioned to perfectly focus the image on the focusing screen at the same optical distance as the film or electronic sensor. Touching it or even blowing compressed air onto it can change its relationship to the focal plane and result in your photographs appearing out of focus even though they looked in focus when you took the picture.

The focusing screen is actually made of ground glass or finely etched plastic, which displays the image for viewing the scene projected by the lens with the focus as it will appear on the film. However, on the focusing screen the image is actually reversed from left to right. Above the focusing screen is a prism that flips the projected image once more, allowing you to see it in a normal, non-reversed, left-to-right orientation through the viewfinder.

The focusing screen has a series of marks that you will see light up in the viewfinder when shooting in autofocus camera. The lights indicate what the camera is focusing on when you shoot.

The term **diopter** is used to denote the optical power of a lens. The term is typically used by optometrists in prescribing corrective lenses.

On most modern cameras, there is also some form of *diopter* adjustment to tailor the camera's eyepiece to your individual vision, or corrective prescription. Many people are not sure how this feature works. So, here's a simple way to use it: just point the camera at a white wall and don't worry about focusing the lens on the front of the camera. Look through the eyepiece and adjust the diopter setting until you can see all the information as clearly as possible, such as shutter speeds and focusing marks. Now, you'll be able to see all the different functions you'll be working with.

Right underneath the focusing screen, through the viewfinder, you will see a bar containing all of the information that is pertinent to the camera's current settings, such as the shutter speed and f-stop (which we will cover later).

Photosensitive

Never leave a camera lying on its back outside with the lens facing up. Cameras can be damaged by the sun's heat, being focused into the camera's body.

The Focal Plane Shutter

Behind the mirror and just in front of the film (or electronic sensor on a DSLR), there is the *shutter*. Because of the shutter's location, it is called a "focal plane shutter."

Focal plane shutters are one of the most important features and advantages of small-format SLR cameras. On the other hand, they can also be one of the significant drawbacks, so let's take a moment to review how they work.

Shutter refers to the camera component that allows controls the amount of time light is allowed to strike the film or digital sensor.

The focal plane shutter is like two window shades that move in unison across the focal plane and uncover the film or sensor. At slower shutter speeds (typically, less than $\frac{1}{60}$th to $\frac{1}{250}$th of a second) one shutter simply opens across the entire focal plane—beginning the exposure—and then the other shutter simply follows behind it and ends the exposure.

At higher shutter speeds, the two shutters move in unison creating only a slit that "paints" the light as they move across the film. The actual amount of light hitting the film is controlled by the size of the slit. At extremely high shutter speeds, the slit might be only a few millimeters wide. (This has some ramifications when you are shooting with flash, so you should understand the basics of how the shutter works.)

The focal plane shutter is a marvel of engineering. Capable of such high speeds—some as high as $1/8000$th of a second—it can actually stop, or capture, the motion of a bullet in flight.

Having the focal plane shutter in the camera also means that lenses for small-format SLR cameras are less expensive compared to other camera types, because each lens doesn't need to have its own shutter (like some professional cameras).

The Light Meter

The light meter is positioned in various places depending on the make, model, or vintage of the camera.

For our purposes right now, the most important thing to know is that the light meter reads the actual light coming through the lens. One of the most foolproof ways to accurately make a perfect exposure The recommended settings are displayed in the viewfinder and the photographer can choose to over-ride these recommendations, accept them, or use the camera in a fully manual mode. Learning to use the light meter well is probably the most necessary step to advancing your personal photography and avoiding the most common technical problems.

Pros and Cons of SLRs

The SLR camera (in all its forms), while virtually the most versatile photographic device created to date, does have some limitations. Here are its main pros and cons:

Pros:

- Very easy to pre-visualize the final image
- Vast array of available optics lenses, including those from third-party suppliers at a reduced cost
- Highly accurate exposures even with filters (we'll cover filters more in a little bit)
- Highly portable, fast, and easy to use

Cons:

- Limited lighting options in certain situations due to slow flash synchronization

- Temporary "blindness" at the moment of exposure

- Highly portable, fast, and easy to use

Wait! Why is that last item on both lists?

Well, because as terrific as SLRs are, they are also common. The downside of being common is that the photographs made from these small cameras (especially digital ones) have a certain uniformity to the way they look and the way people use them. So, if you want your photographs to be truly interesting and unique, you have to add another ingredient: yourself.

Camera makers have made modern SLR cameras so easy to use that it's easy to think you don't need to know anything about photography to use them. But to use your camera well—to really understand how to take great pictures—you have get past thinking of and using your camera as a fancy point-and-shoot, and that means learning a little about photography. You might not know how to build a car, but you likely know the basics of how they operate—they need gas, oil changes, tune-ups, and so on. You also took lessons to learn how to drive, earned a driver's license, and probably "practice" driving every day. Think of your photography in the same way—the camera is your car, and you're learning to drive.

Setting Up Your Camera

If you have a brand-new camera, you should spend a few days just shooting with it—using the basic guidelines from its instruction book—and just getting a feel for your new camera. This will familiarize you with the basic menus and controls as well as teach you how to "fall back" on the camera's automatic mode if you are totally confused in an important picture-taking situation.

Assuming you have done this already, let's set up your camera so that you can get the most out of using it (along with this book).

Here are a few basic setup steps:

- Set the picture quality to JPEG (fine). (I'll explain more about JPEGs later on.) On Canon cameras, this setting is called "Large" and has a smooth arc icon next to it. This will give you the highest-quality JPEG photos.

- Leave the camera set to "Auto White Balance" for now. (Again, more on this setting in a little bit.)

- On the Nikon D40, set up the "info display format." Press the Menu button on the back of the camera. Then select the wrench icon then scroll down to choose "info display format." This is followed by "Select info display," scroll down and you will then see a bar with "P, S, A, M," select this option, press "OK" and then you see two more options, one says "classic" and the other "graphic." Highlight the graphic bar and press "okay." This will display a little graphic icon for lens aperture that we will discuss in the next chapter. If you prefer not to see this icon, you can change it later. Most other cameras have a separate window to display this information and need no setup. If you are a real beginner then seeing this icon might help you to get a better understanding of what the aperture is doing when we discuss it in the next chapter.

- Set your exposure mode dial to "A," which will allow you to set the camera's aperture easily (and the camera will set the shutter speed itself).

Don't worry if you don't fully understand all of these settings at this point. You will soon enough.

Pro Tip

As an assignment for young photographers, I often require that they spend a week shooting everything on a tripod—no matter how much light there is. Spending a solid week or month shooting everything on a tripod will absolutely make you a better, more thoughtful photographer. The surprising thing is that it will also make you faster because you'll learn to see more carefully and think more decisively.

Camera Accessories

There are several photographic accessories that even the most casual photographer simply can't live without.

Tripods

Tripods ($125 to $900) do a lot for photographers besides just hold their cameras. They make you slow down and really think about what you're shooting. They enable you to truly level the camera on all of its axes, which gives a certain authority to photographs.

Every photographer needs a tripod. It's not a very sexy thing to buy, but you need one readily available at all times. The tripod you left at home can't help you and will only cause you frustration. Most quality tripods are sold as separate head/legs units. If you buy an all-in-one tripod, then be sure it is made for still photography. Many cheaper tripods are made for video cameras and might not allow you to rotate your camera for vertical shots. You will curse a cheap tripod every time you use it. If you buy a good tripod the first time, chances are you'll own it forever. You might also want to buy a strap or bag to free your hands when you carry the tripod.

I'd start by setting up the tripod in the store; the legs should extend quickly and effortlessly. Make sure that you can get the top (without the camera attached) to at least the height of your chin without extending more than half of the center post. A good tripod should allow you to look though the camera without stooping. You might think this is because of back strain, but it's really because we tend to compose photographs from our natural eye level. There is nothing more frustrating than setting up a tripod and discovering you don't have the height you need.

Your choice of tripod material—aluminum, carbon fiber, basalt (a new lightweight fiber made from volcanic rock), or even wood—is just a matter of how much weight you're willing to carry and how much of your budget you're willing to spend.

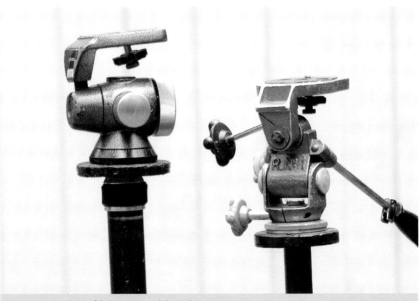

Two examples of basic tripod heads.

A last point on tripods is that there are two basic types of tripod heads (the part that sits on top of the legs):

- Ball heads are very compact and fast to work with. They also travel well because there are fewer protruding handles to break or bend.

- Three-way pan and tilt heads are more precise because they allow you to position each of the axes of the camera independently. Some are also geared, which allows for extremely precise movement and camera positioning.

The proper use of a tripod seems self-explanatory, but I see so many people making basic mistakes that a quick primer seems in order.

Always try to set the legs of the tripod so that you are using the minimum amount of center post. You'll want a few inches of center column protruding so that you can fine tune the height but not so much that it introduces instability or camera shake.

Position the camera so that the lens is in alignment with one of the legs. Why? First, with longer lenses it puts the weight of the

heavy lens over a leg for more security. Second, it means that you aren't tripping over a leg sticking out from behind.

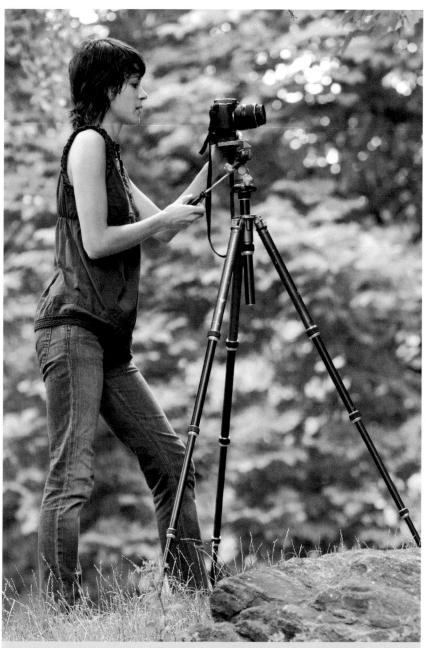

Proper use of a tripod.

On three-way-pan heads, the long adjustment paddle/locking knob goes behind the camera and the short one sticks out to the right. This allows the camera to flop quickly to the left for vertical photographs.

If it's windy or the tripod is simply a little too light for the camera, hang a camera bag or something with some weight from the center column. This will allow you to get away with using a lighter tripod.

Quick Releases

Most tripods screw the camera onto the head using a knurled thumbscrew on the tripod head. This works perfectly, but can slow down mounting the camera to the tripod for each shot.

A quick release (about $100, comes standard on certain tripod brands) allows you to quickly and easily attach or detach the camera from the tripod. It works by using plates that are semi-permanently mounted to your camera and snap into the receiving unit that is screwed onto the tripod. A quick release is a real convenience if you like working on a tripod.

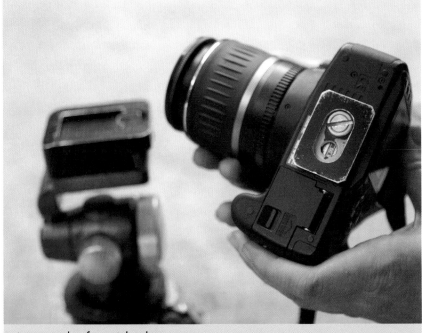

An example of a quick release.

Gaffer Tape

There are certain things a good photographer just doesn't leave the house without, and gaffer tape is one of them. Next to Velcro and computers, gaffer tape is one of the hallmarks of advanced civilization. I have used this miracle adhesive to temporarily fix lenses, hold filters, tape extension cords to floors, tape cameras to motorcycles, fix flat tires, and shorten a model's skirt. Gaffer tape is not to be confused with cheap duct tape. Although they look very similar, duct tape will leave gummy residue on your equipment and can rip the paint off walls.

Once you have a roll of real gaffer tape in your bag or at home—and use it—you will discover it is indispensable, not only to photographers, but modern life in general.

Cable Releases and Remotes

A cable release ($5 to $100) is a device (usually a flexible wire with an internal spring and plunger mechanism) that allows you to trip the cameras shutter without actually touching the camera.

If you are using a tripod at slow shutter speeds, you should use a cable release so that you don't shake the camera.

Many modern digital cameras require an electronic cable release. Most manufacturers of digital cameras also offer remote shutter releases that use infrared light beams (like the remote on your TV) to trip the camera's shutter. These can be very handy for including yourself in the shot.

If you don't have a cable release available, use your camera's self-timer in order to minimize camera shake during long exposures.

Filters and Lens Hoods

Filters ($20 to $100) and lens hoods ($15 to $40) are accessories that screw onto the front of your lens, they both help to protect the lens and preserve it's optimal performance.

You should always use a lens hood, period. If you didn't let the salesperson talk you into one when you bought your camera, get in the car now. I'll wait here while you go back and buy one.

Any light—and let me repeat, *any light*—that strikes the lens and

is not part of the scene you are shooting degrades the image to a certain degree. We call this stray light "flare," and it's usually most noticeable as little points of light that radiate from light sources in the photograph. A lens hood helps reduce or eliminate flare caused by sources outside the picture frame; yet, flare that is caused by a light source in the frame can't be controlled.

Flare is caused by light that reflects on the interior surfaces of the camera and the individual elements of the lens. Other more subtle forms of flare can also occur, such as when you are using a skylight filter (more on this in a minute) on an overcast day. The large expanse of sky will reflect light onto the filter and slightly lower the contrast and resolution of the photograph. Lens hoods do a silent but effective job of controlling this type of flare as well.

In spite of (or possibly because of) all the advances in modern optics, flare actually seems to be more of a problem than it used to be—which is why lens hoods are a good idea. Modern zoom lenses (like the one that probably came with your camera) are a great convenience, but they are also far more complex optically and more prone to flare than the simpler lenses that are typical of older cameras.

The pinpoint of sun you see reflected in the lens will cause lens flare. The dust will also be visible as a slight reduction in contrast in the final photograph.

This lens will not flare, and the small amount of dust is now negligible.

This photo was shot without a lens hood. The pink area in the trees is lens flare; the slight haziness to the right is caused by some dust that was on the skylight filter. Both flaws would be very difficult to fix in post-processing.

Skylight and Ultraviolet Haze Filters

Filters are like clear lens caps. Your lenses are significant investments, and they will never again be as clean and perfect as the first time you take them out of the box—so I highly recommend using filters (with a lens hood).

Good skylight filters are not just clear pieces of glass; they are optically neutral, multi-coated, precise additions to your lens that will protect it from the damage of everyday dust, grime, children's fingerprints, and over-cleaning, it's best to buy quality filters. A simple cheap one might be $20 while the top multi-coated filters might be $80. It may seem like a lot of money, but this is not at item to scrimp on. My lenses are all pristine—in spite of the abuse I subject my equipment to—because of skylight filters. When the filter is ruined I just throw it away.

The difference between a skylight and an ultraviolet haze filter is that a skylight filter is optically totally neutral while a UV haze filter cuts down the effect of atmospheric haze (slightly) but has no effect on the rest of the scene.

For most of my photography, I prefer to record things as I actually see them (which includes haze), so my wide-angle lenses all have skylight filters instead of UV haze filters. Long lenses get UV haze filters because the effect of haze is greater with long lenses, and the filters do seem to make a slight difference in the overall contrast.

Polarizing Filters

A polarizing filter is really an optional accessory, but it's one of those things you don't know you need until you need it.

When light strikes a reflective (but non-metallic) object, it becomes polarized. The light rays become parallel, and this is why you can see the reflection.

Polarizing filters act like the louvers of a Venetian blind, allowing you to control whether or not you want the reflected light to come through. You rotate the filter until the reflection is diminished to your satisfaction.

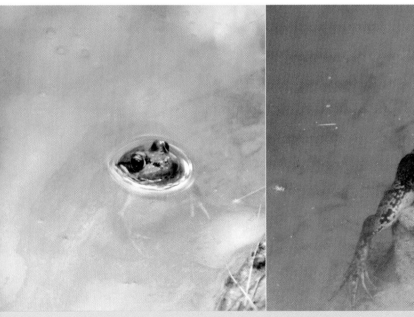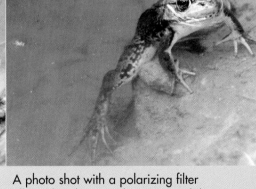

This photo was shot without a polarizing filter. The reflections (due to polarized light) in the water's surface obscure the view underneath the water.

A photo shot with a polarizing filter allows the photographer to control the reflection by reducing the polarized light.

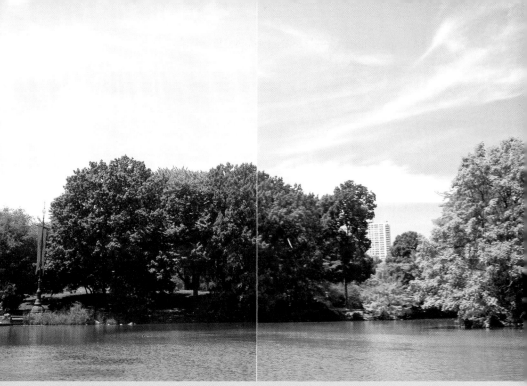

This photograph was shot without a polarizing filter.

This photo was shot with a polarizing filter in order to accentuate clouds in the sky.

Because the blue of the sky is diminished by stray reflections in the atmosphere, a polarizer can also accentuate clouds in photographs by darkening the blue of the sky.

Newer autofocus lenses require use of a "circular" polarizing filter in order to maintain their ability to auto focus. However, the newer circular filters are so prevalent today that almost any salesperson will automatically assume you want this model. If you have a hand-me-down of the older "linear" polarizers it will still work with a modern camera as long as you focus the camera manually.

Card Readers

A card reader ($30) is a device that allows you to take the memory card out of your camera and download your photos directly from the card. It quickly transfers photographs to your computer (and also ensures that your camera's battery won't be exhausted midway though downloading photos from your memory card). You just insert your memory card into your card reader, which is plugged into your computer, and download your photographs. It is a very inexpensive convenience, and I highly recommend it.

Digital Storage Devices

Small hard drives/viewers ($100 to $500) can be used to download the pictures from your camera's digital media card so the media card can then be erased and reused. But because digital media cards, such as *Secure Digital* (SD) and *CompactFlash* (CF),) have consistently come down in price and are currently quite inexpensive, a digital viewer/drive isn't as important as it was a few years ago.

While not all storage devices have screens to view your work, the ones that do are a great way to look at your photographs in the field when you don't have a computer available. I'd certainly want one on any extended vacation as a way to back up photos and share them. Most can also serve as media players, enabling you to watch movies and listen to music.

An example of a photo storage device.

Point-and-Shoot Cameras

I include these cameras as an additional piece of equipment because this book assumes you are beyond the *point-and-shoot* stage as a photographer.

Chances are you already own one, but if you are considering getting a new one I would suggest that you get one that uses the same SD or CF cards as your SLR.

I own a digital point-and-shoot camera, but my personal choice is still one that shoots film. The tiny sensors in digital point-and-shoot cameras still aren't good enough for my tastes (yet). I also require an optical viewfinder in any point-and-shoot camera I'd own. Good photography isn't done at arm's length on a TV screen.

Some examples of point-and-shoot cameras.

A photo shot with a point-and-shoot camera.

Whatever type you choose, every photographer needs a great point-and-shoot camera, something, small and inconspicuous to throw in your pocket when your SLR is more than you want to carry.

The Least You Need to Know

- The small-format, *single-lens reflex* (SLR) is the most versatile camera created to date.

- Lens hoods, skylight filters, and tripods are essential accessories that will extend your photographic capabilities.

- Great photography takes some investment and time. Practicing every day or at least a few hours per week will quickly take your photos from good to great.

In This Chapter

- The ins and outs of your lens

- How focal length and format affect angle of view

- The relationship between aperture and f-stop

- How to control depth of field

- Other lens choices for your camera

Chapter 2

Exploring Photographic Optics

Now let's look at the specifics of the lens you're using. Before you go any further, it's a good idea to fully understand the advantages and disadvantages of your lenses and how different lens use will affect your photos. So, let's look at the different types of lenses and figure out what you can and can't do with the ones you have.

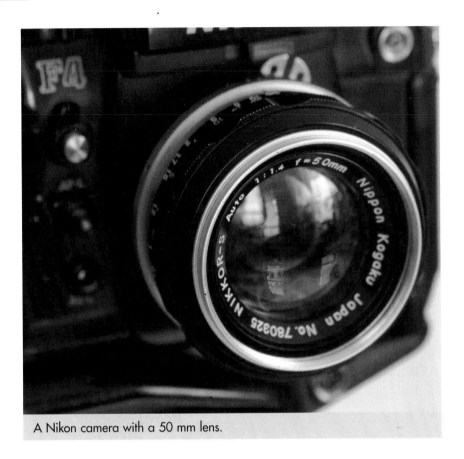

A Nikon camera with a 50 mm lens.

The 50 mm Normal Lens

If you own a 35 mm film camera, then it probably came with a 50 mm "normal" lens. This lens has a lot going for it, such as being probably quite fast—f/2.0 (meaning it has an f-stop capability of 2.0, which we'll discuss more in a minute)—or maybe even faster. It's also lightweight and probably very sharp, even if it was comparatively inexpensive.

One of the big advantages of the 50 mm lens is that, depending on the vintage, it can be used with a digital camera of the same make. If you have a digital camera with a sensor that is smaller than 35 mm film (and most are), then your "normal" lens can become a very nice moderate telephoto for portraits when used on your digital camera. The only real drawback to the 50 mm lens is the obvious fact that the focal length is fixed (more on focal length in a minute).

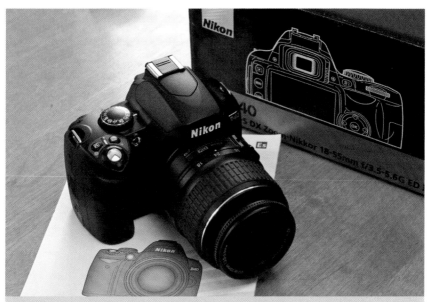

A Nikon D40 camera with kit zoom lens.

If you bought a DSLR, it probably came with a zoom lens with a range of about 18 mm to 60 mm (wide-angle to moderate tele-photo, respectively). It probably also has a variable maximum aperture, which means that the aperture changes as the lens changes focal lengths (we'll see how that happens soon). Modern cameras have electronic couplings in the lens that make the vari-ability of the aperture quite seamless in use, so you probably won't even notice it most of the time.

Zooms such as this are incredibly versatile; they are fantastic for most casual photography. For many people, this zoom is the only lens they'll ever need to own.

This type of lens can be prone to flare, though, so use a lens hood. They are not equally sharp at all focal lengths or apertures (sometimes they differ dramatically), and they are prone to both *vignetting* and *curvilinear distortion*. The small maximum aperture and inherently shorter focal lengths of these lenses means that you will have less control when using selective focus techniques.

For photographers who shoot both film and digital, the big prob-lem with kit zooms is that they are usually only compatible with digital cameras.

Vignetting is when the light from the lens is not distributed equally across the focal plane, making the corners and edges of the photograph appear darker than the middle. While vignetting is considered a technical flaw, some photographers like the effect.

Curvilinear distortion can take two forms: barrel and pincushion. Barrel distortion occurs when straight lines that are parallel to the edge of the frame bow out at the middle, and it is common when using lenses at extremely short focal lengths. Pincushion distortion occurs when straight lines at the edge of the frame pinch toward the middle. (See the "Case Studies" at the end of the chapter for more on distortion.)

Focal Length and Angle of View

The focal length of a lens is pretty simple to understand. For practical purposes, it's the distance that the lens has to be away from the plane of focus (where the film or the digital sensor is located) in order to focus an object at infinity.

The angle of view is determined by the focal length of the lens. It's the area that a lens covers, or "sees."

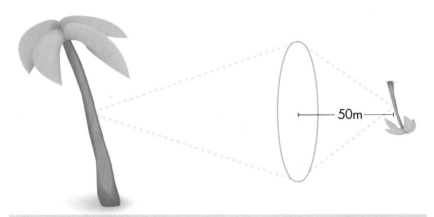

50m

Illustration showing the focal length of a lens.

Understanding the difference between a lens's focal length, its angle of view, and its coverage was a lot easier when everyone shot film that was the same size. It's still easy, but digital cameras have thrown in a wrinkle or two.

As we now understand, a lens at a given focal length—say, a 50 mm lens from a 35 mm film camera—is 50 mm from the film plane when focused at infinity. At that focal length, the lens projects a circular image of a certain diameter. For a lens designed for a 35 mm camera, the diameter of the circle will typically be slightly larger than the diagonal of the 35 mm frame, or about 44 mm. The film simply cropped a rectangle out of the circular image (24 mm by 36 mm, in the case of 35 mm film).

However, if we mount that same lens onto a digital camera, the digital sensor is much smaller than a piece of 35 mm film. Therefore, the same lens now "sees" a much smaller angle of view.

Most DSLRs use a sensor that is 25.1 mm wide by 16.7 mm high. This yields a magnification factor of 1.5, so a typical digital camera would have needed a 33 mm lens to yield the equivalent angle of view of the 50 mm lens.

This is why so many sales brochures give the equivalent lens length instead of the actual length of the lens.

This photo was shot with a 24 mm lens on a full-frame 35 mm SLR. The clear area in the center shows the area that would have been captured by a typical DSLR. In order to duplicate the photo on a DSLR, I would have needed a 16 mm lens.

This means that as the f-stop *numbers* seem to get bigger—f/8, f/11, f/16, and so on—the actual opening is getting *smaller. So the bigger the f-number, the less light is actually entering the camera.*

Let me hear an, "Ah ... now I get it!"

As many times as I have explained this to beginning photographers, this is usually the point that they have always slightly misunderstood. So, I am going to explain it one more time—but a little differently.

On a 50 mm lens, an opening of f/2.0 means that the aperture has a diameter of 25 mm. At f/4.0, the aperture is only 12.5 mm in diameter; at f/5.6 the aperture is 8.9 mm in diameter. The f-numbers are getting bigger, but the physical diameter of the diaphragm is getting smaller.

Got it?

Lens Aperture and Depth of Field

Depth of field is a very important creative tool. You don't need to know the theory behind it, but if you want to progress past the point-and-shoot stage, you have know how to control it.

Pro Tip

Depth of field is typically the hardest thing for beginners to understand. So, here it is in the simplest terms possible: to get more depth of field, you should use a short focal length lens, a small lens opening, and/or move farther away from the subject. To get less depth of field, you should use a longer lens, a large lens opening, and/or move closer to the subject.

Here's How It Works

Theoretically, a lens is only truly, precisely focused on one particular plane of focus.

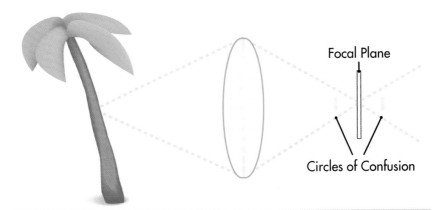

Focal Plane

Circles of Confusion

Illustration showing a wide-open lens.

Anything that is slightly in front of, or behind, the plane of focus is not sharp and shows up as unfocused pools of light. These unfocused areas are called "circles of confusion."

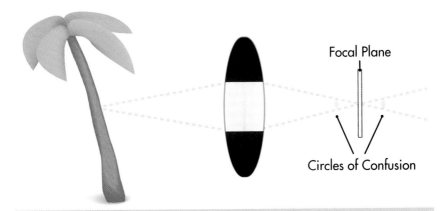

Focal Plane

Circles of Confusion

Illustration showing a closed lens.

When the aperture of the lens is large, the circles of confusion are correspondingly large. By closing the aperture of the lens, the circles of confusion become smaller and smaller. The result is a greater effect of sharpness in front of and behind the main plane of focus. This is what photographers call "depth of field."

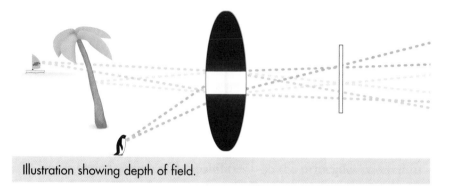

Illustration showing depth of field.

Strictly speaking, only the tree is truly focused. However, the other objects in front and behind become sharper and sharper as we close the lens aperture.

How to Use, See, and Predict Depth of Field

When you are setting the lens aperture on the camera, it doesn't actually close down. It only closes when you take the picture. This means that most photographs will have more depth of field than what you see in the finder when you are viewing the scene. Most people like this, but there are times when you want to see or predict the depth of field that the lens will actually deliver.

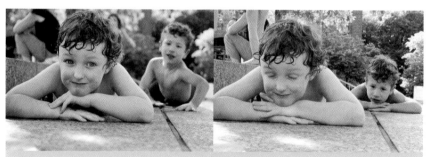

These photographs were both shot with the lens set to 40 mm focal length. In the first one, the aperture is set to f/4; in the second, it is set to f/16. The focus was the same for both, but the aperture and shutter speed were changed. The effects of the change in depth of field were not apparent when I looked through the finder.

Most cameras have a depth of field preview button somewhere near the lens mount. This button will cause the lens's adjustable diaphragm to "stop down" to the actual aperture at which the camera will shoot and allow you to see the effects of depth of field in advance. It will also make the image darker.

Unfortunately, on many modern cameras this is the only provision for predicting depth of field. The image gets so dark at small apertures that it's difficult to see clearly.

Pro Tip

A company called Expoimaging makes a handy little disc that can calculate the depth of field for any lens/distance/aperture combination. In my humble opinion, this little device should come as standard equipment with every camera supplied with a zoom lens and belongs in every aspiring photographer's bag.

Depth of Field: Inherent to Focal Length

Most photographers believe that depth of field is related to the size of the f-stop/aperture, and for practical purposes, this is true.

However, it is important to remember that the f-stop of a lens is a *ratio* between the opening and the focal length. So while a given f-stop (f/2.0, for example) represents an opening of 25 mm across a 50 mm "normal" lens, the same f-stop of f/2.0 would represent an opening of 50 mm across a 100 mm lens.

This is why longer lenses have less depth of field for any given aperture setting; the aperture is actually larger, hence less depth of field.

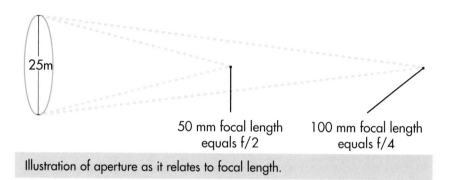

25m

50 mm focal length
equals f/2

100 mm focal length
equals f/4

Illustration of aperture as it relates to focal length.

Why Should We Care?

This relationship has enormous impact when we apply our lens choices to digital photography. Because digital photographers are almost always using a lens of inherently shorter focal length to achieve the same angle of view (than they were accustomed to in 35 mm film photography), they are also working with much greater depth of field for a given angle of view. In fact, with the comparatively small maximum apertures of typical kit lenses, it can be difficult to achieve very shallow focus even with the lens fully open.

Pro Tip

How do you achieve that effect you see in magazines when everything is blurry in the background?

With the increased depth of field in digital photography, it is actually harder to get things out of focus than in focus. The problem is twofold: the short focal length of the lens and the (comparatively) small aperture of the zoom lenses that come with the camera.

In order to get the background to be really soft, you have to push everything to the extreme. Open the lens wide, zoom it to the longest focal length you can, and get as close to the subject as you can.

Depth of Field and Distance

There's just one more thing I need to mention. Depth of field is also dependent on your distance to the object you're focusing on. As you move closer and closer to something, the depth of field will steadily diminish. At very close distances it will virtually disappear, and it will be very difficult to achieve deep focus. This means that you can afford to open the lens more and more as you get farther and farther away from something, and you might need to close it more as you get closer. When you shoot objects that are distant, you can probably afford to shoot with a larger aperture.

Congratulations! If you have been able to understand everything so far, it will be clear sailing from now on.

If you didn't get it all, then just go shoot some photos. Use your lens at the extremes: largest and smallest apertures, longest and shortest focal lengths. Then, reread this section. You'll get it—don't worry.

Focal Length, Angle of View, and Composition

People talk about how long lenses "compress" or "flatten" space and wide lenses distort space, but this isn't really accurate.

If two objects are a certain distance away from us (let's say, 10 and 15 feet), they have a certain relationship—a ratio between them and us. As we move toward the objects, that ratio changes. The object in the foreground becomes bigger faster, but the object in the background does not grow in size as quickly.

As I move father away from the two objects, the space between them seems to diminish and the object in the background appears larger relative to the object in the foreground.

The lens seems to have the effect of compressing the space between the two objects, but it is really a natural effect of how our proportional distance to the objects changes their relationship to each other. The lens simply records this phenomenon.

This makes the choice of focal length, together with depth of field, a powerful compositional tool.

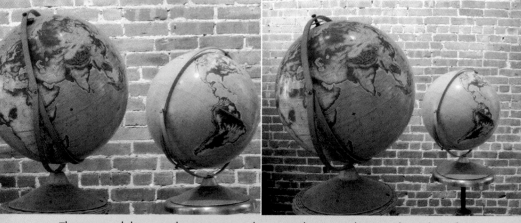

These two globes are the same size; the space between them is about three feet. The first photo was shot with a 40 mm lens. For the second photo, the camera was moved closer to preserve the size of the globe in the foreground and shot with a 17 mm lens. This makes the farther globe look much smaller in proportion and emphasizes the distance between them. Another thing to notice is how much more of the wall beyond is visible in the photo shot with the wide-angle lens.

Autofocus: What It Is and How to Use It

Almost any modern camera these days has *autofocus* (AF). The two types of autofocus systems are either *active* or *passive* autofocus, and chances are your camera uses both systems and knows when to switch back and forth between the two.

Most of the time, your camera works in the passive autofocus mode. Inside the camera, there is an array of focusing sensors that are analyzing the contrast of the focusing screen at certain key locations within the picture area. By searching these different points, the lens focuses and refocuses in order to optimize the contrast at the AF sensor points. You can chose which point is the most important by using a control like a wheel or thumb pad on the back of the camera.

When your camera is actively autofocusing, it actually sends out a beam of infrared light (usually when you are shooting with flash in low light) which reflects from the subject in order to assist the focusing system.

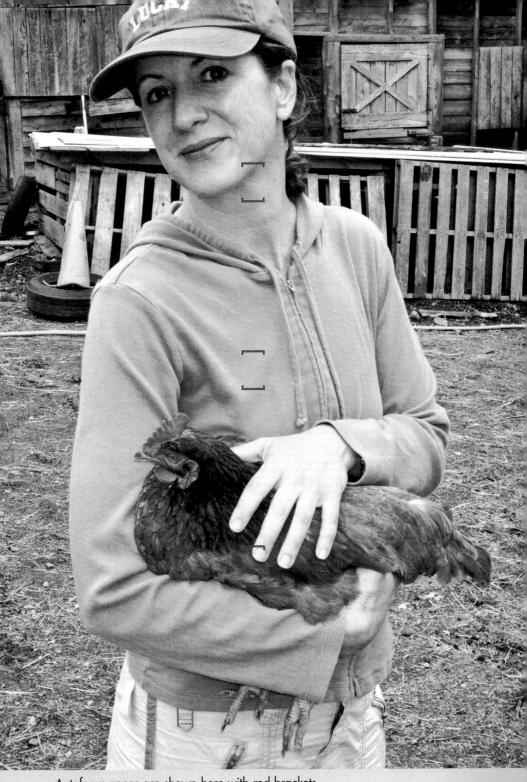

Autofocus zones are shown here with red brackets.

Here are some helpful and common autofocus *frequently asked questions* (FAQs):

I was shooting through a glass window, and all of my photos are blurry. What happened?

Chances are you were shooting in very low light or with a point-and-shoot camera. The camera was in active focus mode and the infrared assist beam was reflected by the glass, causing the camera to focus on the glass instead of the scene beyond the glass. Many point-and-shoots have an infinity setting that will lock the focus to infinity in order to avoid this problem. With SLRs, you should focus manually.

I was shooting close-ups of a car, and they all turned out blurry. What happened?

This is essentially the opposite of the other situation. The lens focused on the reflection in the shiny surface instead of the surface itself. This is the time for you to turn off your cameras autofocus and focus manually.

I was shooting a car race (or some other action scene), and all my photos are blurry. What happened?

Hmm, could be a few different things …

Remember that the AF system needs detail in order to focus. Putting the AF sensor on something that has no detail (like the hood of a white car) isn't going to give it enough information to function properly.

Another possibility is that the action is too fast for your AF system. While modern cameras are incredible in terms of how quickly they can focus, they have their limitations. If you set the film motor drive or digital equivalent of *frames per second* (fps) too high, the AF sensors won't have enough time to read the contrast of the scene. Some pro-level cameras can be very fast, but with prosumer-level, or advanced amateur cameras it's often better to use a lower capture rate and be more decisive about when to shoot.

Finally, it is also very possible that your photographs aren't out of focus but are blurry because your shutter speed is too slow. We'll look at that issue in the next chapter.

Other Lenses

So … when is it time to graduate from the kit zoom?

Maybe never. The zoom lens that came with your camera is remarkably handy. I still use the one that came with my Canon 20D for trips to the beach and other family outings where I don't want to endanger my pro gear.

Using the kit lens will help you to find "sweet spots" at certain focal lengths and within certain limitations. The kit zoom can be indistinguishable from a pro-quality lens. And if you never make prints bigger than 8"×10," then the kit zoom might be all you ever need.

On the other hand, if you are starting to make exhibition prints or feel like you are getting serious about photography, you might want to upgrade your lens in the same range as your kit zoom.

This photograph was shot with a very inexpensive kit zoom at 18 mm at f/3.5 (wide open). If you look carefully, you can see that the corners are darker (vignetting), and on a large print you would also be able to see the difference in the detail of the woman's sweater from the center of the frame to the edge. The center of the frame, where the main subjects are, is as sharp as any of my pro lenses. Knowing the limitations of a lens helps you to use it well.

Prime Lenses

Do you find that you always seem to shoot at the same focal length? Many amateur photographers are under the impression that pros own and carry a virtual camera store of lenses in their bags. This might be true for some pros, but even then I think most pros and fine-art photographers have a certain focal length that they gravitate toward and shoot with most of the time. It might be a fashion photographer who consistently needs the shallow focus of an 85 mm f/1.2 or a sports photographer who shoots with a 300 mm f/2.8 all day long. If you've been shooting for a while, there is probably a prime/single focal length lens that you really need. These are the lenses that are worth top dollar. There are lots of famous photographers out there who never carry more than one lens.

Besides the obvious optical properties, shooting with fixed focal lengths can also be good for your growth as a photographer. They make you move around a subject and think, instead of just dialing in a composition. Moving from the kit zoom to a prime is probably the most important upgrade you can make to your camera.

Pro Tip

Using a tripod, shoot a series of photographs of a brick wall using different apertures and at a few different focal lengths.

Look at the photos on your computer. Look at both the center of the photographs and at the corners. Remember that even pro-quality lenses aren't universally perfect at all apertures or focal lengths. Testing is a tool to optimize the way you use your lenses.

Long Zooms

Are you consistently frustrated by not being able to get close enough—and simply changing your vantage point isn't an option? If this is the case, then perhaps you need another lens with more length. Moderate telephoto to long telephoto, variable aperture zooms like a 70–300 mm f/4.5–5.6 can be fantastic values and still be light enough that you won't mind the extra weight in your camera bag. These are great for photographers who occasionally need a long lens but don't make their living on long focal lengths.

Fast and long zoom lenses are sexy, but the reality is that unless you really need the speed and you shoot long focal lengths regularly, you won't want to incur the weight penalty they exact.

Professional zoom lenses are really marked by the term "consistency." They usually have a constant maximum aperture, and the quality of the lens is more consistent throughout the zoom range. All zoom lenses have certain sweet spots, but the optical quality of professional zooms ranges from really good to awesome. Another important feature of pro-level zoom lenses is the fact that the front element doesn't rotate as the lens is zoomed or focused, so the effect of a polarizing filter doesn't change.

Pro Tip

Optical *image stabilization* (IS) and *vibration reduction* (VR) used to be options that were only available on very expensive professional-quality lenses, but this technology has recently become available to amateur photographers and really extends the range of using longer lenses without using a tripod.

The mechanics of how IS or VR works varies among different manufacturers, but the basics are that there is a special floating element in the lens that is moved during the exposure to compensate for the slight movement of the lens while the shutter is open.

What you need to know is that, within limits, IS and VR work very well and will allow photographers to handhold long lenses at shutter speeds we never could have considered in the past.

Ultra Wide-Angle Zoom Lenses

Do you find that you often can't get back far enough to take the shot you want? Many of the ultra wide-angle zoom lenses like Canon's 10–22 mm are made exclusively for digital cameras and will not adequately cover or even fit onto full-frame 35 mm film cameras. If you only work digitally, then the "digital only" DX lenses are often significantly cheaper and perform very well. But if you like to still shoot with film or are considering upgrading to a full-frame camera like Canon's 5D, it makes sense to buy lenses that work for both (your kit zoom won't). Think carefully about how you will use the lens before dropping your cash on the counter.

Lensbabies

The basic idea of the Lensbaby is that the proprietary Lensbaby lens (a simple 50 mm lens) is mounted to the end of a flexible tube that is focused by pushing or pulling the lens until you achieve the focus effect you want.

A camera with a Lensbaby lens.

The Lensbaby isn't exactly a precision optical instrument, but it does give you back some of the selective focus that we have lost in digital photography. They are quite inexpensive ($100–400 depending on the model) and a fun little accessory to spice up your photography.

Because they really work best in close-up applications, you can also use the Lensbaby to gain back some of the depth of field you lose when working closely. I can definitely see how someone could use this inexpensive little device to spice up a wedding album for a friend or a bunch of vacation photos.

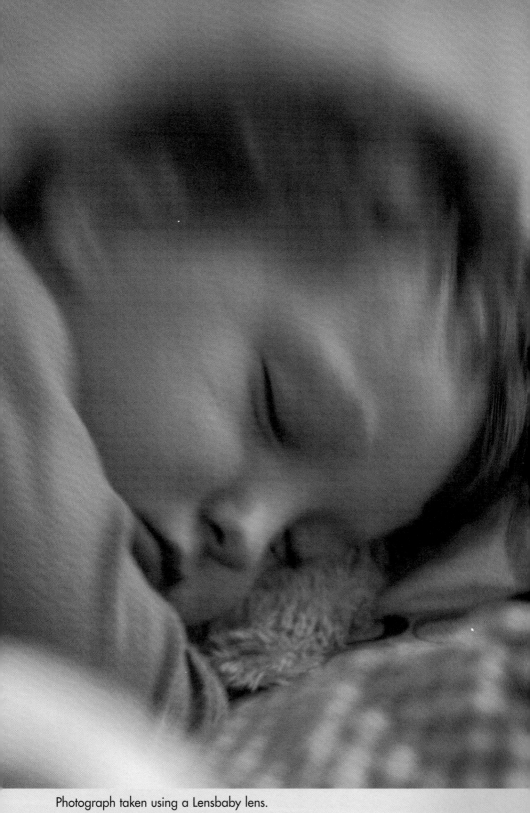

Photograph taken using a Lensbaby lens.

Teleconverters

Teleconverters are a small set of additional elements that attach to the back of another lens. The teleconverter combines with the original lens and increases the effective focal length by a certain amount (usually 1.4X, 2X, or 3X). This accessory can be a very effective way of extending the focal length of your long lenses without adding a lot of weight to your camera bag, but there are a few tradeoffs to consider.

Because a teleconverter is effectively changing the focal length of your lens, it is also effectively changing the lenses aperture. A 1.4X teleconverter used on a 200 mm lens with an f/2:8 maximum aperture makes the new lens/converter combination a 280 mm f/4. All other apertures are also affected, so you lose a stop of light across the board (two stops with a 2X converter). Most modern cameras have circuitry that senses the presence of the teleconverter and adjusts the light meter accordingly.

These tradeoffs might seem pretty severe unless you have carried a 300 mm f/2:8 in the hot sun for a couple of days. Then, the telecoverter seems like one of the best inventions in the history of the world.

This is a perfectly nice picture of two kids on the street. It is shot with the lens set at 24 mm (equivalent to 38 mm on a 35 mm camera) at f/2.8. Still, the parked car and building don't help much …

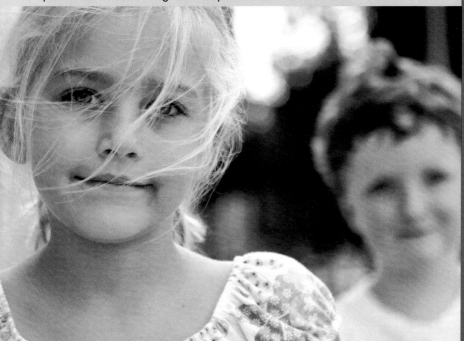

In this photo, the lens is zoomed to about 100 mm while the f-stop remains at 2.8. There's a lot more impact due to the more selective focus of the longer lens and elimination of so many extraneous background elements. Notice how much less focus the boy has due to the decreased depth of field from the longer focal length lens.

This photo uses extreme depth of field. The focus is as deep and sharp as I could get it because I wanted both the boy and the bubbles in the foreground to be sharp. It's shot with a 17 mm (equivalent to 27 mm on this camera) and represents a series of compromises due to the low light of the original scene. I shot this photo at f/4.0 at a fifteenth of a second while holding my breath and praying I could hold the camera steady.

This photograph was made with a very expensive, professional, ultra wide-angle lens, but it still has a little barrel distortion. (Look at the very edges of the frame.)

This photograph was made with a very inexpensive zoom lens at its longest setting. The pincushion distortion is noticeable along the top of the frame.

Both forms of distortion are pretty easy to fix on the computer, and neither is very noticeable in most casual photography.

The Least You Need to Know

- Depth of field is determined by the actual focal length of the lens, not it's apparent field of view.

- Shorter lenses have more depth of field; longer lenses have less depth of field.

- Bigger apertures equal less depth of field; smaller apertures equal more depth of field.

- Closer distances equal less depth of field; farther distances equal more depth of field.

In This Chapter

- The basics and importance of correct photographic exposure

- The interaction of shutter speeds, film speeds, and aperture

- How shutter speeds affect the ability of the camera to record motion

- The ins and outs of light meters

Chapter 3

Understanding Photographic Exposure

How Exposure Works

The purpose of this book is not to teach you to be a photo lab technician but to give you the basic knowledge and tools to become a better photographer. While I won't go into great detail about photo processing, it is important to understand the fundamentals of it—which, in turn, will make you a better photographer. So in a nutshell, here's how exposure works.

In black-and-white photography, the film is coated with a layer of gelatin that contains silver halide particles, which are sensitive to light. We call this the "emulsion" of the film.

As light hits the film, the silver halide particles are excited in direct proportion to the amount of light that hits them.

When the film is processed, the areas that received the most light are transformed into silver particles. If too much light has hit, or exposed, the film, then the highlights (bright parts) of the scene will become blocked with too many silver grains. This means the picture was "overexposed." If too little light hits the film, then the shadow areas will lack detail and the overall photograph will be muddy and lack contrast (underexposed).

The same effects happen in digital photographs. Digital photos shot in JPEG format (the default setting on your camera) are actually much more demanding of perfect exposure than photographs shot on film. Because it seems as though we can "fix" them so easily with photo editing software on the computer, they just seem to be more forgiving.

A digital photograph that lacks highlight details and looks blown out (overexposed) can't really be saved. This is because the information—the detail—is actually lost, and a digital photograph that has too little exposure will have *digital noise*. Manipulating the photograph on the computer can mitigate both problems, but there's a limit to what can be achieved.

You should aim to expose all photographs as well as you can when you're shooting them.

All electronic devices have a certain amount of noise or static due to the electrical current that is passing through them, called **digital noise.** On your stereo, it might be the low hum of the speakers when you turn up the volume but don't have music playing. The hum is still there once you play a CD, but the music masks it.

In digital photographs, the "noise" is visible in areas that didn't receive enough light and shows up as colored speckles that actually resemble the "grain" patterns of underexposed film.

In this digital photograph, I accidentally overexposed by more than three stops (I let in more light than I should have). This photograph has already been fixed as much as it can be. There is no way to recover the detail in the face. (The blue tongue has nothing to do with the bad exposure; it was really blue.)

This photograph was underexposed by about three stops (not enough light). It has also been fixed to about the limit of what is possible. The speckles are digital noise. Notice also that the photograph lacks contrast; there are no true blacks.

A display
showing aperture.

Shutter speed dial
and digital display.

Digital display
and film speed

The Basic Exposure Controls

There are three basic controls, or considerations, for properly
exposing photographs of any type:

1. The aperture, or f-stop, of the lens

2. The shutter speed

3. The ISO speed of the film or digital sensor

Aperture (F-stop) and Exposure

In the last chapter, we learned how the f-stop can be used to con-
trol depth of field, but the primary function of the lens aperture is
to control exposure.

Pro Tip

Modern cameras will dis-
play f-numbers (f/6.3 or f/9,
for example) between the
commonly used f-stops (f/2,
f/2.8, and so on). They are
still indicative of the ratio
between the aperture and the
focal length. They are there
as a way for you to fine-tune
the exposure in smaller incre-
ments than entire stops.

As you close the aperture (bigger num-
ber equals smaller size, remember?), the
lens lets in less and less light. At each
of the common f-stop numbers—f/2,
f/2.8, f/4, f/5.6, f/8, f/11, f/16, and
f/22—the lens lets in twice as much
light as the next *bigger number* in the
sequence (or vice versa; each f-stop lets
in progressively more light, twice the
amount for each stop).

So, an aperture setting of f/4 is letting in half as much light as an aperture set at f/2.8, and an aperture setting of f/8 is letting in twice as much light as an aperture setting of f/11.

If you're still not quite getting it, don't worry. We'll come back to it, and it will all become clear.

Shutter Speed

This one is much easier to understand. As the shutter speed gets shorter, or quicker, less light is allowed to enter the camera.

The common shutter speeds are 1 second, $\frac{1}{2}$ second, $\frac{1}{4}$ second, $\frac{1}{8}$ second, $\frac{1}{15}$ of a second, $\frac{1}{30}$ of a second, $\frac{1}{60}$ of a second, $\frac{1}{125}$ of a second, $\frac{1}{250}$ of a second, $\frac{1}{500}$ of a second, and $\frac{1}{1000}$ of a second. On some cameras, the progression even goes up to $\frac{1}{8000}$ of a second.

In this sequence, the relationship is quite clear: each number is half of the number that preceded it, and each lets in half as much light.

As with f-stops, modern cameras will allow and display shutter speeds between the common speeds. But for the purposes of keeping the learning curve simple, we'll just use the common f-stops and shutter speeds.

ISO Setting (Film Speed)

The International Organization for Standardization (ISO) assigned ratings to films to distinguish their different sensitivities to light. The ratings are also used for digital cameras to define the sensors' sensitivities to light.

Photosensitive

Do you see how the more the camera thinks for you, the less you are thinking for yourself?

To make sure you keep thinking, try switching to the full manual mode on your camera for a while. If you feel unsure, then choose shutter priority mode and let the camera set the corresponding f-stop. This will make you more conscious of the choices you are making.

The common ISO settings, or film speeds, are 50, 100, 200, 400, 800, and 1600. Again, the relationship is pretty simple to understand. Each setting is twice as sensitive as the preceding one—meaning that the higher the number, the faster shutter speed or smaller f–stop you can use.

How It All Goes Together

Choosing the optimal combination of film speed, aperture, and shutter speed is one of the first and most fundamental creative decisions for any photographer. What should be fairly obvious when we look at the settings for aperture, shutter speed, and ISO is the way they are all based on each setting being half as much—or twice as much—as the adjacent setting.

Think of it this way: if you were trying to fill a bucket of water (exactly to the top), you would have three things to consider:

1. The size of the bucket (this is equivalent to the ISO setting)

2. How much you opened or closed the faucet (this is equivalent to the size of the aperture)

3. How long you left the faucet open (the shutter speed)

For pros, it is a series of quick, seemingly instinctive choices based on years of experience: "I need that race car to be absolutely sharp; I need at least $1/1000$ of a second," or, "That background looks like hell; maybe I'll slow down the shutter and pan with the car so the background will just be a blur of indistinct color."

So how do all of these fundamental choices affect the final image? Let's find out.

Choosing Film Speed

While there are pros and cons to higher and lower film speeds, or ISO settings, most of the time we tend to simply pick a speed and leave it there (a holdover from when you couldn't just change the film anytime you wanted).

In digital photography, there is always a tradeoff between the ISO and image quality. Digital sensors will become progressively

noisier as the ISO is increased, so pros try to shoot digital at the lowest ISO setting they can for a given situation.

For our purposes, an ISO of 400 is a good starting point. This speed will offer a good variety of available shutter speeds and f-stops both indoors and out. So for now, let's assume we're working with a film, or ISO speed of 400.

Many digital cameras will automatically choose a new ISO for you (in Program mode) in order to optimize your aperture and shutter speed. Personally I don't like this because I'd rather be fully aware of what ISO I am shooting at. I'd rather know that I have to set up a tripod at ISO 100 instead of the camera telling me it's okay to shoot hand-held at ISO 800.

Shutter Speed Decisions

Shutter speed is also fairly intuitive and easy for beginners to understand, so let's tackle that now.

If you set your camera to a one-second shutter speed and try to photograph a busy street scene, it will become very obvious that a second is a very long time. A New York City taxi covers almost an entire block in one second (except when you are in it and are late for an appointment). Therefore, a second is likely too long. You need to pick a shutter speed that is fast enough to stop any motion in the photograph (or slow enough to make motion apparent, if that's what you want).

Pro Tip

Your shutter speed should equal the focal length of the lens you are shooting with in order to minimize camera shake. If you're shooting with a 28 mm lens, your minimum shutter speed should be at least $\frac{1}{30}$ of a second. With a 100 mm lens, the minimum shutter speed would be $\frac{1}{100}$th of a second and so on.

Setting Aperture

You must now set the aperture (f-stop) to allow just the right amount of light in for proper exposure. This final decision has actually already been determined by your first two choices for film and shutter speeds. Your aperture choice should correspond accordingly.

But wait … aren't there more options than that?

Of course. A shorter shutter speed would mandate a larger aperture (less depth of field). A longer shutter speed would mandate a smaller f-stop (more depth of field but a greater risk of camera shake). You could even change the ISO setting (with a digital camera) if you really need to.

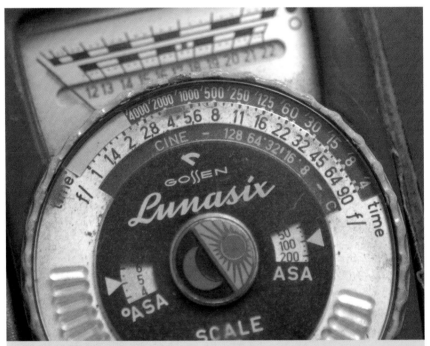

An analog light meter.

One of the great things about old-style analog light meters was that they showed you at a glance all of the choices available for a given lighting situation. There are actually many choices when it comes to aperture and shutter speed. As far as the film/sensor is concerned, it doesn't care whether you shoot at f/16 at $1/125$th of a second, f/11 at $1/250$th of a second, or f/8 at $1/500$th of a second. Each setting will allow exactly the same amount of light to reach the film/sensor. Each setting reflects a set of compromises:

- Too high an ISO will degrade the image with film grain or digital noise.

- Too low a shutter speed will cause the image sharpness to suffer. However, sometimes camera shake or blur can be good (see the following discussion).

- Too big an f-stop will result in less depth of field. (Again, this can often be desirable.)

How Light Meters Work

Light meters are very stupid devices, but people think light meters are infallible. Once you understand just how dumb they are, you are on your way toward using your light meter well.

Here's how stupid light meters are: they think that everything you point them at is gray. If you point one at a black cat sitting in a coal bin, it will assume the scene is gray and set your camera to make the scene gray (resulting in overexposure). If you point one at a polar bear in a snowstorm, it will assume the scene you are shooting is gray and will set your camera accordingly (resulting in underexposure). If you are shooting a landscape that includes a lot of sky, then it will assume it is gray and set the camera accordingly (underexposure).

Because light meters try to make everything gray, photographers often carry "gray cards"—special pieces of heavy gray cardboard to point the camera at—in order to ensure that the camera will average out to gray (resulting in accurate exposures).

You can try this yourself at home. First, find a piece of white typing paper. Then, focus your camera so that the paper fills the frame—and look at the exposure the camera recommends. Now, replace the typing paper with a black book cover and look at the new exposure recommendation.

The amount of light present never changed. The only difference was the reflectivity of the object. Photographs are recordings of an object's reflectivity. You want the white paper to look white and the black book to look black.

If you now put the book and typing paper together so that each fills half of the frame, then they will average out to gray and the exposure will be proper.

The model is holding a gray card. A spot meter reading from the light reflected off the gray card determined the exposure. The photograph is correctly exposed.

The rectangle the model is holding is actually a white piece of paper. A spot meter reading from the light reflected off the paper determined the exposure. Consequently, the photograph is underexposed.

The rectangle the model is holding is actually a black piece of paper. A spot meter reading from the light reflected off the paper determined the exposure. Consequently, the photograph is overexposed.

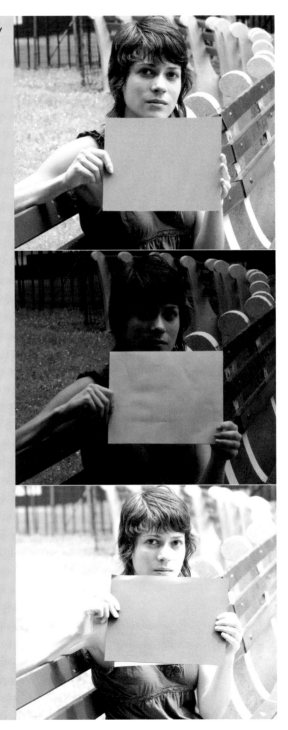

Most of the time, this works out just fine because the tones we encounter in the everyday world average out to be gray most of the time. But it means that as a professional photographer, I am always looking at the world through my lens and wondering, "Does this scene average out to gray?" If I think that it does, then I just keep shooting.

When I shoot, I am always looking at the settings the camera is giving me and questioning whether they make any sense. My years of shooting with handheld meters has enabled me to build a mental catalog of past situations and how I handled them. You will build your own mental catalog as well if you devote just a few hours a week to shooting with no distractions and looking at your results critically.

Your Light Meter

The light meter in your camera is a remarkable device and is actually a little bit smarter than what I just described.

Any modern camera has some form of segment metering (different brands have different names for this; for example, matrix metering). This is kind of like having lots of meters in your camera—all of which are reading different parts of the frame and comparing notes. The camera also has software to evaluate the segments and compare them to situations that the designers have programmed into the software. The result is a meter that is *almost* foolproof.

A modern meter in a contemporary camera would still make a mistake with the polar bear or black cat scenarios but probably not with the landscape. Why? A couple of the segments read "bright" and a couple read "dark," and the software says, "I think this is a landscape" and makes a calculation to optimize the exposure for what the camera "thinks" you are shooting.

Remember that photographs aren't unlimited in terms of the tonal range they can capture. No camera or film can resolve both a white wedding dress in bright sunlight with a black tuxedo in deep shade in the same image.

This was a situation that played havoc with my metering. The huge expanses of snow and bright sun (combined with a headlight shining into the lens) had my camera convinced that my proper exposure should be about $\frac{1}{1000}$ of a second at f/16. I knew it was wrong, but it's hard to trust your instincts when the camera is always warning you that you are overexposing by at least three stops. This was a situation where a handheld meter and the "Sunny 16" guide saved the day and resulted in perfect exposures.

Pro Tip

Pros often use the "Sunny 16" guide as a way to shoot with cameras that don't have meters. You simply match your shutter speed to the ISO setting of the film/sensor (ISO 100, for example), then set your f-stop to 16. So on a sunny day (with clear, distinct shadows), this would give an exposure of $1/100$th of a second at f/16 (with the ISO set at 100). Similarly, the exposure for "bright overcast" (softer shadows) is f/11; "overcast" (shadows barely visible) is f/8; and "heavy overcast" (no shadows at all) is f/5.6.

Knowing the "Sunny 16" guide can help you double check whether your meter is being fooled in tricky situations.

Try using your meter in a few different situations on the "M" (Manual) setting to see just how it works. Try adjusting the shutter speed and aperture to any given exposure that your camera deems to be "correct." Now, try a different shutter speed and find the new f-stop to correct the new exposure.

This will show you the relationship between shutter speed and f-stop. If I am shooting outside on a sunny day, then my base exposure might be $1/125$ of a second at f/16—but I could also choose $1/500$ of a second at f/8 or $1/4000$ of a second at f/2.8. To the film/sensor, it's all the same.

Verifying Proper Exposure

Digital cameras have three amazing tools to help you verify correct exposure:

1. Simply look at the back of the camera at the image in playback. This is better than nothing, but it isn't a terribly accurate way to check your exposure because the camera has "processed" the photograph and already tried to compensate for what it thinks you wanted. It also requires a certain level of experience with your camera because different screens can render images differently according to how the screen brightness has been set up.

2. Use the "histogram." This is a terrific tool but is a little advanced for what we are trying to do now. We'll learn a little more about histograms later, but for now just realize that

in theory, a good histogram (good exposure) for most situations looks like a bell curve. Fat in the middle indicates good mid-tones, and tapering at each end means good highlights and shadow detail. When the fat part of the curve goes far to one end or the other, this usually indicates either overexposure or underexposure.

In theory, this is fine—but in the real world, many photograph's don't yield an ideal bell curve. So while the histogram is a useful tool, you need some real experience to know how to interpret them. Again, the histogram for our black cat and polar bear scenarios isn't going to look like a bell curve.

3. The third and best tool for you right now is the "clipping warning." On a Nikon, just look at the image in playback and then press the thumb pad multi-selector up or down until the image shows the highlights blinking. On a Canon, do the same thing with the "Info" button. Almost any camera will have this feature.

 The areas that are blinking in the clipping warning mode are areas that will not have highlight detail (they are "clipped" and outside of the range of the sensor). These areas will be rendered as pure white in the final image. You now have to decide how important these areas are because they can't be saved later. Bear in mind that it is acceptable for certain parts of a photograph to be pure white as long as you want them to be. I'll accept a clipping indicator in a background window or in the reflection of the sun in a car … but not in a bride's dress.

The clipping warning only applies to highlights, so you still need to be careful and eventually learn to use the histogram.

Other Metering Modes on Your Camera

Your light meter can be fooled, but the amazing thing about your light meter is that you can also change it into different types of meters in order to get it to work in various, difficult shooting situations.

Most modern cameras offer a couple of other options besides the segment/matrix metering mode. One is "center weighted." This gives a special priority to the center of the frame (where you are most likely to position a face, for instance). There might also be a full "average" mode, which simply measures the entire scene and averages everything in order to come up with an optimal combination of shutter speed and f-stop. Neither of these options are likely to be better than the segment/matrix metering, so I don't feel it's necessary to go into detail on them.

Spot Metering

Spot metering, however, does offer some real advantages in tricky situations. It reduces the angle your meter reads to a very small spot in the center of your viewfinder (usually the middle autofocus sensor area). Spot metering can be very valuable when your main subject is surrounded by a large expanse of bright light (in front of a window or a field of snow, for instance).

Pro Tip

Bracketing exposures is a way pros safeguard themselves against making exposure mistakes. It simply means that you take three photos at three different exposures; usually one at the recommended setting, another with one stop less light, and another with one stop more.

Remember that the spot meter still "sees" gray no matter where you point it. If you are using a spot meter and the small area you have singled out is very bright or very dark, the meter will still be fooled.

Be sure to switch your meter back after you have spot metered and shot your photograph.

Cameras do have an exposure compensation button that will allow you to override the camera's settings and overexpose/underexpose in Program mode, but I find it's faster and more accurate to just switch to Manual mode. Besides, forgetting to reset the exposure compensation after you have made the shot (easy to do) will ruin everything else.

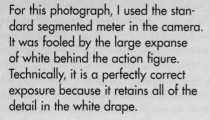

For this photograph, I used the standard segmented meter in the camera. It was fooled by the large expanse of white behind the action figure. Technically, it is a perfectly correct exposure because it retains all of the detail in the white drape.

This photograph was made using the camera's spot meter option to read the light reflecting off the toy motorcycle (notice that it's silver/gray). The highlight detail in the drapes is gone (the camera can't handle everything), but I was really looking for the figure to be exposed correctly (and it is)

Handheld Light Meters

If you are getting serious about photography, you might want to consider purchasing a handheld light meter.

Handheld meters also make everything gray, but once you learn how to use them they can tell you much more than the meter in your camera. Most can also meter flash/strobe light.

Pros all have their preferences for different kinds of meters, and they all have their advantages. Handheld spot meters can meter different parts of a scene in order to accurately determine the entire tonal range of the scene. Handheld meters are also far more sensitive in low-light situations.

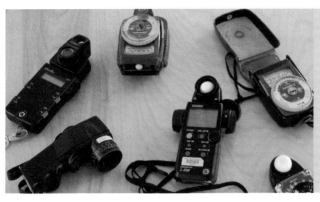

Different types of light meters.

My personal favorite—and the one I am never without—is an all-purpose "incident" meter. The incident meter measures the actual light falling on an object, and for this reason it can't be fooled by extremely bright or dark areas in a scene. As a general-purpose meter, it is close to infallible and easy to use.

The incident meter has a plastic translucent dome on the front. This dome is made to approximate the basic shape of a face. To use an incident light meter, you walk up to your subject and point the dome of the meter back toward the camera's position, making certain that the light on the dome is similar to the light on the subject's face. (If you don't want to hold the meter right up to your subject, you can just look at the light as it is hitting the dome and make sure that it is approximately the same as the light hitting your subject.) You press the button, the meter gives you a reading, and you are done.

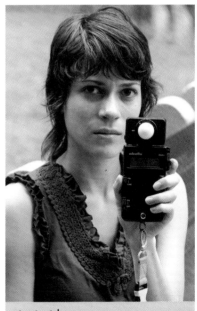

An incident meter.

Case Study:
Motion and Exposure Choices

Legendary desert racer Johnny Campbell negotiates a tricky bit in the Baja 2000. For this photograph, I wanted as much depth of field as possible because I felt the landscape was integral to the romance and adventure of the race.

Shooting with a 300 mm lens and ISO 100 film, I stopped down to f/16 and set the shutter speed to $\frac{1}{125}$ of a second. These settings were fast enough to stop the action of the rider (about 80 mph) because he was moving parallel to the axis of the lens. However, it wasn't fast enough to handhold the camera with such a long lens; I needed to use a tripod to support the camera.

This is a good example of why learning to go beyond Program mode is a good idea. The "sports" setting on most cameras would have chosen a larger f-stop (and higher shutter speed) and not given the depth of field I wanted.

The billboard in the background is a painting that mirrors the body position of the racers in the actual corner they ride through.

For this photograph, I wanted to stop the motion of MotoGP star Casey Stoner. His speed is in excess of 100 mph, but I also wanted as much depth of field as I could get in order to keep the billboard in focus. Shooting with a digital camera allowed me to experiment a lot in order to find the optimal combination of shutter speed and f-stop. I shot the photograph with other racers in order to find my final setting of about $^1/_{2000}$ of a second at f/5.6 with a 300 mm lens and an ISO setting of 200.

The programmed "sports" setting would give a very similar (perhaps better) result.

In this photograph, I wanted to convey the speed and power of World Superbike Champion Neil Hodgson's Ducati.

Hodgson was going well over 100 mph, and his trajectory was perpendicular to the axis of the lens. By panning (moving the camera at the same rate of speed), I was able to blur the ground but keep the bike sharp despite my relatively slow shutter speed of $\frac{1}{125}$ of a second with a 100 mm lens.

In this photograph and the next, the "sports" program mode would have given too high a shutter speed to let the motion blur slightly.

Panning is hard to get the timing right You are trying to match your body/lens speed exactly to the motion of the object you are shooting. Like shooting clay pigeons with a shotgun, the key is to follow through with the motion and not stop the panning motion once you have pressed the shutter release. The tricky part is that the mirror is up, so you are temporarily blind when you are trying to follow the motion.

Panning can also make slower-moving objects look like they are going very fast. These kids were probably only going 5 mph. I shot this picture at about $\frac{1}{15}$ of a second with the lens stopped all the way down and an ISO of 200.

The Least You Need to Know

- Proper exposure is important and exact. Your photos will suffer if you are sloppy with exposure.

- Getting the most from your camera requires finding the optimal combination of shutter speed, aperture, and ISO setting.

- A handheld light meter might be a worthwhile investment if you often find yourself in tricky lighting situations.

- Learning to use your camera manually (or semiautomatically) will make you a better photographer.

Chapter 4

Formats: Digital Sensors and Traditional Film

For the purposes of this book, I will steer clear of going into the ins and outs of various types of digital sensors (CMOS, CCD, Fovean, and so on). Whatever sensor you already have in your camera is probably fantastic, so don't worry about changing anything.

However, it is important to look at some of the primary differences in the file size and compression options, as well as the different capture formats, to get a better idea of how to use what you've got.

All Megapixels Are Not Created Equal

A pixel is a "picture element." Each pixel represents one of the mosaic-like tiles that creates a digital photograph.

On the digital chip inside your camera, there are "imaging arrays"—millions of little light-sensitive photo sites that are filtered to respond to red, green, and blue light. These sensors correspond to the *megapixel* (MP) count, or dimensions, of your camera. A six megapixel camera, for instance, has about 6 million of these little photo sites crammed into the space of its sensor.

The common misconception is that more megapixels are better. While there's some truth to that, there are many other factors that contribute to a digital image than simply counting the photo sites on the sensor. In some respects, this is the least important thing to be concerned with.

Image quality is determined primarily by the optical quality of the lens, the sensor's "dynamic range" (the capability of the sensor to record both highlights and shadows), and by the inherent "noise" (remember our discussion from Chapter 3) of the sensor. Finally, each camera also has an "image processor" that interprets the information and is ultimately far more important than pixel count in determining the quality of the final image.

My point-and-shoot digital camera has 7.1 megapixels, but the sensor size is only about 10 percent as big as the sensor in a typical DSLR—and the lens quality is questionable for anything more than snapshots. The photographs are also noisy, even at low ISO settings.

The Nikon D40 is "only" a 6-megapixel camera, but it blows my point-and-shoot away with image quality. The photographs I've shot with the 6 MP Nikon, even with the kit lens, could easily be published or possibly even submitted to a stock agency.

A Note About ISO Settings and Digital Noise

As you increase the ISO sensitivity of a digital sensor, the sensor has less and less "signal" (light) to mask the inherent noise of the electronic circuitry. This means that digital photographs get noisier and noisier as you increase the ISO setting of the camera. At very high ISO settings (ISO 800 and beyond), the photo might look fine on the back of the camera but will turn out to be a totally unprintable mess once you look at it on your computer screen. I only shoot higher than ISO 400 when I am desperate. However, I'm also a photographer whose work is defined by clarity and detail. A photojournalist might accept a lot more digital noise in order to photograph in certain environments. It also bears mentioning that the effects of noise can also be mitigated to a large degree in Adobe Photoshop, (and other photo editing programs) as well as with other digital noise reduction software and plug-ins like Noise Ninja.

The ISO setting on a digital camera represents another level of creative control that is on par with the shutter speed and f-stop. You can change it, and you should experiment with it in order to find what levels of noise it (and you) can tolerate.

For the following photographs, I set up this little still life to illustrate the differences in the noise as you increase the sensitivity of the camera's sensor. This is difficult to reproduce in a printed book, but on a computer screen or in a finished print it's pretty dramatic.

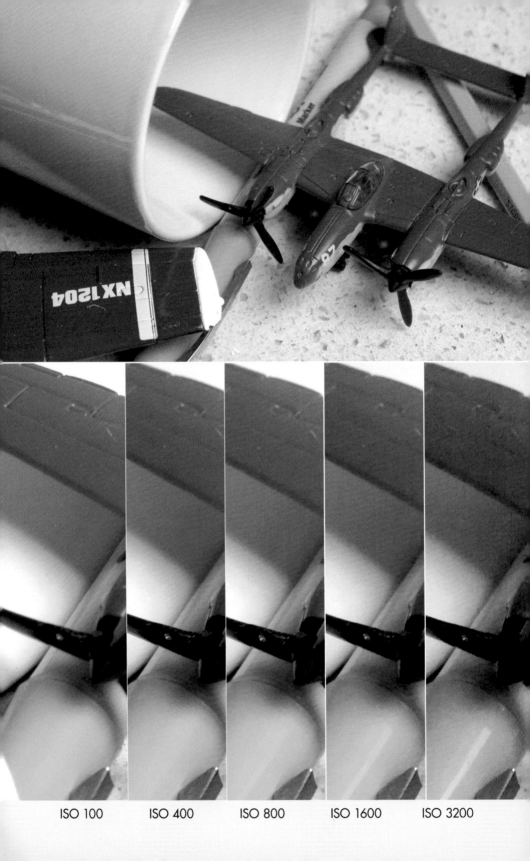

ISO 100 ISO 400 ISO 800 ISO 1600 ISO 3200

In looking at these photos (from ISO 100 to ISO 400), you can see that there is very little change in the noise levels. This is completely acceptable for almost any use.

At ISO 800, the noise becomes much more visible and objectionable in the smooth areas (the shadow on the cup and the wing of the green plane). But the granite countertop has so much texture that it masks the effects of noise.

Still, you probably wouldn't notice it in a small snapshot.

At ISO 1600, the noise is very visible in all the smooth surfaces, blacks, and *midtones*.

Midtones are the areas of medium brightness, or the middle range of tones, in a photographic image.

At ISO 3200, the noise is so bad it looks like the photo was shot with a cameraphone.

Capture Format: JPEG

JPEG is the default format on all digital cameras. With many cameras, if you are shooting in one of the custom program modes (portrait, sports, landscape, and so on), your camera might only be shooting JPEGs (this varies among different manufacturers).

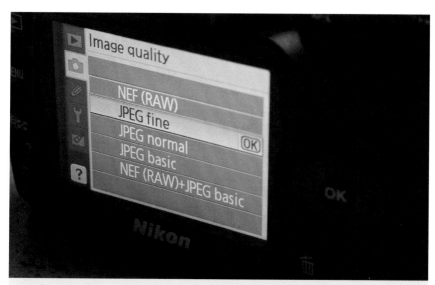

Display showing that the camera is shooting in JPEG mode.

When you move to one of the advanced settings—AV (Aperture Value or Aperture Preferred), TV (Time Value or Shutter Preferred), M (Manual), or P (Program)—you can chose to shoot in either the RAW (more on this in a minute) or JPEG format. You can even opt to shoot both at the same time. The options vary widely from brand to brand, so you will have to check your manual.

JPEGs are compressed files. For our purposes at the moment, this means that the camera takes the picture, assesses the information, decides what to keep, decides what might be redundant, and throws away everything else.

The term **JPEG** is an acronym for Joint Photographic Experts Group, an international committee that created the standard.

When you set up your camera with its basic menu, you can choose to shoot JPEGs with both different pixel dimensions (how many pixels per inch—S, M, and L on your menu) and different levels of compression (usually represented by a symbol that looks like little stairs or a smooth arc) next to the sizes. (Or, it might say something like "Fine.") You should set your camera to Large/Fine JPEG. You can always resize it later to make it smaller.

When you choose to compress your files (the little stairs icon on Canon and many other cameras), you are giving the camera more permission to interpret what is important and what isn't. Let's say that I take a picture of a piece of coal lying in the snow. The sensor sees a little black dot in a white field. It decides to throw away a lot of the white because much of it is redundant and can always be recreated later. For most casual snapshots, this is true—and we seldom notice what information has been discarded. If I choose to compress the file a lot, I might lose much information in the snow—like very fine gradations in tone, for instance, that the camera decided were unnecessary. Most of the time, you won't notice the effects of compression in an original camera JPEG. In a more complex photo, though, the camera might not compress the image as much.

Most digital files use some form of compression in order to save disk space. But some (like RAW files) do not lose or "throw away" any information in order to compress the file. JPEGs are a "lossy" form of compression in that every time you slightly change or alter a file, some of the information is discarded when the file is recompressed differently. This has significant ramifications for the archiving of your work, which we'll discuss further in Chapter 11.

JPEGs are 8-bit files (more on this to come). In other words, in digital images, for every different color channel (red, green, and blue) there are 256 distinct levels of gradation between black (no light) and pure white. Remember: this is per color, and strictly speaking your camera can only "see" three colors. The other colors you see are a result of these three colors combining.

Because JPEGs are compressed and only 8 bits "deep," the camera processes the information and decides what is valuable and what isn't. Film actually does the same thing; that's why we choose different films for different situations.

Within the menus of your camera, there are "looks" that you can choose—vivid color, softer color, black-and-white, sepia, and so on. These are roughly the equivalent of using different films. Still, you are telling the camera what is important to you and the camera is "throwing away" everything else.

I think of JPEGs as digital color slides. What you see (on the screen) is what you get. If you got it right, that's great; but if you didn't, then you probably aren't going to be able to change it much later. For this reason, JPEGs are terrific for learning how to use your camera. The JPEG format is also a universally accepted file. You can send a JPEG to anyone who has a computer, and they will be able to open the file and look at the photograph. The compression of the JPEG file also means that the file is small enough to send as an e-mail attachment.

Pro Tip

Keep your sensor clean by never taking off your lens (of course this isn't always practical). But when you do change lenses, you should always turn the camera off so the static charge of the sensor doesn't attract dust.

Pros and Cons of JPEGs

Of course, as with anything, there's good and bad to shooting in JPEG. Some of the pros and cons of JPEGs are:

Pros:

- JPEG is a universally accepted format and is easily read by computers (into the foreseeable future, at least).

- Compression allows for many more photos per memory card and small files for data transfer and e-mailing.

- Because they are unforgiving of sloppy technique they're a great learning tool.

Cons:

- "Lossy" compression can sometimes compromise image quality. (Choose minimal compression in your camera menu—usually denoted as "fine" in the menu.)

- The 8-bit file depth limits the ability to fix mistakes later.

- All digital photographs (including RAW) are only as permanent as your hard drive and storage. Back up everything!

- JPEGs are actually the most demanding of all capture formats (including film). Underexposure equals noise; overexposure equals a loss of detail.

Capture Format: RAW

RAW files (also called RAW image format files) are photographs that are minimally processed and minimally compressed, with no loss of information in the camera.

RAW files are unique to each camera brand and model. In other words, you will need special software in order to look at your photographs. Your camera almost certainly came with the necessary software, but you can't just send someone a RAW file and expect them to be able to open it. Adobe Photoshop can read RAW files, but you might need to download a plug-in if you have a new camera and an old version of Photoshop. RAW files also have a unique

file extension designation for each camera type or manufacturer (.NEF for Nikon, for example, or .CR2, .CRW, and so on for Canons).

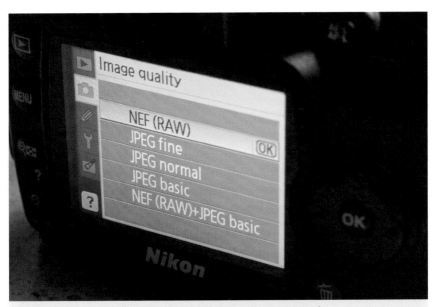

Display showing that the camera is shooting in RAW mode.

This presents a potential problem for future storage/access to your work because we are never sure how long software manufacturers will continue to support certain types of files. Adobe has help on the way with a new type of file called DNG (Digital Negative) that can essentially back up RAW files (more to come on this), in a more universal format, but converting RAW files is another step in the archiving process that has to be considered.

Because RAW files are not processed in the camera, they include *all* of the information the camera received (hence the term "raw"). In other words, they are not color corrected and the exposure hasn't been optimized. The software you view them with might make some default corrections that are really good, but RAW files require post-processing that is analogous to printing in a dark-room (but much easier).

RAW files have a -12-14 bits per color channel of information. This sounds like 1.5 as much information as JPEGs; however, it

represents an exponentially longer and wider range of tones and colors than an 8-bit file can achieve. This allows them to be more forgiving of mistakes.

RAW files are very much like color negatives; you can extensively manipulate the palette of the photograph because you can create a palette of your own. They can be overexposed by about a stop (sometimes more) and will still be beautiful. You can correct the white balance of the photograph and fine-tune the level of post-production "sharpening." You use a RAW file to create the photograph in another file format, like a JPEG, that reflects your choices on how you want to present the image.

Wait! Why Not Just Shoot a JPEG?

Okay … I know what you're thinking. Why would I want to shoot a file one way just to turn it into another?

When you shoot an original JPEG, the camera throws away all the information it deemed unimportant. When you shoot an original RAW file, everything is saved. This gives you much more flexibility over the image. You view and manipulate the image in a RAW file converter program (special software) and use the converter to create a new file in one of the more universally accepted formats (like JPEG). This way, you are deciding what information should be thrown away instead of the camera making that choice for you.

This has two important advantages. First, you have much more flexibility to fix mistakes in exposure, white balance, and so on. The–12-14bit-per-channel file allows you to get more subtle tonal transitions and colors than you could with original JPEGs. Second, you are never destroying or throwing away any information in a RAW file. This means that you can always "start over" in the editing process, even if you have done something drastic (like converted the image to black-and-white).

But there is a price to pay for all this flexibility. RAW files take up lots more room on your camera's digital media and your hard drive. On an 8 MP Rebel XT, a 2GB (gigabyte) card will shoot about 518 Large JPEG images set on Fine (minimal compression) but only 225 RAW files. If you shoot RAW files all the time, you are going to need a new hard drive sometime in the future. I cur-

rently have 750GB of hard drive storage on my computer, and I am running out of room fast.

In many ways, RAW files are the digital equivalent of color negative film. They are more flexible and forgiving, but they require some training and knowledge to actually use them correctly.

Pro Tip

JPEG OR RAW? Just tell me what to shoot! Here's what I recommend: keep shooting JPEGs if you consider yourself a casual photographer. They are simple, handy, and a great learning tool.

If you aspire to more, then shoot large JPEGs and RAW simultaneously. Use the JPEGs as your learning tool. They are completely fine for almost all purposes. Keep the RAW files on backup DVDs as a way to hedge against the point in the future when you can really sit down and learn how to work with them.

Pros and Cons of RAW Files

Pros:

- It's very forgiving of mistakes (with training and software).

- Information is never lost.

- Because RAW files require post processing they require you to look at your work much more critically. Conceptually, they're almost like working in your own darkroom.

Cons:

- RAW is a professional format that requires special skills to make the most of it.

- RAW files are unique to each camera, so there are potential risks to accessing your photographs in the future.

- Long-term access to RAW files is an open question. It's best to back up all important photographs in another more universal format (for example, JPEG or DNG).

- RAW files eat up a lot of disk space on your camera's media and on your hard drive.

Film

The explosion in digital photography notwithstanding, there are still plenty of great film cameras out there—and many good reasons to shoot with film. Film offers many advantages over digital capture:

- Most films have more dynamic range—a greater ability to capture both highlights and shadows—than digital sensors and digital photographs.

- Most films (excluding color slides) are more forgiving of mistakes in exposure.

- Film is still much better at making very long exposures.

- Film allows any camera to be upgraded by new technology. A 40-year-old Leica is still a viable professional camera if it is loaded with modern film.

- Film teaches you to think more decisively about photographs (more on this in Chapter 5).

- Film creates a permanent archive of your work that requires little maintenance.

Film Speed and Grain

This close-up shows film grain.

As I mentioned in the last chapter, film is sensitive to light because silver halide crystals are embedded in the photo-sensitive side of the film. Photographers commonly refer to these tiny particles as "grain." These particles are actually what you see when you look at a traditional photograph. They are darker or lighter depending on how much light struck the film. Grain constitutes the very fabric of the photograph.

When these particles are larger, they have more surface area available for light to strike them—and the film, therefore, has a greater sensitivity to light. This is the determining factor in the *ASA*, or ISO settings—the speed of the film.

In order to make faster films, manufacturers make the grain larger (bigger chunks equal faster speed, which equals lower resolution). In order to make film resolve more detail, they make the grain smaller (smaller chunks, slower speed, and higher resolution).

Some older cameras and light meters will have **ASA** designations (American Standards Association) as opposed to ISO. The settings are the same: ISO 100 equals ASA 100.

For this reason, professional photographers usually choose the lowest possible film speed they can.

I would guess that 99 percent of my professional work is shot on films with a rating of ISO 100, but these are photographs that have to be used as double-page spreads in a magazine. For most amateurs, a film speed of ISO 400 should yield a very good compromise between flexibility in different lighting situations and image quality.

Types of Film

Despite the convenience of digital photography, the best reason to still shoot film lies in the millions of awesome film cameras already out there. I still own two view cameras (4×5), seven medium-format cameras, a couple of Leicas, and a panoramic camera. All of these film cameras have unique capabilities and "looks" that are beautiful and intrinsic to the design of the camera. Despite its age, that old Rollei or Hassleblad your dad handed down to you is an awesome camera, too, and it only shoots film. Take it out for a spin.

Black-and-White Negative Film

Black-and-white films are easy to understand. Light strikes the emulsion of the film with the tiny particles of silver halide, and these particles are excited in direct proportion to the amount of light they received. The film is processed, and the silver halide is transformed into silver particles. Excess silver (in the areas that received proportionately less light) is washed away, and the result is a photographic negative.

Example of a photograph taken with film.

The negative is then put into an enlarger and printed onto photographic paper (that is also coated with an emulsion of silver halide particles), and a positive print is made.

During the printing process, the contrast and tone of individual areas can be modified to a very large degree—affording many more controls to a skilled photographer. This secondary level of control and interpretation is one of the hallmarks of traditional black-and-white photography.

Black-and-white negative film is available from many manufacturers in speeds from ISO 100 through 1600. Even higher speeds can be achieved with special processing.

Pros and Cons of Black-and-White Film

Once again, there's good and bad to think about when deciding whether or not to shoot with black-and-white film. Some of the most important points to consider are:

Pros:

- There is still a special magic to black-and-white photography.
- Negatives can last for centuries with proper storage.
- It's quite forgiving of mistakes.
- Extremely long tonal ranges are possible.

Cons:

- There is no color.
- In an era where digital is taking over, it has become increasingly difficult and expensive to shoot black-and-white film.
- Quality black-and-white labs with master technician/printers are becoming extinct. Alas, it's a dying, but beautiful, art.

Color Slide/Transparency Film

Color slide film is also known by the terms "transparency film," "reversal film," and "chrome." When you buy color film, you can usually tell that you are buying a color slide film because it will have the word "chrome" in the name (for example, Ektachrome, Fujichrome, Kodachrome, and so on).

Color slide films produce a direct positive image on the actual film that was in the camera. They also use light-sensitive silver halide crystals to collect the light that strikes the film. As a consequence, the grain and resolution of the film is also affected by film speed.

There are two important differences in all color films:

1. The film has three different layers to the emulsion, each of which is sensitive to a different part of the spectrum of light that hits the film.

2. These different layers are coupled with special dyes that correlate to the respective colors in the film. When the film is processed, the actual silver is completely carried away but the dyes remain. These dyes form the different colors of the final photograph.

Example of a photograph taken with color slide film.

Pro Tip

Because slides are a direct record of the light that was present when the photograph was made (with no added interpretation such as printing or digital manipulation), they are a fantastic way to learn how to see color the way cameras and films see color. They are also unforgiving of sloppy techniques.

In my color photography course, I require students to shoot color slides for almost a month before we move to making color prints or shooting digitally.

When color slides are processed, they are typically mounted to cardboard mounts for viewing in a slide projector.

Because color slides are the actual film that was in the camera, the film must be perfectly exposed when the photograph is made. A slide that has been overexposed by more than a stop can't be saved. Color slide films are also "balanced" (more on that later) to a particular type of light (daylight or incandescent). Pictures that have been shot out of balance can't really be fully corrected later, even on the computer. You have to use either the correctly balanced film or special filters to correct the film during exposure.

Each brand and type of color slide film has a unique look, or "palette of colors." Each also has a range of contrast. These special qualities are very difficult to modify. Pros spend years learning how to exploit these unique characteristics and might base an entire style around a particular type of film.

Pros and Cons of Color Transparencies/Slide Films

Some considerations when thinking about using color transparencies/side films are:

Pros:

- Beautiful, vivid color when done right

- Still the best way to learn critical color photography skills for the advanced photographer

- Produces beautiful scanned files for computer manipulation and printing

- Decent archival storage—about 30 years if stored casually (room temperature, in boxes or archival sleeves)

Cons:

- Extremely demanding
- Fragile; no other record for the photograph unless it is scanned into a digital file

Color Negative Films

Color negative is the most commonly used film for amateur photography. In recent years, it has become widely accepted by professional photographers as well.

Pro Tip

What's the difference between drugstore film and the pro film sold in photo stores?

Amateur films sacrifice a certain amount of quality (less color saturation and chalky highlights) in order to withstand the abuse amateurs put their film through. ('Fess up … you've left a camera in your car on a hot day, haven't you?)

Pros can see the quality difference easily, but most snapshot photographers can't. If you want the best results, shoot professional film and get it processed in a timely fashion.

Color negative films are sometimes called "print films" and are widely available. You can usually tell when you are buying color negative film because the name of the film will have the word "color" in the name (Vericolor, Fujicolor, and so on).

Color negative films also use three layers of light-sensitive emulsion and are subject to the same grain/film speed tradeoffs as every other film.

Traditionally, color negatives were put in a special color enlarger to make color prints. Most photo labs now use automatic scanners to scan the negative and then use a special digital printer to print the photographs onto color photographic paper. The printer uses tiny points of colored light to expose the paper in a similar

A color negative.

way that inkjet printers use tiny drops of ink to produce a print. A technician typically looks at the photograph on a computer screen and quickly optimizes the scanned file in order to make a color print that has acceptable color balance.

Color negative films are amazingly flexible. While they do have a color balance (almost always daylight), they can be shot out of balance and still produce beautiful prints.

They are not tolerant of underexposure without a very noticeable loss in quality (about a half a stop is okay), but they are very forgiving of overexposure (two to three stops is often fine and sometimes desirable). They scan beautifully.

Color negative film does require a secondary level of interpretation in the printing process. This means that (within limits) what you see in your print was what the automated printer or technician decided you probably wanted. They usually get it right for casual snapshots; in fact, they often fix your mistakes because there's a reference point (like a face or some other easily recognized object) in the photograph.

However, when you shoot more creatively, these reference points become open to interpretation and are often less recognizable. This is why color prints aren't a very good way to learn critical color skills.

Pros and Cons of Color Negative Film

Some considerations when thinking about using color transparencies/side films are:

Pros:

- Available anywhere
- The most flexible and forgiving of all film types
- Very fine resolution
- Easily corrected when shot incorrectly (within limits)
- Makes many old cameras fully modern tools
- Easy archiving of original negatives with a fair level of permanence (about 30-plus years) with casual storage

Cons:

- Requires a trained eye to correctly interpret and optimize final prints
- Very high cost per roll including processing and proofs
- Final prints (enlargements) can be expensive.

Format FAQs

When is color negative a better choice?

I'd look at what kind of photographer you are. Do you shoot fewer than 10 rolls a year because you are too busy?

If that's the case, I'd stick with color negative for three reasons: it forgives mistakes, the cameras are cheaper, and you can throw the negatives in a shoebox and they'll probably be fine.

If you are shooting that little, you probably won't invest the time

to back up digital files on you computer. You can request a CD of your work for computer files when the film is processed. Then, throw the negatives into a shoebox for posterity.

When is color transparency the best choice?

Any photographer who is serious should shoot color slides for a while. It's cheap (there are no prints to make), very unforgiving, and shows you the color that the film saw without interpretation.

When are JPEGs the best choice?

Casual snapshooters and serious photographers both benefit from shooting JPEGs due to pure economics. No cost equals lots of photos, and backing up your work on a DVD is a pretty simple process with JPEGs because the files are so small.

When are RAW files the best?

Raw files offer the best of everything with two important exceptions: you'll have to invest at least a few days learning the software, and you'll have to maintain your archives diligently.

The Least You Need to Know

- Film isn't dead and is still preferable for many applications.

- JPEGS are the simplest and most handy format to shoot in; what you see is what you get.

- Digital photographs shot in RAW format offer many more controls and options for creative photography.

Chapter 5

Photography Rules and Conventions

If you've noticed, throughout the book so far we have really been talking about making decisions at every level— which shutter speed, where to focus, and so on. Good photography is all about thinking decisively and either following or ignoring photographic conventions (like stopping motion or freezing motion).

In fact, if you think about it, all art forms are just a tangible record of a series of decisions—where to put a blob of paint, striking a C-minor chord, choosing one word instead of another, or deciding to write about romance instead of crime.

One difference that separates trained photographers from snapshooters is that photographers are familiar with the *conventions* of art. These conventions are guidelines that have become hammered into the history of our culture and its images. They denote certain things because they are used over and over again in certain ways—yet they are powerful precisely because they are clichés.

Pro Tip

Now, to consult the rules of composition before making a picture is a little like consulting the law of gravitation before going for a walk. Such rules and laws are deduced from the accomplished fact; they are the products of reflection ...

—Edward Weston

All art forms have conventions. For example, rock and roll has the beat, the guitar riff, and the wail of the singer; poetry has iambic pentameter and the meter of the verse. The conventions of all art forms are the grammar and syntax of its language, and they are there to be used intelligently. They are also made to be broken, however.

Some Conventions of Composition

The following are conventions of composition to help provoke ideas of your own and get you to experiment. But remember, composition doesn't make great photographs any more than good punctuation makes great writing.

In the history of art, there is a long-standing notion that there is an innate beauty and elegance to any rectangle proportioned 2×3. Remarkably, this is also the proportion of your camera's frame. Coincidence? This also happens to be the proportion of the Parthenon's façade. I think I am beginning to smell an international conspiracy.

Western art was built on this "golden rectangle," so who am I to argue with the ancients? Look around you—in fact, look at the proportions of this very book—and you will see golden rectangles everywhere.

The golden rectangle.

The Rule of Thirds

Every book on photography has to include a section on the rule of thirds; it's a rule.

The rule of thirds states that if you divide a golden rectangle into thirds, you get six more golden rectangles. By placing the subject of your image at the intersections of these new rectangles, the composition has more tension and interest. Once you get hip to the rule of thirds, you will see it everywhere in art, advertising, and cinematography.

Division of the golden rectangle, resulting in the rule of thirds.

Oh, and have you noticed that most camera's autofocus sensors are placed at intervals that correspond to the rule of thirds?

Photo shot using the rule of thirds.

The Spiral

The spiral convention is actually a continuation of the Rule of Thirds. In this particular spiral, the same mathematical formula is applied as if you were continuing the progression of dissecting the golden rectangle into ever-smaller rectangles.

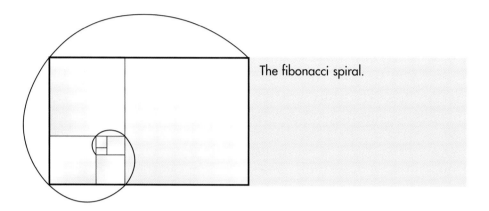

The fibonacci spiral.

For the math geeks out there, this is also known as the *Fibonacci* spiral because it is based on the Fibonacci sequence of numbers. If you look at the squares and rectangles that are the guides for creating the spiral, you will notice this pattern a lot in everyday life—especially in older office buildings.

Fibonacci (a.k.a. Leonardo of Pisa) was an influential mathematician of the middle ages. Although he did not discover the Fibonacci numbers, it was named in his honor.

The number sequence begins 0,1,1,2,3,5,8,13,21,34 and continues ad infinitum. In the sequence, any two numbers (in order) add up to the next number in the sequence 2+3=5, 5+8=13 and so on. The sequence is often found in nature; like the chambered nautilus sea shell, or the way trees shoot off limbs, limbs shoot off branches, branches shoot off twigs and twigs give rise to leaves. There's a formula that applies the Fibonacci sequence to a method of tiling squares that results in an ever-expanding series of golden rectangles, on which the Fibonacci spiral can be drawn.

The number sequence has held a special place in the hearts of mathematicians and artists as a possible hint, or even a proof, of a Divine Intelligence in the creation of the physical universe.

Diagonals, Zigzags, and S-Curves

Diagonals, zigzags, and S-curves are another variation on the rule of thirds because you are usually connecting two of the rectangles' intersections with a diagonal.

The valleys and ridges beyond the skier form a series of zigzags which draw your eye to the main subject of interest.

An example of dynamic symmetry.

Dynamic Symmetry

This one gets a little trickier because symmetry is supposedly boring. Most photography books tell you to avoid putting the subject in the center of the frame.

But then there's "dynamic symmetry." Dynamic symmetry is a composition that looks symmetrical at first, but there is an element that causes it to be slightly unbalanced. This imbalance causes you to keep looking although the photograph seems simple.

Negative/Positive Space

The yin-yang of compositional devices, *negative* and *positive space* uses the edge of the photograph's frame to create tension within the photograph.

To paraphrase an anonymous art teacher: "When you put a peanut in the bottom of a barrel, it's a dot. When you put it in a match-box, it's sculpture."

> **Negative space** is "empty" or background space. **Positive space** is the area that contains the image the viewer is expected to identify.

Use of negative and positive space to create interest.

Coming in close emphasizes the sinuous lines of the object in contrast to the straight edge of the frame.

The Dutch Angle/Lasso

The Dutch angle is a device used a lot by cinematographers where the camera is cocked at an angle to create tension in the frame. It is often used to denote a time when the main character is mentally unbalanced. I've used it a lot in my automotive photography as a device to make a static car photographed in the studio seem more dynamic.

My own variation on the Dutch angle is the "lasso" (actually, my entire generation really stole it from the great photographer Garry Winogrand). In it, you simply "throw" the rectangle of the frame around all that you want the photograph to have in it without worrying about keeping the frame level.

Photograph shot using the Dutch angle device to emphasize the potential power and speed of a static car.

When you "lasso" a photograph, you are just trying to connect two different things in the frame to show their relationship. Photojournalists use this compositional device a lot to include as much content and energy as possible in each photograph.

It's a happy coincidence that this photograph looks like someone lassoing something.

Take a look at this photograph. We are actually looking straight up a sheer rock face that a specialized truck is climbing in a rock-crawling competition. The person holding the rope is helping guide the truck up the rock wall. (These vehicles can do amazing things.)

A photo as confusing as this would never have been accepted 40 years ago, but we have become accustomed to seeing these kinds of compositions in contemporary photographs and films. It's another example of how our visual language is always evolving.

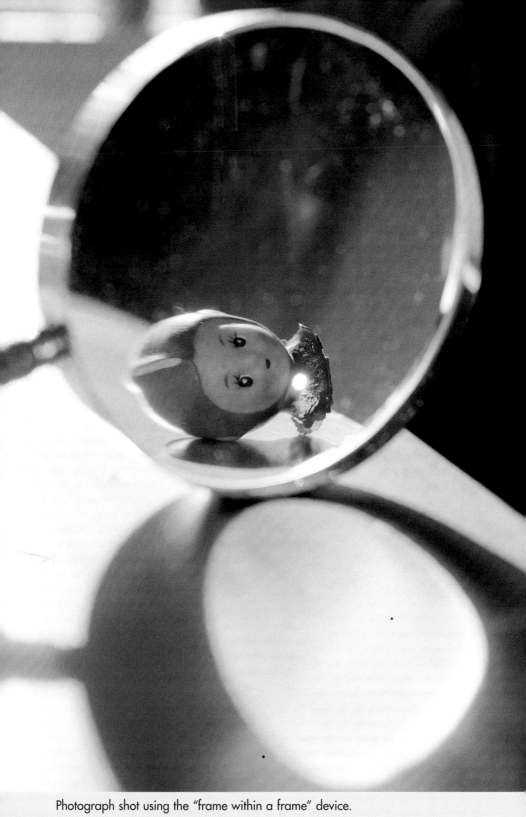

Photograph shot using the "frame within a frame" device.

This photo is a great example of how conventions have power. The child looks like he's being threatened, and perhaps a fight is about to break out. The viewer's reaction is a conditioned response because Hollywood uses this exact composition all the time for dramatic effect.

The Frame Within a Frame and the Dirty Frame

The "frame within a frame" convention uses one object to frame another.

The "dirty frame" is a term I might have made up. I'm not sure where it came from. But this convention is used a lot in cinematography where the main subject is framed by other objects or people (usually out of focus) for dramatic effect. It heightens the viewer's feelings that he or she is a "fly on the wall" and is privy to a secret event.

Take a look at this photograph. Although the photo is completely candid, there is nothing "lucky" about it. The kids were playing happily, and I just watched for the right framing and expressions to illustrate the point. Sometimes knowing what you are looking for can help filter out all the clutter and make the hunt easier.

Watch the Background

It almost goes without saying that you need to watch the background in your shots—remembering that when you look through the camera, the lens is wide open and has limited depth of field. When you actually take the photo, the lens closes down to the working aperture. At very small apertures, the increase in depth of field might yield some unpleasant surprises in the final image (like this one, where the woman seems to be standing on the little boy's head).

The interesting thing is that you probably already know the rules. As you went through the points I just made, I'll bet at every single one you thought silently, "Oh yeah, I've seen that before." Or if not, now you know more than you did about the rules of composition.

In the same way that our number system is based on how many fingers we have, the rules and conventions of composition are "hard-wired" in our culture and our collective psyche. You already know the rules because you see them all the time. What you probably haven't been doing is practicing them and putting them together.

Pro Tip

What's wrong with just putting your subject(s) in the middle of the frame? Absolutely nothing. Diane Arbus did it, and so did Richard Avedon and Walker Evans. In fact, I sometimes think this is the subtlest of all the devices because it places the attention on the actual thing you are looking at and less on you as the photographer. The key is to make sure the "thing itself" is interesting.

Composition is a tool, not an end.

Keeping an eye on the background while shooting ensures that you don't wind up with odd-looking photos like this one!

Talent vs. Practice

The word talent implies a special gift or aptitude, like a singer with perfect pitch or an athlete with a genetic gift that enables him or her to jump higher or run faster.

I've been fortunate to meet and know some of the greatest photographers in the world. I don't think they are necessarily talented. They are just people who work very hard—people who get up before dawn to shoot, who live in the darkroom, who go to every exhibition and spend all their money on photography books. They eat, breathe, and sleep photography. Remarkably these are also the photographers who seem to be the most talented. When we speak of their talent, we actually denigrate their hard work and commitment.

Talent is exclusive and mysterious—kind of like you're either born lucky or you aren't. But practice is inclusive; *anyone* can practice and learn. Practice is what makes anyone better at anything.

Here are some everyday assignments to make practicing fun.

Practice the Rules

Make a copy of the list of compositional devices I outlined earlier. Carry it with you, and make a series of photographs that uses every one of them. Practice them over and over again, then practice some more. There are an infinite number of interesting images out there to photograph, so you can never get bored just practicing.

Break the Rules

The traditions of composition help you think about photographs and help the viewer interpret them. But sometimes the challenge is to make a photograph that breaks all the conventions and still works.

A photographer must first know the conventions before breaking them—hence the need to practice. Once the conventions are understood, breaking them is where you can breathe more of your own creative life into things you shoot.

This photograph is pretty bad according to all the conventions of composition. The kid is in the middle of the frame; the seesaw behind him looks like an "x" growing out of his head; and the color is off. But who cares? Those are all the reasons why I like it. Bottom line: don't be afraid to break the rules once you've learned them.

Move, Don't Zoom!

In my time as a teacher, I have watched the popularity of kit zoom lenses grow. The problem with zoom lenses is that they make us lazy and actually encourage the point-and-shoot mentality. We compose by turning a dial instead of moving around the subject and figuring out ways to overcome the limitations of the lens by changing our own vantage point. Because of this, when I ask students what focal length they used, they seldom know.

Try to find a focal length you feel comfortable with on your zoom lens and then tape the zoom ring into that position. Spend a day moving yourself around instead of using the zoom as a convenient crutch. If something just doesn't work, then go ahead and remove the tape and zoom the lens to a focal length that works. The exercise will make you more aware of when and why you use different focal lengths.

Invent Pressure and Goals

When a photographer is on assignment, there are a lot of other people (art directors, editors, and so on) who are depending on him or her. There are photographs we absolutely have to get (beautifully)—or careers (even besides our own) can be ruined.

Critiques at art schools can be brutal. When I was a student, it was common for students to be regularly reduced to tears during a critique either by the teacher or fellow students.

I'm not quite that brutal as a teacher (although my students might disagree), but the weekly pressure of an art school critique is an important incentive for a student to produce outstanding work. Teachers also cheer students on, and everyone in the class applauds each other's successes. Of course, the pressure is really just a pretense. No one is going to die because a student didn't make a good photograph, and a good photograph isn't a cure for cancer. In essence, teachers and students agree to pretend that it really matters because the pretense of pressure makes them better photographers. As they say, "Pressure makes diamonds."

The hardest part for photographers trying to learn on their own is a lack of pressure. So it might be helpful to invent some, like challenging yourself to make a really good photograph every week. Don't just shoot an image and look at it on the screen of your computer. Shoot it many times, practicing all the conventions and breaking them, and then print what you're most proud of. Put it somewhere you'll see it every day. Better yet, put it someplace where other people will see it.

Putting a photo on the wall of your cubicle or your refrigerator is a great way to discover how good it really is. Good photographs have staying power; they are interesting every time you see them.

Reinvent the Everyday

This is a little game a lot of professional photographers play in order to keep themselves interested and sharp.

The idea is that you just pick any object or scene that is likely to come into your view at least once a day. The trick is that every time you see it, you must stop everything else you are doing and

make a good photograph of the thing that is different from all of the other times you have photographed it.

I have five things on my personal list. Some are just mundane, like this particular lamppost along my daily commute that I try to make new and interesting every time. The photographs of my son's toys you see in this book started out as one of my everyday exercises, then evolved into a body of work that is actually exhibited in galleries.

Shooting a common scene every time you see it can produce some interesting results.

It doesn't matter what you pick as long as you stop, look, and make a photograph every time you come across it.

Try to make the objects you're shooting look new and interesting every time you take a photograph.

Go Someplace New

A new place is always exciting. Get on the subway and take it where you've never gone before. Go to an amusement park alone and don't ride anything just walk around and take pictures. Get in the car and drive with no destination. Let the world wash over your eyes like the surf, and just enjoy the pleasures of sight and translating some of these experiences on into photographs.

Nothing can invigorate a photographer like the adventure of finding new places—which become new worlds—to photograph.

Shoot Digital Endlessly

The big problem with digital cameras is that you look at the back of the camera and say, "I got it." The creative process is effectively over the second you know you have it. When you've "got it," you stop thinking.

The beauty of film was that we were never sure we had it, so we kept shooting and tried everything until we had exhausted every possibility we could think of. Even then, we still weren't sure we

You never know when a particular time of day may result in some interesting lighting or effect.

"had it." The problem was that all of that experimentation was expensive unless you were on an assignment and someone else was buying the film.

Digital cameras are the best learning tools in the history of photography. But they do, unfortunately, encourage a certain sloppiness and simplicity. The small screen is no place to edit your work.

Pro Tip

Which eye do you shoot with? Cameras are designed to be used with the right eye. If you shoot with your left eye (as I do), then you will have a hard time seeing the left side of the frame because your nose forces you to hold the camera awkwardly.

I happen to shoot with my left eye, and many of my students do as well. I often notice that in their work that left-eye photographers can be sloppy with composition on the left side of the frame. If you shoot with your left eye, make a conscious effort to look at the left side of your frame when you are composing photographs until it becomes second nature.

So cover the screen or turn off the display. Hoodman makes a great little screen protector that closes the screen but still allows you to look at the back by flipping it up (it also helps you view the screen in bright light).

Shoot as if you were shooting film—which means no checking your exposure on the screen and no flipping through the images in playback. Just shoot carefully and try to completely exhaust every possible combination you can think of. Then look at your work later on the computer screen.

The Least You Need to Know

- Learn all the basic conventions of photography so you can then learn how to break them

- Great photography requires lots of practice, even for those with a natural predisposition or talent for it.

- Go somewhere new to practice your photography, but also shoot images you see everyday.

- Practice with a digital camera as if you are using film—meaning no checking the results right away on the little screen.

In This Chapter

- How we see color and how cameras and film see color

- Why different light sources are different colors in photographs

- How to balance photographs for different light sources

- Ways of looking at light and using flash

Chapter 6

Light Is Color, and Color Is Light

We all know what color is, right? Stoplights tell us when to hit the brakes or the accelerator while driving. Orange cones mean we have to be careful, and blue skies mean good weather.

If color is so simple, why has it occupied—and confused—some of the greatest minds in the history of the world?

Plato, Goethe, Van Gogh, Richard Feynman … the list could continue on and on. The great thinkers of science, art, and philosophy have all been fascinated by color for one simple reason: color is a physical fact, but the perception of color is undeniably subjective. Color is where the physical and the metaphysical collide in our consciousness. One person's fuchsia is another person's magenta and still another's pink. For a special few, it might even be gray and indistinguishable from chartreuse. Color is truly in the eye of the beholder.

But is it, really? We have machines that can measure, quantify, and calibrate color. But can we measure our perception? A red Ferrari is ablaze in the light of a desert sunset but turns to a dull gray parked under the mercury vapor street lamp of a parking lot. Why? Because the street lamp emits almost no red light, and if there is no red light present then there is no red light for the red paint of the car to reflect. While, in the red, rich light of the sunset, the car is supersaturated and seems unbelievable in its pure "redness."

If the conventions of composition have power, then the power of color is exponential. Color is big to say the least, and it requires attention and practice to learn its secrets.

Color Perception

Color perception and the psychology of visual perception is a very rich topic that people have devoted their lives to understanding. Let me say that my explanation here, for the purposes of this book, is a vast oversimplification of a very deep and fascinating subject—and I encourage anyone interested in honing their photography skills to explore the subject of color even further.

How We See Color

In a nutshell, our eyes have two different types of photoreceptors: rods and cones. The rods have no color perception at all, and we use them in low-light conditions.

Cones are only sensitive to three colors: red, green, and blue. These are actually the only colors we can see, and we create all of the other colors by mixing them in our brains. When we look at a dandelion, our red receptors and our green receptors are excited. They send a message to our brain that says, "See red and green." Our brain combines these two colors and says, "Wow, that's a really yellow flower."

Pro Tip

Here's a simple way to test color: look at your computer screen or TV through a magnifying glass. Focus on something that is yellow, and you will see that there is no yellow on the screen—just red and green dots. Your brain "makes" the yellow.

The thing that's important and amazing about our eyes is that they can adapt very quickly to different spectrums of light. When we walk into an elevator lit with fluorescent light, it can look pretty nasty at first (often a sickly green). But after just a few moments, our eyes adjust and we see colors pretty closely to the way they appear under different lights.

Arriving at a friend's for dinner at dusk, you might find that the house looks something like this. The interior is warm and yellow while the last remains of the sun reflected in the sky make the exterior deep blue.

By the time we reach the front door, our eyes have begun to adjust to the color of the newly predominant light source—and the scene might look like this.

Once we're inside, our eyes completely adjust to the color of the incandescent lights. The food and our hostess still look a little warm, but the dusky daylight outside the window is completely blue/cyan.

Proportions of Color in Light Sources

If you remember your high school science classes, you may recall one of Isaac Newton's many big discoveries that white light is actually composed of different colors (see what I meant about great minds thinking about color?).

Newton found that when you project white light into a prism, it is broken into a spectrum composed of the light's constituent parts—which he identified as red, orange, yellow, green, blue, indigo, and violet. Depending on what the light source is, the spectrum might have all of these colors in different proportions. It might even have holes in the spectrum where certain colors are absent.

Light passing through a prism.

Black Body Light Sources

Most traditional light sources are called "black body" sources. A black body light source is a theoretical object that is black when it is absolutely cold and begins to radiate light as it is heated. The sun is a black body, and so is a light bulb or a candle. The light that these objects create is a byproduct of heat.

As the heat of these objects increases, the amount of light they generate also increases. The spectrum, or color of the light, also changes with increasing heat. For instance, a poker in a fireplace glows red-hot after sitting in the fire for a while and getting hotter. It emits a lot of red and yellow light but almost no blue light.

A candle flame burns hotter and brighter than the poker in the fireplace and creates enough blue light for us to see blue objects. The filament of a light bulb burns even hotter and brighter, and it produces a full spectrum of color but still has a preponderance of yellow light. The sun is truly "white hot" and produces much more light on the blue and violet ends of the spectrum than on the red, orange, and yellow side than the candle or a light bulb.

Pro Tip

The famous British scientist Lord Kelvin also noticed the correlation between a light source's temperature and the spectrum of light it produces. He created a system to measure both the heat and the associated color of black body sources that is very similar to the Centigrade and Fahrenheit scales we are familiar with. This scale refers to the color of a light source in degrees "Kelvin."

How Film Sees Color

Black body light sources can vary wildly in the proportions of yellow and blue light they produce, but within certain limitations our eyes can adapt to these changes.

Film, on the other hand, cannot adapt and must be manufactured or filtered in order to render different light sources with neutral and natural color. When photographers choose a type of film or filtration to compensate for a light source's unique spectrum, we call this "balancing" the film to the light source.

Most color films are manufactured with a daylight balance, which is roughly the equivalent to the color of the sun at high noon (5,500 degrees Kelvin or "5,500 K.")

For reference, here are the degrees Kelvin for other light sources:

- Incandescent Photoflood lamps or quartz halogen bulbs made for photography: 3,200 K

- 100-watt household light bulb: approximately 2,700 K

- Candles on a birthday cake: approximately 1,800 K

This photo shows a range of color temperatures in the same photo. The top of the Chrysler Building in New York City is being lit with the sun at sunset (about 4,000 K). The buildings in shade are bluer (about 8,000 K), and the common light bulbs of Grand Central Station are warm yellow (about 2,700 K).

This photo draws all of its cues from the low direction and warm color of the light source.

We call these candles and light bulbs "warm sources" although their actual temperature is cooler (a candle is not as hot as the sun). They produce much more yellow light, and we associate the color with warmth.

Sometimes the sun might seem "cooler" or bluer (like at dawn or in the shade) because the blue sky is reflecting a lot of blue light into/onto the scene or object we are shooting. The color temperature in the shade of a building is typically about 8,000–10,000 degrees Kelvin. Pictures made under these conditions will typically have a blue/cyan cast unless we compensate for the excessive blue by either filtering the light coming in the lens (using color slide film) in the printing process (using color negative film), or by adjusting the white balance of when using a digital camera.

Similarly, the sun can also seem "warmer" when it is low in the sky at dawn or sunset because the light has to pass through more of the Earth's atmosphere. Atmospheric haze filters out much of the bluer end of the spectrum, resulting in red sunsets. We see these types of colors in magazines and movies all the time. Like the guides of composition, we seem to have an innate sense of what they mean when we encounter them.

Non-Black Body Sources

Photographers run into big problems when they encounter light sources that don't create light through radiant heat. Some examples of non-black body sources are fluorescent lights, mercury vapor lights, neon lights, and sodium vapor lights. Many of these light sources don't produce complete spectrums or create excessive amounts of a particular color (like green). Non-black body sources can be extremely efficient, producing huge amounts of light in comparison to the power they consume—and some are excellent for photography, producing a spectrum of light that matches and mixes with daylight.

There was a time not so long ago that I carried a very expensive color temperature meter and about 50 filters in my camera bag in order to compensate for the problems these non-black body light sources created. Now, digital photography has simplified these problems enormously—but it doesn't completely solve them.

Fluorescent bulbs typically photograph with some form of green cast when shot with daylight film or balance.

Flash and LEDs

Flash units use xenon gas in a sealed glass tube to generate large amounts of light for short durations. They are made to correspond with typical "daylight" color temperatures (5,500–6,000 K).

Flash has its own set of benefits and shortcomings:

Pros:

- Short flash duration; photos shot with flash can freeze motion
- Huge output in a relatively small package
- Battery powered and portable; pro units can be plugged into AC outlets

Cons:

- Very difficult for beginners to learn how to previsualize
- Typical prices for professional units start at about $1,000 for a single light and can be much more.

Flash units can have extremely short durations, enabling photographers to stop motion like these cards flying through the air.

This amazing private residence was a job I shot for a lighting design company. It is lit almost entirely with LEDs. The owner can completely change all of the colors in the home with a keypad.

(Photo courtesy of design one corporation)

Light-emitting diodes (LEDs) have undergone some amazing advances since the little red lights that graced digital watches and calculators in 1980. They are emerging as one of the most interesting and efficient daylight-balanced (or variable balance) light sources suitable for photography. I predict that LEDs are going to be an important light source in both photography and our homes in the very near future.

LEDs are a continuous source (like a light bulb) so they can't stop motion, but because they are continuous they are much easier to use. They are also cool to the touch (unlike a light bulb).

Here is a pro and con of using LEDs:

Pro:

■ Easy to use and previsualize; what you see is what you get

Con:

■ Not as powerful or versatile as flash

Digital Photography and Color Balance

Digital photographs shot in JPEG format must be "balanced" in the same way that film is in order to have the best possible color rendition. This is because JPEGs throw away information that is deemed to be unimportant. If a JPEG is shot out of balance, the other colors that were present in the original scene have been discarded and can't fully be recovered or recreated. Photographs shot in RAW format allow you to choose the color balance later on, when you are viewing them on the computer.

When you shoot JPEGs and select a balance on your camera, you are telling the software in the camera what is important and what can be discarded. If you get it wrong, there is little you can do to fix it later.

Your camera does have an *auto white balance* (AWB) setting, and chances are it will do an amazing job of approximating, or averaging, the correct balance for almost any situation you encounter. I

recommend that for 90 percent of your photography, you should leave your camera set to AWB. It's tough for an amateur to beat the AWB setting because it requires so much vigilance. You have to constantly keep track of the light source every time you shoot. Many a pro has had a terrifying moment when they realized they forgot to change the white balance when they moved from inside to outside—and chances are, you will forget as well.

The problem with AWB is that it also corrects things you might not want corrected (like a deep red sunset). It will still look good but probably not as rich as if you had set the camera to "Daylight." It also might not correct some things enough.

Pro Tip

When you shoot indoors, you will get better photos if you set your white balance to "tungsten" (the little light bulb symbol). Your photos won't look so yellow. Just remember to set it back.

You camera has a menu of "stock" settings that approximate the common color balance situations:

- Daylight (5,500 K); the sun at high noon

- Flash; approximately 5,500–5,800 K

- Tungsten (3,200 K); Photofloods or professional quartz halogen (pretty good for household incandescent bulbs as well)

- Open shade; 7,000–10,000 K

- Cloudy; 6,000–8,000 K

- Fluorescent (there may be two different fluorescent settings); usually adds some magenta filtration to compensate for the green cast common in fluorescent lights There are a vast array of fluorescent fixtures out there, all with slightly different white balances, but the most common are "cool white" and "incandescent fluorescent." You might have to experiment to find the best setting or simply create a custom setting.

- Custom white balance: Enables you to calibrate your camera to a specific light source

Creating a Custom White Balance

When it is really important to get the color as accurate as possible, you might need to create a custom white balance. Times that this is particularly problematic are when you are shooting under fluorescent or mercury vapor lights (very common in gymnasiums and sports arenas).

Fluorescent lights can vary wildly in their color spectrum according to brand and age. Mercury vapor lights are just plain awful; they look like giant light bulbs but are very green, and their exact spectrum can change according to how long they have been on. Sodium vapor lights (very common for modern street lamps) are even worse. Sometimes they are so yellow/red that they can't be fully corrected.

The exact procedure for creating a custom white balance varies slightly from camera to camera, but all of them involve photographing a white object that is illuminated by the light conditions you will be shooting under.

Pro Tip

The folks at Expoimaging make a great little gadget that fits onto your lens and makes this procedure even easier. You use it like an incident light meter. You take a photo of the light source that is lighting the scene with this translucent disc in place. This becomes the reference image your camera will use to create a custom white balance. It takes less than a minute and has worked perfectly for me.

You first take a photo of a blank piece of white paper (use an auto exposure setting to take the picture; you want the photo to be underexposed and rendered as "gray"). Then, select "Custom White Balance" in the main camera menu. The camera will ask you what photo you want to use as your ideal, so select the image you just shot and instruct the camera to use this image as your

custom setting. The camera will color correct the image and use these settings to color correct all of the subsequent photographs you take while you are in "Custom White Balance" mode. Your stock white balance settings will not be affected.

This all sounds more complicated than it is once you have done it, and it makes shooting under difficult conditions so easy that I wonder how I ever got along without it.

Learning to See in Color

While it's true that you can choose or create a custom white balance for any situation, this doesn't really solve all of the problems of photographing in color. A good example is the earlier photo of my dinner hostess at the stove; she is correct, but the background in the window beyond is not. Similarly, the photo of the exterior of the house is not correct anywhere. The outside is blue/cyan, and the inside is yellow.

Whenever you have a few different light sources in a scene, you have to choose which source is the most important and correct for that particular source. This can sometimes get really complicated and require special lighting equipment.

But there's another way to get around this problem: training your eyes to see the world the way the camera/film sees the world. Is it really so terrible that the interior lights of the house are so yellow? I don't think so; I think it actually enhances the photo.

If you can learn to see the way the camera sees, then you can use the disparity of color in various light sources to your advantage. This makes the mismatch of different sources a tool instead of a problem. Even the green cast of fluorescent light can be used to your advantage once you know how to use it. (For a great use of the green fluorescent color cast, watch the Clint Eastwood film "Million Dollar Baby." The unique color signature of fluorescent light is used as a background accent throughout the film and reinforces the atmosphere of a boxing gym.)

Turn Off Auto White Balance

Like I said, it's tough to beat the AWB setting—but try shooting for at least a few days with the camera set to the "daylight" setting. (Don't worry; you will turn AWB back on later.) This will approximate the effect of shooting color slides and help you learn to see color the way the camera sees it. Photos shot in the shade will go blue/cyan; photos shot indoors will go yellow/orange. Photos shot under fluorescent light will be green.

Even better, try to balance the settings of your camera to the light sources as you are shooting. The important thing is to become aware of the fact that different light sources will register color differently in your photographs.

Assignment: Seeing Color

In the previous chapter, I outlined an assignment to photograph a scene or an object every time you see it. This is also the best assignment I know to learn how to see in color.

When I was in college, I gave myself the challenge of photographing the Chrysler Building every time I saw it. There were times when I saw and photographed it 10 times over the course of the day. After a few years, I had several hundred slides showing me what the building looked like in early morning light, late afternoon light, the winter, the summer, sleet, and fog. I shot it at night so I learned how street lights and the fluorescent lights in office buildings looked. I shot with different films so I learned the "palettes" and color ranges for all of the different films on the market. It was one of the most valuable everyday assignments I've ever done.

Looking at Light

Light is also an emotional and visual cue to the viewer. When we look at a photograph shot in the desert, we don't need to feel the heat to know that it's hot. The quality and direction of the light can supply those cues. Light is a powerful tool, but it is so subtle that it's easy to take for granted.

I made the three photos of the Chrysler Building in this chapter recently to illustrate the point about shooting a single subject under different lights in order to learn the colors of different light sources. These two show the color of sodium vapor street lamps and another (weird) yellow/green fluorescent light.

The Sun

The sun is the big daddy of all light sources, and the sun's behavior influences all of our ideas about light. The sun is so powerful as an icon of lighting that any light source that doesn't mimic the sun looks artificial.

They might seem obvious, but here are a few very important facts about the sun:

- The light from the sun comes from overhead most of the time.

- The sun is a very small light source (relatively), which means that it usually creates shadows with a sharp edge.

- Some of the sun's light is refracted and diffused in the atmosphere. This means that the shadows that the sun creates aren't completely black.

- Sometimes clouds cover the sun, effectively creating a very large, overhead light source that produces very soft or shadowless light.

- The apparent color temperature of the sun can vary from extremely warm yellow/red to extremely blue/cyan, depending on atmospheric conditions.

These points seem incredibly basic, simple, and obvious, but when you see a photo where the light comes from too low or has a shadow that is too feathered, it is a visual cue that the light is artificial. And that's not necessarily a bad thing, but it's still something to keep in mind—especially in the next chapter when we start to look at how to photograph people.

Letting the color be a little off sometimes helps to cue the viewer to the ambiance of the room. One reason we know the boy is in a home is because the color of the light is a little warm.

Other Common Sources

One common, everyday light source is the household incandescent light bulb. The incandescent light bulb is one of the great inventions of all time—just ask Thomas Edison.

In the past, it wasn't an ideal light source for photography because no color films were made to balance for it (tungsten-balanced film is rated for 3,200 K and still renders most household bulbs with a slightly warm cast) and because slow film speeds limited photographers.

With digital cameras, both of these problems are largely eliminated. Moreover, light bulbs have one huge advantage over photographic flash: the light source is continuous, so you can see what you are doing and you can see the effect of the light on the subject as you move around (which can be very difficult to visualize with flash).

Another everyday light source is the fluorescent light. These lights have the same traditional problems as incandescent bulbs (color, temperature, and speed), but they have one other big problem: they're ugly.

Well, not really. No light source is ugly all by itself, but fluorescent sources are invariably placed in fixtures hidden in ceilings—and this results in soft light from directly overhead. If you could eliminate the green cast and move a fluorescent fixture around (there are professional units called Kino Flos that do this), it could be a great light source. Ordinary fluorescent lights can be good for certain kinds of object photography (like eBay auction photos).

And what about flashlights? I love using flashlights in photography. You just put the camera on a tripod in a dark room, open the camera (put it on "B" for the shutter speed), and then walk around the subject and "paint" the light where you want it to be. Better yet, the new LED flashlights often match daylight perfectly.

Painting with flashlights requires some experimentation, but it can make for very beautiful photographs. Photographers have been painting with various light sources since the beginning, but with new technologies every generation seems to reinvent the technique anew.

This photograph is entirely lit with two flashlights. The night was pitch black with no moon.

In this photograph, the tripod was set up in the pond with the car in the foreground. The car was on cinder blocks so it looks like it's sitting on the surface of the water. The car is illuminated with a fluorescent "camp" flashlight, which I walked around with and pointed at the car (I was in the pond as well, wearing all-black clothes).

As I walked up the hill, I switched to a conventional flashlight (the yellow streaks) and then switched back to the fluorescent light to light the car on the cliff. The exposure time was about 20 minutes. We did the photo 10 times to get it right. There is no digital photo-editing.

I got very wet.

Light Direction

Years ago, camera instructions recommended that you position yourself with the sun at your back when taking a photo—but that was in an era when lenses weren't coated with special anti-flare coating and cameras had rudimentary (if any) light meters.

With modern cameras, there's no such thing as good or bad light for photography, but there is light that has purpose—and that can be used well or badly.

I could write an entire book about light, and maybe I will someday. But for now, here are a few quick thoughts about light direction and quality.

Front light: Light coming from the front shows us the world as we expect to see it.

Side light: Sidelight emphasizes the volume and texture of objects.

Backlight: Backlight is often surprising.

Reflected light: Reflected light is soft and diffuse.

Shadow Quality

Photographers have more ways to describe light than the Inuit have words to describe snow. We talk about hard light, soft light, specular light, kickers, fill, rims, and spots. Most of the time, what we are actually talking about can be boiled down to two simple ideas:

- The contrast between light and dark
- Whether the edge of the shadow cast by the light is hard or soft and feathered

The ability to change, or *modify*, the size of a light source is often within your power—even when you are using simple amateur equipment. It is the key element to think about when you start working with flash photography beyond the point-and-shoot mentality.

We'll discuss the finer points of light source size in more depth in Chapter 10.

In this photograph, there are almost no shadows and little contrast between light and dark. This is because clouds are filtering and diffusing the sun. This transforms the small sun (relatively speaking) into a very large light source: the clouds.

This photo is shot with a point-and-shoot camera with a tiny flash, resulting in hard-edged, distinct shadows and a marked difference in light and dark values.

A **light modifier** is any device that a photographer uses between a light source and the subject to change the size or shape of the light hitting the subject. This can be something as large as the giant silk sails that are used on film sets to diffuse light or as simple as bouncing a flash onto a ceiling.

Flash: Lightning in a Bottle

In my teaching experience, I have learned that the hardest craft for my students to learn is how to use flash effectively. I can't cram a three-semester course of study into this book, but we can look at some of the most basic problems and flaws with how people use flash and some simple ways to avoid the pitfalls.

The first big hurdle for everyone using flash is that we are attracted to something because we see a certain quality to the light. When we shoot with flash, the flash destroys and obliterates much of what we wanted in the first place. It replaces the existing, or *ambient light*, with the flash.

The photo of the boy in the bathtub is pretty good example of how people use flash. They put the camera on "Program" and the camera picks a high shutter speed that freezes motion and excludes, or overpowers, all of the existing light.

Ambient light is all of the light sources that exist in a scene before the introduction of a new photographic source.

Modern through-the-lens (TTL) flashes on DSLRs makes mixing ambient light and on-camera flash a breeze.

We'll continue to look at how to use flash in specific situations in the coming chapters, but for right now let's just look at some of the advantages to some auxiliary flash units and accessories that might be in your future.

Shoe-Mounted Flash

While the pop flash on your camera is very convenient, it's not very powerful. It is also tiny in size, resulting in hard shadows. It is very close to the lens, which often results in red-eye and can't

be swiveled or pointed in any other direction besides straight ahead (so you can't bounce light).

Shoe-mounted flashes offer a lot more power, faster recycle times (the flash is ready for the next shot more quickly), and they can be pointed at other surfaces. Most of the really top models can also serve as the "master" unit for multiple wireless flash setups.

Multiple and Wireless Flash Setups

Until just recently, multiple flash systems were only practical for professional photographers. There were three reasons: expense, slow film speeds (largely solved by the adjustable ISOs on DSLRs), and the need for a method to "preview" the lighting.

Because flash is so quick, it was very difficult to see what the film would record. This meant that professional photographers usually carried some kind of Polaroid back or camera. We used the Polaroid as a way to previsualize and control the light we would actually get on the film.

DSLRs allow you to see the results immediately. They open up a world of possibilities to amateur photographers.

This is the basic gear to my wireless flash setup. The unit in the middle is the wireless controller that goes on the camera's hot shoe; the two flash units can be placed remotely. I control them from the middle unit.

Most of the camera manufacturers also offer some form of wireless flash system. These systems allow multiple flashes placed in remote locations away from the camera to be controlled from the camera via radio or infrared link. They allow amateurs to create lighting setups that would have required carloads of equipment and assistants in the past.

All of the simple documentary photos you see in this book were shot with nothing more than the following equipment—with the addition of a small softbox and light stands.

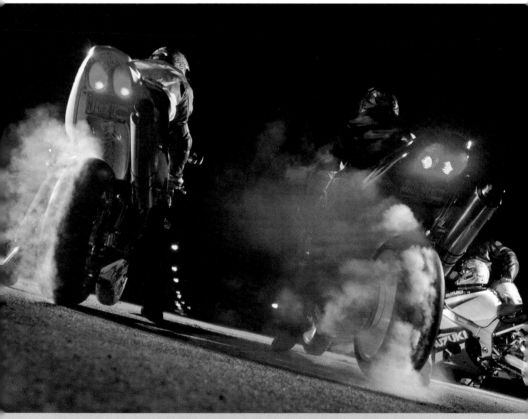

This is a great example of what wireless flash photography can do for you. This photo was shot with two small flash units while I was on a photojournalism assignment for MAXIM magazine. A portable wireless flash allowed me to work fast and travel light but still get the results that I would have needed heavy professional equipment for in the past.

Case Study: Mixing Ambient and Flash

The real key to getting flash to work for you is to actually try to make the photo work with the available light first. Then, add just the right amount of flash to "fill in" the areas that are lacking.

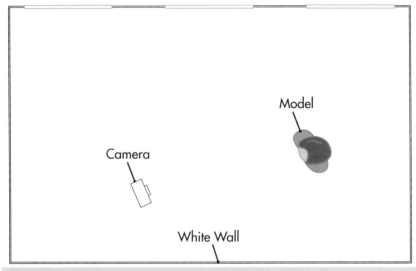

Model

Camera

White Wall

This diagram of the room will help you to understand the conditions under which the following photographs were made.

This photo is shot with the popup flash on a typical DSLR set to "Program" mode. The camera assumes that we want the young woman to be properly exposed and exposes her correctly. It sets a high shutter speed (1/125) and adds way too much light to the scene from the flash, destroying the ambient light from the windows.

The shadow is hard and the background is underexposed, making the woman look like she has been pasted into the background.

This photo is shot with only existing light and the same 2.8 f-stop, but the shutter speed is now ¹⁄₂₀th of a second. The background is exposed correctly and looks pretty nice.

I also like the edge of light on the left side of her face. Wouldn't it be great to get the best of both photos?

This photo is shot with the popup flash mixed with the ambient lighting of 2.8 at ¹⁄₂₀th of a second. The trick is that I used the exposure compensation of the popup flash to automatically underexpose the flash by one stop. It's just "filling in" her face.

This is a huge improvement, but we can do even better ...

This photo is still shot with the popup flash, but I added a light modifier (in this case, a tiny softbox diffuser to the popup flash). It's only about four inches square, but at close distances it makes a big difference. It also threw some light on the wall at my right, which helps fill in the shadows and makes the light less contrast-y.

This little softbox will fit in the pocket of your jeans. At close distances, it's a pretty effective little accessory.

Still, if I could use a more versatile flash unit, I could do even better ...

In this photo, I eliminated the popup flash and went to a semi-professional flash on the camera's hot shoe. I pointed the flash at the wall directly to my right and "bounced" the light onto the subject. In this case, the wall became my light modifier, and the flash created a light spot almost three feet in diameter (much larger and softer edged than the size of the actual flash on the camera). I still underexposed the flash by one stop in order to preserve the nice ambient light. (I know what you're thinking: Why didn't I just move her to the window? Simple— because it's harder to control the sun than the camera and the flash.)

In order to get the most out of the scenario covered in this case study, you should use your camera manually. But there is an easy "cheat" that often works well. I'll outline it in Chapter 8.

One thing to remember is that light modifiers are all around you. Bouncing a flash onto the ceiling turns a tiny source (the flash) into a large one (the ceiling). Moving a subject into the shade makes every building the sun is bouncing off of a light source. Pointing a light through a plant turns the plant into a light modifier that casts shadows in the background. The automatic flash units on modern cameras make this very simple. You just need to be resourceful with what's around you.

Learning Lighting: The Strobist Blog and Flickr Group

I hesitate to promote this website because it could eventually put me out of a job. It's a little advanced, but it's really incredibly good.

The website "Strobist" (www.strobist.blogspot.com) was started by David Hobby, a photojournalist on staff at the *Baltimore Sun*. As a photojournalist, David has to work lean and fast and doesn't have the luxury of two or three assistants to lug his lights around. He's learned a lot over the years about how to do very sophisticated lighting with very minimal equipment, especially with battery powered, wireless strobe setups. His blog started as a way to share his knowledge and has grown into a true Internet phenomenon with more than 135,00 regular readers.

On the website, David and other members of the "Strobist" community give monthly lessons, share ideas, and provide assignments on how to use small flash effectively.

There is also a Flickr group (www.flickr.com) that participates in the assignments and critiques each other's photographs on the Flickr website. How popular is it? There are more than 12,000 members in the "Strobist" Flickr group. Most of them are amateurs just like you who want to make better photos.

As I said at the beginning of this section, using flash well is one of the hardest things for any aspiring photographer to learn. David Hobby and "Strobist" are making it a lot easier.

The Least You Need to Know

- Color and light are really the same thing.

- Photographs shot in JPEG format must be correctly balanced to the light source when they are shot..

- Good flash photographs often start as good available-light photographs. Experimenting and practicing will help you to learn how to creatively mix flash with existing light.

- Learning to see light as color (as the camera sees it) makes color balance a creative tool instead of an obstacle.

- Color and its conventions are powerful and subtle cues for the viewer, learn to use the conventions to your advantage.

In This Chapter

- How to shoot better portraits

- The right use of equipment, techniques, and lighting

- Different styles of portraiture

- How to take better candid photos

Chapter 7

Photographing People

When I interview new students I always ask them what they like to shoot and why they want to be photographers. Invariably one of them says, "I like shooting people."

This is a big subject! What kinds of photographs of people do you like? Candids? Portraits? Why do you like making photographs of people? Is it because you get to engage and talk to them? Do you photograph the people you know, or is it all about observing strangers?

Pinpointing your reasons and interests is the first, and most crucial step, to making better photographs of the people in your life.

Portraits

My guess is that 90 percent of the photographs that the average amateur shoots are some form of portraiture. Most of the time, our subjects are people who are central to our lives. These photographs are some of the most important photographs you will ever take. They are the records of everyone who touched and helped define your life. You also touch and help define theirs. Looking at your photographs of friends and family can and should be a moving experience.

They might seem like simple snapshots, but they are so much more. If my hard drive crashed tomorrow, I could deal with losing the archive of my professional work (which is all backed up), but losing the photos of my family (which I'm sloppy about) would be devastating. These are the photos that bring me joy, and I take them as seriously as any assignment or fine-art project. (I gotta get a new hard drive!)

The Bathroom Mirror as a Camera

The way we see ourselves is directly influenced by what we see everyday in the bathroom mirror. We often look different in photographs, so a quick look at how the simple bathroom mirror works might be instructive.

Take a typical mirror about 18x24 inches in size. When we frame ourselves in the mirror, we are standing about two to four feet away. However, the optics of how a mirror works means that we are actually twice that distance from our image in the mirror because the light has to go from our face to the mirror and back again.

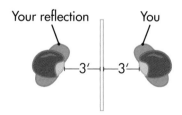

You can demonstrate this easily by focusing a camera on your reflection in a mirror and looking at the scale on the focusing ring. It will be twice the actual distance to the glass. If you focus on the surface of the mirror, your reflection will be out of focus.

Why We Look Different in Photos

When we hear someone say, "I hate the way I look in pictures!", the important part of that statement is that he or she doesn't hate the way he or she looks—only the way that he or she looks when photographed.

This is largely because in order to achieve the same head-and-shoulder cropping that we see in the bathroom mirror, we have to move the camera in close, typically about three to four feet away (or half the distance we see in the bathroom mirror).

Supermodels don't look good that close up. Noses become too large, and ears disappear. It's positively cruel to photograph some-one with a short/normal lens. It's also invasive. When I've been shot for television shows, I'm usually fairly at ease in front of the camera until it gets to about four feet away. Then, I become very self-conscious; I can't stop looking at the camera sideways in can-did shots, and I can't look straight at it for an interview. It's awful, and I would wager that most people feel the same way.

The Psychology of Portraiture

The brain behind the portraiture is another huge topic, but I think there are a couple of universal concepts that help make sense of it.

First, it starts with you. When I became a professional, I pur-posely started in a field (architectural photography) that never required me to shoot people. The simple reason was that I was painfully shy, and when you shoot photographs of people … guess what? They are looking back at you.

It's the same fear of public speaking that many people have, that the audience is judging them. I had flop sweat every time I had to shoot a person. I couldn't bear it. From talking to my students, I became aware that this is a very common experience. At least half of them find it difficult to photograph people for their own psy-chological reasons.

At a certain point, I realized that my inability to photograph people was a professional liability. I consulted with a sports psychologist for a year in order to get past a psychological handicap that was limiting my career. Now, I photograph people on almost every assignment, and I like it. I'm still nervous, but I can cope.

Second, it's also them. Most people hate *being* photographed for the same reasons I hated shooting. It is painful to be looked at critically. Every time the camera clicks, they are aware that a judgment has been made—and they are right.

When you press the button, you have made a series of judgments and decisions. The shutter click is an audible signal to the subject that you saw something that you judged. It might have been good, but many of us are not very secure with our self-images.

This is why fashion photographers chatter and reassure models through an entire shoot. It tells the models (who are only human and often as insecure as anyone else) that they look good and that the photographer is interested in helping them look good.

How to See Others the Way They See Themselves

People are usually happiest with photos that conform to their self-image. So it's not a bad idea to ask people flat out what they hate when they see themselves in photographs. Common complaints are:

- Crooked or large noses (easily mitigated by lens selection, posing, and/or lighting)

- Weak jaw lines and/or weight (lighting and posing makes a big difference)

- Receding hairlines (lighting and camera angle can help a lot)

The most important thing about asking them the question is psychological. The question tells them that you care about making them look as good as you can.

Here again, I use the bathroom mirror as the model. I ask my subjects to check their appearance in the mirror to see whether they are happy with their hair and makeup, and I watch them as they do this. When you watch subjects looking in the mirror, they

will invariably stand or move their head to an angle that they feel makes them look their best. This is incredibly valuable knowledge. Try to find a camera angle that corresponds to the view they saw in the mirror.

People never stand or look straight when they look in a mirror. However, they walk onto a set and stand straight in front of a camera. Gently coax them to find the same position that they took in front of the mirror. Look carefully at the subject to find the most striking thing about him or her. In truth, I don't think as much about hiding flaws as I do about accentuating the positive. Everyone has something great about their faces. It might be incredible cheekbones, a beautiful open smile, or piercing eyes. I just find something to love about them and build on that.

Lens Selection

For portraiture, it's actually not about focal length—it's about distance.

Most people start to look their best from about six to eight feet away. If you are including their entire body and parts of their surroundings, then go ahead and shoot with any focal length you want.

If you are shooting the classic head-and-shoulders portrait, then it's simple. Use a focal length that is *at least* one and a half times the normal focal length. This mimics the view in the bathroom mirror and positions the camera at a comfortable, conversational distance. The corresponding focal lengths are at least 85 mm on a 35 mm camera or about 60 mm on a DSLR. If you can use (or have) a longer lens, then use it. The subject will just get more attractive as you move the camera away then use the lens to zoom in.

Remember the photos of the two globes we saw in Chapter 2? By using a longer lens and moving the camera back, the lens minimized or seemed to compress the distance between the two globes. The same thing happens with noses, ears, and foreheads. Shooting with a longer lens minimizes the spatial differences and yields a perspective that conforms to the subject's self-image in the bathroom mirror.

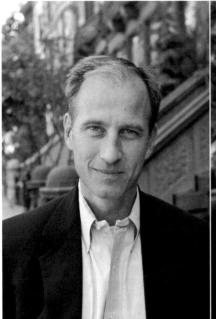

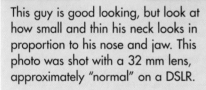

This guy is good looking, but look at how small and thin his neck looks in proportion to his nose and jaw. This photo was shot with a 32 mm lens, approximately "normal" on a DSLR.

Doubling the focal length and moving twice as far away (six to seven feet) results in the man appearing the way we see him at a normal conversational distance and the way he sees himself in the mirror. A longer lens would probably look even better.

The funny thing is that some people have faces that often look a little too angular and odd when you meet them in person. However, when viewed through the longer focal-length lenses, their faces "flatten out" and they become devastatingly attractive. We call these odd creatures "supermodels." It's the effect of the lens flattening the strong, exaggerated, and angular features that makes some people more photogenic than others.

Lighting for Portraits

Here's another important reason why supermodels are who they are: facial symmetry. Their faces look very similar on both sides. If you look at most photographs of typical fashion models, the

lighting is usually from a large but fairly hard source directly above the lens.

Models can look great with this kind of even and symmetrical lighting because it flattens the face and because their faces are very symmetrical. They can look great when lit with a pop-up flash directly over the lens.

Most of us are not so blessed. We might have broken noses or our jaw lines might be slightly different on each side of our faces. We're not hideous, but the pop-up flash is brutal and really exaggerates the asymmetry of the average person's face. This is the other big reason why people hate photos of themselves: the pop-up flash is a cruel light source.

It is also important to remember that lots of very attractive people have very asymmetrical faces. Actor Harrison Ford's crooked smile hasn't seemed to hurt him a bit. But you'll also notice that he seldom gets lit from the front when he is facing the camera.

In everyday life, we seldom see ourselves with symmetrical lighting (remember what I said about the sun being the cue to lighting?). The light is almost always stronger on one side than the other. Again, there are no rules to lighting any more than there are to composition—but there are some conventions that can be helpful, and we'll explore those next.

A Primer on Three-Point Lighting

Think back to the last chapter and the first photograph where the young woman looked pasted onto the underexposed background.

Let's call that one-point lighting (because all of the light was coming from one place: the pop-up flash). She looks pasted into the background because there was no secondary source to light the background and separate her from it. The light was contrasty because there was no *fill* to lighten up the shadows.

Three-point lighting is the mainstay of Hollywood. Virtually every frame you see in any film is some variation of three-point lighting. Modern film emulsions have changed the game a lot, but there are some strong principles at work in terms of how we look at people and space that continue to make the convention of three-point lighting compelling in the twenty-first century.

A **fill** is a light source (usually large, diffuse, and soft-edged) that reduces the contrast in shadows.

When you look at the classic photographs by George Hurrell of Marlene Dietrich, Lauren Bacall, and Humphrey Bogart, you are looking at a master of three-point lighting at work.

Here's the basic formula:

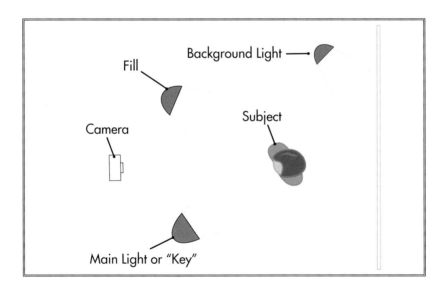

In a classic three-point light scheme:

- The main light, or key light, is placed to one side. It is usually the strongest light on the set.

- The fill light comes from near the camera or just on the other side. It is usually a large and diffuse source. It should be so weak relative to the main light that it casts no shadows.

- The background light is positioned so that it throws light on the background and visually separates the subject from the background.

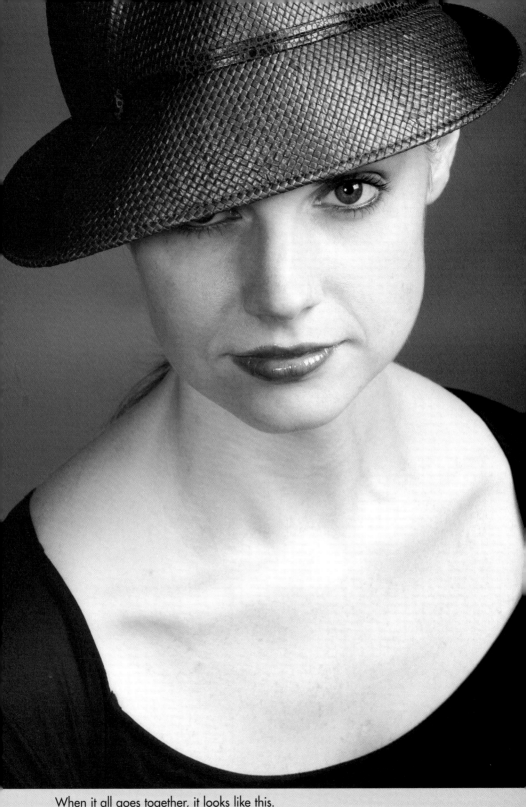

When it all goes together, it looks like this.

Now, I *know* what you're thinking. "I don't have three lights and a studio! I can't do that with my camera!" But you can. I did this same basic thing to create the following photograph:

The main light was the flash bounced off the wall. The fill light was from the windows, and the background light was another window.

Now, you might think that I made the two photographs like that on purpose in order to demonstrate this point. I didn't. The "flash-on-camera" photograph was simply made to illustrate how to mix flash and available light. I composed the photos on pure instinct. It was only when I looked at them later that I realized the similarity, which proves the point about how strong the

underlying principles are in three-point lighting. Once you know what it is, you will notice it in virtually every photo you see in magazines and movies.

There are hundreds of variations on this basic setup: the background light could face forward and backlight the subject; the fill can be bounced off the ceiling or even eliminated; and so on. The lights can even be different color temperatures. It's like a pool table with a million possible shots depending on the relative location of each ball.

The basic three-point formula also applies to different races and ethnicities. There are some subtleties to the amount and strength of the fill light, but three-point lighting isn't about skin color or complexion as much as it's about defining the architecture of the facial structure (the bones) and the space the subject is in. Denzel Washington gets the same basic light as Harrison Ford because their bone structures are very similar.

Three-point lighting is the mainstay of Hollywood. It is also the formula for tacky high school yearbook photography. Your skill and sensitivity separate the two, however. As the famous architect Ludwig Mies van der Rohe said, "God is in the details."

Context

I actually hate the tricks used to make people look "attractive." It's not what real portraiture is about. But with practice, it will become very easy for you to take photographs that make people look good.

Not everyone is beautiful, but everyone is interesting. Everyone has a story and a passion. The real challenge of portraits is to make the viewer interested in the person you are photographing.

When we look at photographs of celebrities, they come with their own context. We know who they are, and that is why we are interested. When we see a photo of the president picking his nose or a pop star leaving a club, it is only interesting because of the person's public persona. Photographing ordinary people who are unknown is a bigger challenge in many ways because the photographer has to show and explain to the viewer why the person who has been photographed is interesting.

If only you could somehow show more than just the person's face … now things could get interesting.

Photographs that show a person's surroundings and tell us about the person through his or her possessions or situation are commonly known in the business as "environmental portraits." Some photographers like Annie Leibovitz, Mark Seliger, and the late great Arnold Newman have built their careers on the environmental portrait.

If you think about it, most of the photos you make are probably some form of environmental portrait: "Here's my wife after her first triathlon" or, "Here's my kid on our vacation."

Almost all common snapshots are somehow built around giving the subject some form of context or story. We do this largely on instinct. The problem with photographs like the one earlier is that they have nothing to interest a viewer who isn't emotionally connected to the subject. The missing ingredient is something that is visually compelling—some kind of visual "oomph."

Now, I could take the easy road and say, "Don't ask me what oomph is—but I know it when I see it!". But that wouldn't be very instructive.

It might be one or many things: the camera angle, the lighting, and/or the pose and beauty of the subject. I think one thing it might be is a visual surprise of some kind—something that is odd or unexpected that hooks the viewer into the photograph. Another element might be universality—something that takes the viewer beyond the specifics of the person and situation being photographed.

The interesting thing is that the "universal" is usually accomplished by being extremely specific. This is really the key to all great portraiture, from Diane Arbus to Annie Leibovitz. Somehow, the more specific a photograph is, the more universal it becomes.

Bringing the idea of context and situation into your photographs can make a huge impact on the "staying power" of your portraits.

Case Study:
The Environmental Portrait

This portrait of a dancer doesn't need the surroundings to establish context. His body supplies all the information we need to know about what he does. This freed me to use an unusual location as the "odd" element.

Having a cooperative subject is a huge help. For this portrait of NBA star Rafer "Skip to My Lou" Alston, I relied on using the sun as my background light. Lighting was set up at 4 A.M. for a sunrise shoot. Alston was a good sport and graciously arrived before dawn in order to catch the early light.

Candid Photographs of People

Candid photographs of people should be the easiest photographs to make, but this is the one area where I think the kit zoom lens and Program mode really hurt amateur photographers.

The problem is that the zoom lens doesn't have a very wide aperture. This isn't a big deal outdoors, but it's a real problem when you are inside and want to remain unobtrusive. At the long end of the lens's zoom range, the maximum aperture is only about f/5.6 for most kit zooms. Even if you crank the ISO up to 800, the maximum aperture of f/5.6 is still very slow for available-light photography indoors. If your camera is set to Auto mode, the flash is going to pop up automatically on most cameras. It's pretty hard to be unobtrusive when the flash is going off all the time. If the shutter click is a subtle, audible signal to the subject about a judgment you have made, the flash is a giant blinking neon sign. If you like shooting candidly, then at least one really fast lens with a large maximum aperture (like a 50 mm, f/1.8) is a good investment and very inexpensive.

There is a really great way to get people to forget that you are shooting (and making judgments about them) that is a little surprising: shoot a lot. A whole lot. Shoot so much that they can't keep track of it all.

Think about it. In the early days of photography, having a photograph taken was a major event. People rented clothes just to be photographed. There was a lot riding on every single exposure.

Shooting a lot of photos when you are trying to shoot candid photographs makes every photograph seem less important to the subject and might help him or her feel less self-conscious. But it can also backfire, so be careful.

Pro Tip

Smile. It tells people that you like them. When I am on an assignment that requires shooting candid photos of people I don't know, I am often greeted with a hard, angry glare when the subject realizes I have been shooting him or her. Just lower the camera, smile, and say, "You looked great!" It works every time as long as it's a true statement (and it usually is).

Point of View in Candid Photography

I am often hired to be a fly on the wall for commercial and pho-
tojournalism assignments, but many of my magazine assignments
are stories that I am writing as well—usually in the form of a
first-person narrative.

Whatever the assignment is, the photographs have to reflect the
differences in the photographer's point of view. Amateurs really
never think about this; neither do a lot of pros. When we read a
book, the author has always made a fundamental choice to write in
either first person or third person. It's either, "I watched the killer
come closer" or "The killer stalked the unsuspecting victim." As a
photographer, whether you know it or not, you are always choos-
ing between the two.

People FAQs

How do I stay inconspicuous when I shoot candid photographs?

The traditional answer to this question is to shoot with a very
long focal length lens, but I couldn't disagree more.

Long lenses actually limit your ability to move around a subject
and change your vantage point because you have to move so far
in order to make comparatively small changes to the composition.
You can end up circling around the subject like a bird of prey and
actually draw more attention to yourself. You are also pointing a
very large and threatening lens at them. When you look carefully
at the work of great photojournalists it's pretty apparent that the
long lens is usually a last resort.

I find that by shooting with very wide lenses I am able to move
closer and then I simply pretend to be shooting something else.
I then focus on an object that is about the same distance as my
intended subject (the pro term for this technique is "surrogate
focusing") and then watch my subject with my other eye (or keep
them in view at the very edge of the frame). When the moment
is right you just swing into the final composition. This technique
also tends to reinforce the first person point-of-view.

Another technique is to simply not look through the lens and just

shoot from the hip. With some practice it is very easy to visualize the final photo without ever looking through the camera. You see photojournalists do this all the time in crowded situations (like holding the camera overhead) and they know to a very high degree of certainty exactly what they will get.

How do I get people to smile comfortably for portraits?

Professional models know how to perform for every frame, and this ability makes them worth every cent they make. Ordinary people need some help and it's our job to help them.

Sitting for a portrait is an almost hypnotic experience; I'll break up the session momentarily when I see the subject start to glaze over or I see the smile become frozen. I'll tell them to take a five second stroll around the set, or have grimace and make faces to loosen up their facial muscles. The little breaks really help them to feel comfortable in front of the camera. Encouraging them to do something that feels silly (like making a big goofy face) can often really help them to relax.

Photosensitive

Whatever you do, don't tell them a joke! I have never seen this work, for me, or any other photographer. At best you get a momentary guffaw, more often it's a condescending smirk.

Case Study: Point of View

Here are some photos that reflect different points of view.

This photo has most of the signature elements of candid photography. The subject is unaware and although it is shot with a long lens, I still used surrogate focusing in order to avoid pointing the lens at him for a prolonged period of time. People seem to be able to sense a camera trained on them no matter how far away you are.

For my Baja story, I wanted to give the readers a feel for what the racers experience from the rider's point of view. I borrowed a race bike from the Honda Team and followed Honda factory rider Steve Hengeveld on one of his practice runs.

I used a relatively slow shutter speed of $1/30$th of a second at f/22 to exaggerate the frantic effect of motion. There was no place to mount the camera, so I just hung it around my neck and guessed at the angle of view. The camera was fired by a remote release taped to my left hand.

I swear that I didn't set this one up. One of the classic elements that reinforces the omniscient, third-person point of view is the "dirty frame." In this case, it's the motion of the car going past.

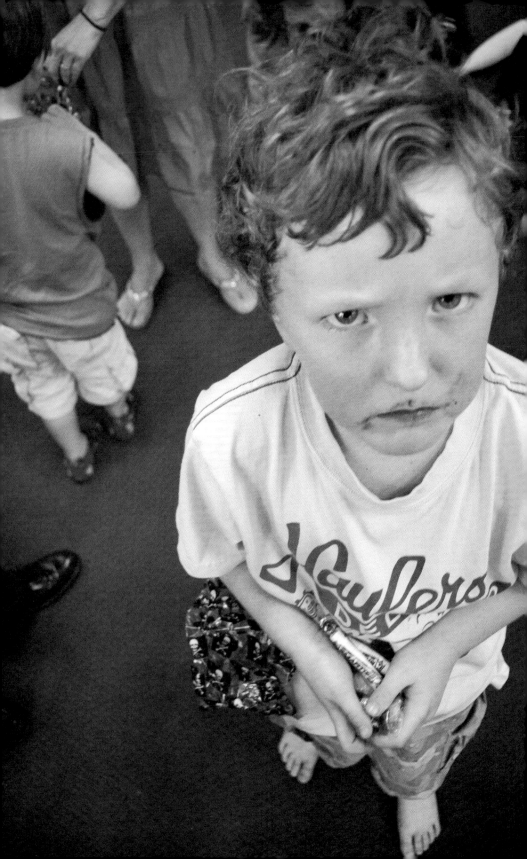

The first-person point of view acknowledges the presence of the photographer and the camera. Even kids who are photographed every day can get a little annoyed.

Like all good art, photographs of people need to be decisive and strongly reflect a particular point of view.

The Least You Need to Know

- Portraits that offer insight into the person are more effective and interesting than photos that simply describe a face.

- Understanding how subjects view themselves is important in making photographs that will be pleasing to both of you.

- Learning to use light well makes your portraits stronger.

- Establishing a distinct point of view helps strengthen your photographs.

Chapter 8

Shooting Events

The biggest issue surrounding event photography in general is the lack of control. The event—whether it's a softball game or a wedding—has a momentum and a life of its own. You have to be ready, because there are no reshoots or "do-overs." You need to anticipate and predict the future but also stay alert and react to the present.

I've been stressing the basics throughout this book because it's important to be vigilant when you do use your camera automatically. Shooting events is the time to harness all of the automatic features your camera has to offer. If you have been practicing, then you will know when it's making stupid decisions and how to quickly override them.

Weddings

I'm going to assume that you (or someone else) have hired a professional to do the major photography at a wedding. If you are even considering shooting a friend or family member's wedding as the sole photographer, without a professional photographer in attendance, you are just plain nuts.

I seldom shoot weddings. The few that I've shot have been the most physically demanding, nerve wracking assignments in my career. Weddings are very hard, and I have the utmost respect for my friends and colleagues who shoot them every week. Weddings demand everything—every ounce of skill, resourcefulness, and stamina that a photographer has. Wedding photographers have a big job to do. Stay out of their way, and give them the respect that they deserve.

Your Role at a Wedding

It is fun to shoot a friend's wedding. Once your friends and family realize your interest in photography, it's inevitable that you will be invited to a wedding … "and we hope you'll bring your camera."

This can be a tricky line to walk. The first priority is to be a gracious guest. The second is to stay out of the way of the professional photographer. The third is that your pride will require you to make at least one great photo that no one else will get.

If you are a member of the bridal party, this is easy and your role is nicely defined. You have a "backstage pass" to photograph during the moments that the pro isn't around—when the bride or groom are getting dressed or during the rehearsal dinner. Look for significant details, like floral arrangements, or shoot candids of wedding party members who are waiting for their turns in the formal portraits. Don't try to shoot the entire event; concentrate on one particular aspect.

Try to shoot candids from a different angle from the pro. If you are jockeying for the same position, you are just hindering the professional and covering something that he or she already has. I use this rule of thumb for all event photography, including major news stories. When I see a gaggle of lenses pointing in one

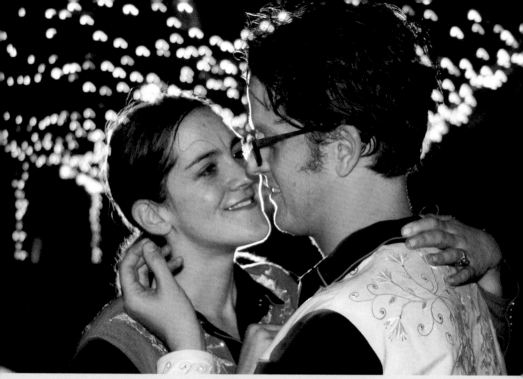

The rim of backlight is from a wireless remote flash that I got another guest to hold.

This wedding was in Nashville, Tennessee, and the groom was a musician. The rehearsal dinner was a country-themed barn dance.

direction, I try to stay away from the pack. It's an indication that the angle is obvious and formulaic—not necessarily that it's good. Our job is to see what no one else is seeing and put a unique spin on the it.

The time when the amateur photographer can really shine is at the end of the reception. This is when the pro is tired and might even be packing up but the party is getting wild. Have fun and play.

Look for candids and details like this while the pro is shooting formal photographs.

Retain as much of the available light as you possibly can.

Pro Tip

RedEye happens when the subject's eyes are dilated (like at a dark wedding reception) because the flash illuminates the blood vessels in the back of the eye. This is one of the reasons why wedding photographers use flash brackets to lift the flash high above the lens. The slight change in height makes the light more flattering and changes the angle of the flash, eliminating red eyes.

Scouting the Location

For pros, location scouting is a science. We often use a compass or special software to predict where the sun will be and plan the shooting schedule accordingly. We might shoot tests for the lighting or plan for weather contingencies. Is there a sheltered area in case it rains? Is there a bathroom nearby to touch up makeup?

The same is true for your shots: What's the existing light like? What's the policy of the pastor/rabbi where you are allowed to shoot? Can you use flash? (Probably not.) Is there a place to stash your equipment?

Try to arrive a little early and take a quick look around for creative possibilities. You might be able to grab the bride for a few minutes if you have a particular location already in mind, but she'll be angry if you take her away from the reception and

wander around without a plan. Scouting and looking carefully at your surroundings will help you set your camera in advance and be ready for opportunities.

It's busy day for the bride. If you are going to try and do something formal, then have a plan in place and let her beg off if she seems reluctant.

Pro Tip

If you are curious about trying RAW files, a wedding is the perfect opportunity. Weddings are contrasty events (white dresses and big dark rooms). You might want to try shooting JPEG and RAW formats for more exposure latitude and contrast control.

Technique

You have to be ready—but you are also a guest, and you want to enjoy yourself. Here's a simple "cheat" to have your camera set up and available all the time.

If you are indoors, set your camera to Aperture Priority mode. Crank your ISO up until your camera is getting an adequate (or slightly underexposed) exposure in the range of about $\frac{1}{20}$th to $\frac{1}{60}$th of a second at about f/4 (an ISO of 400 should work for most rooms; you might need 800 if you are using a kit zoom). Leave your white balance set to Auto.

This setting will ensure that you are including some of the available light in every shot and keeping the background from going completely dark. The background (ambient light) will go yellow but will probably look nice.

Events are about energy. Get in tight and accept some flaws.

You might get some camera motion from the slow shutter speed, but remember that the flash duration is only about $\frac{1}{1000}^{th}$ of a second or less. The foreground, where the couple is, should be quite sharp. If the background has some camera movement, it can often look beautiful.

Photosensitive

If you're set up for an indoor event and you move outdoors, the camera will have to be set a much higher shutter speed and might exceed the maximum flash sync speed that your shutter is capable of.

Now, set the exposure compensation for your flash to underexpose by one stop. Shoot a couple of test photos of another guest at about five to eight feet away to confirm the settings. You might need to adjust the flash compensation a little to suit your tastes. If the photo includes too much ambient light, then switch the camera to Manual mode and set your shutter speed to underexpose by one stop. You want the foreground to be bright but not overexposed and the background to be slightly underexposed but not black (like the photo of the woman in Chapter 6 where the background was underexposed).

Now you can enjoy the party and still be fairly certain that your camera is ready for almost anything.

Bar and Bat Mitzvahs

Everything I said about weddings also applies to bar and bat mitzvahs with one big exception: bar/bat mitzvahs are really fun to shoot. They are raucous, great parties, and have very little pressure.

The family has probably hired a pro to shoot the ceremony and formal portraits. Just stand aside and be a guest. Like a wedding, the ceremony is solemn—and too many cameras are a distraction.

During the party, shoot what the pro isn't shooting. When the family is lifted on chairs for the Hora, shoot the reactions of the crowd. If you are one of the family members who is going up high in a chair, then make sure you have a point-and-shoot camera in your pocket so that you can shoot from your unique, first-person point of view.

Bar and bat mitzvahs often have DJs and dancers to keep the party going, and they can be great allies for photographs.

Sports

I love shooting sports, but I would be lost at a baseball game, and I can barely comprehend basketball. Hockey looks like a ballet with sticks and fighting to me. Nonetheless, all sports and athletes have a grace and beauty that is always a joy to watch, and all sports photography (at any level) represents a distinct challenge to any photographer.

Pro Tip

Events are about moments more than techniques. If you sense that you are missing significant moments because you are confused by techniques, just switch to Program mode. That's what it's there for.

I think the best part of shooting sports professionally is the athleticism that goes in the photography itself. When I'm on assignment I watch the event unfold and find my feet moving of their own accord in anticipation of the future, my eyes locked on the action. The next thing I know I am sprinting along with a 300mm lens trying to find the perfect intersect in time and space with the

event itself. At this point you are no longer an observer, you are a new participant in the event, another dancer on the stage.

Outdoors

The first question to answer here is what level of sporting event you are shooting. If it's a Formula One race or a Major League game, then you had better bring the longest zoom lens you have (or can rent) and are willing to carry. Access is extremely restricted, and you won't be allowed to wander around.

Shooting family sports like little league or high school basketball games is a different story—and another situation where your camera does very well on one of the full program settings.

Outdoor sports are pretty easy. There's lots of light, so you can buy a very affordable (and slow) zoom lens with a variable aperture (like an f/4–f/5.6). Image stabilization is a definite advantage but not completely necessary. Lenses like these are available in the $300–$400 range even if you buy a big-name original equipment lens (like a Canon or Nikon). I'd happily take a lens like this on a professional assignment if I had to travel light. I doubt that I'd see a big-quality difference between these lenses and an expensive pro lens under well-lit conditions.

Photosensitive

Try not to completely fill your CF or SD card. Some cameras will continue to shoot although there isn't enough free space on the card. If there's only enough space on the card for two more images and you shoot a fast sequence of six, the remaining photos will get "buffered" to the camera's internal memory and have no place to go. The camera will probably freeze until you pull the card. Sometimes this can corrupt a card, and you may lose many more than just the few photos in the buffer memory. Change cards before you completely fill them.

I only shoot RAW files, and my personal cameras won't shoot RAW on the program Sports setting, so I have little experience with shooting in this mode. However, it seems to be awfully good; in fact, it seems tough to beat. In my experiments, both the Nikon and my Canons always picked a shutter speed and f-stop on their own that I thought was a pretty smart choice for most sports

situations. They also both automatically change the autofocus mode from "one shot" (which locks the camera up if the focus isn't perfect) to "servo" or "dynamic" autofocus (which allows the shutter to fire even if the focus isn't perfect). And that's what I would have recommended (depth of field often makes up for the slight miss in critical focus).

Sports photos are also an area where the JPEG format works very well. Most prosumer DSLR cameras are a little slow, especially when shooting RAW files. This is because RAW files are large and take more time to write to the digital media. Shooting JPEGs speeds most cameras up considerably. If you want to capture the entire sequence of Junior hitting the ball, running, and sliding into first, then shooting JPEGs is the way to go.

Indoor Sports

Indoor sports are a quite a bit harder. There's less light, so you'll have to crank up the ISO and/or shoot with a faster (more expensive) lens. This a good time to consider a fixed focal-length, large-aperture lens like an 85 mm f/1.8, or a 50mm f/1.8 as the digital equivalent (either are much more affordable than a comparable fast zoom). That should get you close enough in a high school gym. You will also have far less depth of field.

Remember that an image-stabilized lens only helps you handhold a camera at lower shutter speeds. Stopping the motion of an athlete can only be accomplished by a higher shutter speed and/or faster lens/ISO combination. Stabilization is nice, but it's not a substitute for real speed. Shooting with flash is not a great option because you will probably be too far away for it to be effective.

The bigger problem will be white balance—especially if you shoot in a lot of different gyms or arenas (if you are following your daughter's gymnastics career, for example). This is a time when a small investment in an Expoimaging disc makes a lot of sense because you can just create white balance as soon as you walk into the gymnasium. If it's an occasional problem, just use the white piece of paper solution I outlined in Chapter 6. Gymnasium lights are invariably lit with some form of mercury vapor, and if you are shooting JPEGs a custom white balance is really necessary under these conditions.

If you absolutely have to use flash for an indoor sporting event, remember that your flash can't light an entire gymnasium—and it takes time to recycle. Time your shots precisely because you will only get one chance; prefocus on the place the action will happen and wait for the moment. Your pop-up flash is woefully inadequate for indoor sports. You might want to buy a separate shoe-mounted flash if your son just made the varsity basketball team.

One thing to note is that I think cameras will be capable of much higher ISOs with far less digital noise in the very near future—possibly by the time you are reading this book. The typical resolution for amateur cameras will probably stay in the 6 to 10 megapixel range, but noise reduction technology from professional cameras like Canon's EOS-1D Mark III will trickle down to consumer-level cameras and make shooting in marginal light conditions easier than ever very soon.

Hidden Knowledge

I don't really shoot much in the way of stick and ball sports for a very good reason. I was terrible at them, and I don't know how to watch them. I can watch a skier and know exactly when he or she lost a race by $\frac{1}{100}^{th}$ of a second or exactly when and where a particular motorcycle racer is going to crash. When I watch a football game, however, I haven't got a clue.

The top sports photographers are students of the particular game they shoot. They know when to relax and when their finger has to be on the button. They are masters at predicting the future and seeing where the play will happen. The key to being good at shooting sports has much more to do with being knowledgeable about the game rather than equipment.

A few years ago, I wrote a story about one of my favorite athletes, MotoGP star Nicky Hayden. This is Nicky during a practice run checking to make sure another racer isn't following him.

When Nicky won the race, I wanted to be sure I was in his pit for the victory celebration—so I positioned myself and awaited his arrival, only to watch him do a massive smoky burnout a quarter of a mile away on the front straight for the fans. I was sure I had missed a pivotal shot (all the other photographers were there). I took a chance and held my ground. When Nicky pulled into the pits, I was the only photographer there to get this moment.

I ran like a track star for the press conference because I knew the next great shot would be when he walked in—and I wanted to stake out the best spot right next to the door.

Recitals and Performances

In today's visual culture, a simple kindergarten graduation can resemble the photographer's pit at a White House press conference—bristling with lenses, flash, and video screens. Your big problem at the grammar school holiday pageant might be the competition from the uber soccer mom who will deck you if you block her shot.

Dance recitals and school plays are pretty easy to shoot only because the possibilities are so limited. Crank the ISO up so that you can shoot with available light, and set the white balance to tungsten to eliminate most of the color cast from the stage lights. The average kit lens is pretty useless under these conditions (too slow and not long enough). You could rent or buy a long lens, but in these situations I'd completely avoid the traditional approach.

I'd make it a story …

Thinking Cinematically and Editorially

The one great thing all events have in common is that they are complete stories. They have a cast of characters and a beginning, middle, and end. A photo of your daughter as a tiny dot on a dark stage has little interest to anyone but you and her, but a portrait (shot before or after the recital) in her ballet outfit or at the piano keyboard offers some better visual possibilities and is more likely to have some enduring value.

Magazine photographers and photojournalists can't just take one photograph; they have to flesh out complete stories. Even when you only see one photo, it's a sure bet that the photographer shot a few hundred. They have to supply the editor with a range of options and possibilities that will get narrowed down to the best 5 to 10 photos. Some of the photos will run as large, double-page spreads; others will run small and may only serve to supply information or background ambiance. You don't know what's going to be important until later, so you shoot everything and try to make it all as good as you can.

Thinking like this can help you a lot. It keeps you interested and engaged in making photographs through the entire event (and might make the event more fun for you, as well). It makes the moments when your daughter arrives at the auditorium, puts on her slippers, and takes a bow just as important as her grand jetée. The good photograph is usually somewhere in the details, not in the obvious. I'd also remember to photograph your child's friends and the teacher/coach as well. They might not seem important to you, but they probably are to your child.

Not all of the photographs you make will be good, but neither are all of the photographs that pros make. They take chances and are willing to strike out all the time; these are the photos you never see. Editing it down to the four or five home runs is what makes us look so good.

Event FAQs

The bride is coming down the aisle and my camera has completely shut down! What do I do?

This is why pros always have multiple cameras. First, slow down and don't panic. Was the camera on? If it was then check and make sure the card isn't full. If the card isn't full then take the battery out and replace it. Even if the battery is still charged, simply taking the battery out and putting it back in will often "reboot" the camera and fix the problem.

Did you just finish shooting a long sequence close to the capacity of the card? Is the camera displaying an "error" message? If this is the case the camera is probably locked up because the *buffer* has no place to send the images you just shot (you'll probably see a blinking light on the camera indicating that the camera is trying to "write" the images. The only solution is to pull the card and sacrifice the images in the buffer (and possibly more).

Finally, check the lens mount. If the lens isn't locked in then the camera won't fire.

The important thing is to behave as if there's no pressure. If the same thing happened in your living room while you were shooting a still life you might be puzzled, but you wouldn't panic. You would look at the problem methodically and carefully. It's exactly the same here.

The **buffer** is the cameras internal memory. It has enough memory to hold a given number of images (depending on size and file format) until it fills and the camera will no longer fire. As the data (images) are being copied onto the CF or SD card the buffer will continue to accept more exposures. Professional cameras have very large buffers, some can hold over thirty 10MP RAW files. Most amateur cameras sacrifice large buffer space for other features and an affordable price point.

My flash is completely over/underexposing every shot! What do I do?

If it's the pop up flash, and it's a high pressure moment then I'd just switch to "Program." As much as I stressed manual operation in the beginning of this book it's important to remember that the "P" setting is your life preserver. Don't be afraid to use it when you need it.

If you are already on "Program," then check the flash exposure compensation mode. You might have switched the setting for an earlier shot and forgotten to set it back.

If it's an auxiliary flash unit, then check to make sure it's set to "TTL" for through the lens metering. If it is set correctly then check to make sure it is fully on the camera. Sometimes they can slide back on the hotshoe and still fire but not connect to the TTL metering.

My flash unit is firing intermittently, what do I do?

Chances are it's time to change batteries because the flash isn't fully recycling in time.

Planning Ahead

Every time you pack your camera bag, you are predicting the future. (Even if you *don't* pack a bag, you are predicting the future.) and even when you just throw a camera over your shoulder and think, "This is all I need; I'm covered," you have made a prediction.

It might seem obvious, but take a few minutes a couple of days before a big event to close your eyes and imagine how the event will play out. Predict the future. Ask yourself, "What photographs do I want or hope to get?"

I do this before every shoot, and it's amazing how often I realize that I have forgotten to pack or rent some useful item. It might be a long lens, a remote control, or just charging a spare battery—but there's always something.

Rent or Borrow Extra Equipment

Buying a 300 mm f/2.8 lens to shoot Junior pitching in the state finals is probably prohibitive. But it is a big event in his life, and you probably want to shoot it as well as you know how.

Pros can't afford to own every camera, light, or lens there is. Most of us have a basic package that covers 90 percent of our regular assignments, and we rent gear when we have something out of the ordinary. If you live in a major city, then chances are there is a camera store near you that rents equipment. Renting is also a great way to try before you buy, and it's often very reasonable.

I also recommend to my former students who are starting out as pros that they "buddy up" with friends and make sure that they buy compatible equipment so they can borrow from each other. By nature, events are special occasions and might require special equipment.

What to Bring

When shooting events, you should bring along at a minimum (we'll call this level 1, for event scenarios):

- Extra batteries
- Spare film or digital media cards

To take it one step farther, you should have (level 2):

- A tripod
- A shoe-mounted, on-camera flash with a light modifier (small soft box or bounce diffuser)

And, to really go all out, bring along (level 3):

- A fast, long lens like a 70–200 mm f/2.8 zoom or an 85 mm f/1.2–2
- And/or a fast, wide-angle lens in the 20–28 mm f/1.4–2.0 range

Personally, I find the fast, wide-angle lens to be indispensable.

Last but not least, these are all great for weddings (level 4):

- A flip bracket to hold a shoe-mounted flash

- A second wireless flash unit

- An auxiliary battery pack for the flash

Events are a challenge to your skills as a photographer, and this is precisely why they are so much fun. When you strive to impress, (even if it's just for your family, friends, or yourself) you raise the level of your game for all of your photography.

The Least You Need to Know

- Stay out of the way of the pro at weddings, and go for the shots that the pro won't be taking.

- Think ahead when you shoot events; otherwise, you will always be too late for key moments.

- Use Program mode freely.

- Strive to tell a story with your event photos, and be prepared with an equipment checklist.

In This Chapter

- Ways to approach photographing travel and landscapes

- Tips on shooting at night and in difficult lighting situations

- Thinking ahead and planning for travel photographs

Travel and Landscape Photography

Your friends have asked me to raise a difficult subject with you—one they have been too embarrassed to bring up.

They hate it when you go on vacation. It was bad enough in the past when you came to work with 10 envelopes of snapshots fresh from the one-hour photo lab and made them look through hundreds of photos of white, sandy beaches. Now that you are just bringing in the camera and scrolling through the memory card, it has become unbearable. Please stop—they're begging you.

Think about it from the other side. Have you ever been *really* interested in someone else's vacation photos? Probably not. There might have been one or two great shots, but chances are you were bored to tears. It's even worse when there's a story that goes along with every photograph.

French photographer Henri Cartier-Bresson once said, "The anecdote is the enemy of photography." What Bresson meant by this was two-fold:

1. When a photograph requires explanation, it's probably not as good a photograph as it should be.

2. When a photograph is amazing, telling the story behind it detracts from the inherent mystery and beauty of the photograph.

When I'm asked to both write and shoot a story, I'm always trying to imagine what the words can do well and what the photographs can do well. Photographs can't tell you how funky a hotel room smelled, how great a steak tasted, or how warm the sun felt on your skin. Good photographs do something very important that words don't do as well, though: they describe people, places, and things. They describe the light and the weather. They describe the unique point of view of the photographer.

Travel Photography Is Hard

Travel photography seems easy, but I think it is actually the hardest thing for most amateurs to master.

We look at travel magazines it looks so easy—but don't believe it. When a magazine hires a photographer to shoot a travel story, the apparent ease and simplicity in the photographer's portfolio is one of the qualities the editors look for. Photographs for travel stories are supposed to look effortless and simple, and good travel photographers work very hard to make it look that way.

The hardest thing any photographer can do is to engage another person in his or her unique experience. This is one of the main reasons why your friends are (maybe) bored with your vacation photos.

When I do a travel story for a magazine, I realize that I will be lucky to get 10 photos published. Five is more likely. I shoot a few hundred. Why? Because each of the five photographs has to say a lot. Packing a lot of information into a single photograph is hard to do. Travel photographs are where you need to really hone your storytelling skills. Don't aim for a stack of mediocre photos; try to make 10 or 20 *really* great ones that completely sum up the experience. Shoot hundreds; show few. Leave the audience wanting more. Last, don't delete photos in the field. Look at them carefully on a screen at home.

It's All About Being There

In the real estate business, there's a saying: "Location, location, location." In photography, it is "Vantage point, vantage point, vantage point." You already know this, but you might not have been thinking about it.

The Vantage Point of Space

This concept is obvious but very subtle as well. Find something in your field of vision right now, and line it up with something in the background. Close one eye and move your head. This is the vantage point of space. This simple concept is the very backbone of photography.

I don't know if this story is true, but I like it and it's instructive.

The great photographer Garry Winogrand was a man of few words. According to the story, he spent hours looking through a large portfolio of work by the great French photographer Eugene Atget without saying a word. After looking through the entire portfolio, he simply closed it and said, "Boy, that guy really knew where to stand."

How simple—but as true a statement as anyone has ever made. Knowing exactly where to stand is really important.

If I plan a trip to Paris on a vacation, I have made a very active, conscious choice about what kinds of things I wish to see. At this level, the choice of vantage point is truly global in scale. I am deciding to place myself at a particular place in the world.

When I walk down a Parisian street and see the Eiffel Tower framed between two buildings, I make a series of smaller and smaller decisions about my vantage point until finally I am standing in the middle of the street and crouching two inches to find the exact composition. The choices of vantage point represents an ever-shrinking series of choices that zero in to one particular point in space (and time).

The Vantage Point of Time

There are at least two important vantage points in time. The first deals with time in a fairly simple way and refers to the time when you made the photograph.

Photographs made in color are very distinctive in the way they deal with time. Color, and the color of light, is intrinsic to the time of day and season when the photograph is made. If you have been making photographs of "the same thing every time you see it" (as I outlined in Chapter 6), this will be obvious to you in your own photographs.

The other vantage point of time is longer. I call it the "palette of history." Certain colors and styles of clothing, cars, and even photographs place a photograph in a certain time. They tell you when a photograph was made and provide historical context. A photograph of a soldier in a helicopter wearing green fatigues, shot on Kodachrome film, tells you he is in Vietnam. The same photo of a soldier in tan camouflage shot with a digital camera tells you he's in Iraq. The palette of history isn't obvious to us now, but it becomes important in the future. Look at a few old snapshots that your parents took of you, and you will see exactly what I mean (avocado-colored kitchen appliances are chic again!).

Photographs are, by nature also series of smaller and smaller temporal or time-based decisions. Am I in Paris in the summer or the winter? Do I shoot the Eiffel tower at noon, or do I come back at sunset? Do I press the button now, or do I wait for the pedestrian to cross the street so the street looks deserted? Again, out of an infinity of possibilities, a single exact moment is chosen.

The Vantage Point of Identity

It's *your* vacation. Why are you making photographs that look like barcode postcards? Chances are, the photographs your friends and family are going to be the most interesting and will be the ones that reflect your unique point of view and personality.

All that stuff our parents told us is true: we're all special. You are a unique entity in a unique place at a unique point in time. What you are looking at this very instant might not be interesting, but it has never been seen before and will never be seen again in exactly the way you are seeing it right now. Everything you will see in your entire life is a personal treasure. Showing it to others, as you see it, is the strength of photography.

I am often amazed when really promising students, with a strong style come back from a semester abroad and show me the work they did on the trip. More often than not, they make very generic photographs that don't reflect their unique personality or point of view, and I'll think, or even say, "Wow, you went to Paris but you left yourself at home."

Where you have been, and when you were there, is—to a large extent—your legacy. You are an interesting person (I guarantee it), letting your photos reflect that will make them better.

Case Study:
On Top of the World

One of the hardest travel stories I've ever done was a motorcycle trip for *Unlimited* magazine. The basic premise was simple: a buddy and I were to search for the northernmost bar on the continent.

Starting in Seattle, we got on two motorcycles and headed north for 2,500 miles until we reached the town of Inuvik in Canada's Northwest Territories on the Arctic Ocean, 300 miles above the Arctic Circle. Once we got there, we had a beer at great little bar.

This photograph ended up as the opening double-page spread for the story titled, "Arctic Blast." It was originally shot as three separate photos because I thought a pieced-together collage, or triptych, would better communicate the idea that the landscape was so vast it couldn't be contained in one shot.

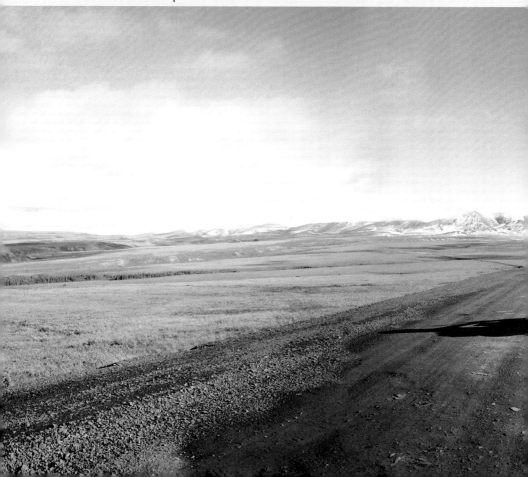

Then, we got back on the motorcycles and drove home. It was 5,000 miles round trip through some of the most desolate terrain on Earth.

The story was hard because there was so little to see. No beautiful women, no nightlife—just two average guys, the open road, and a whole lot of bears.

The art director disagreed, (he was right) and the magazine digitally stitched the three photographs together into this panorama.

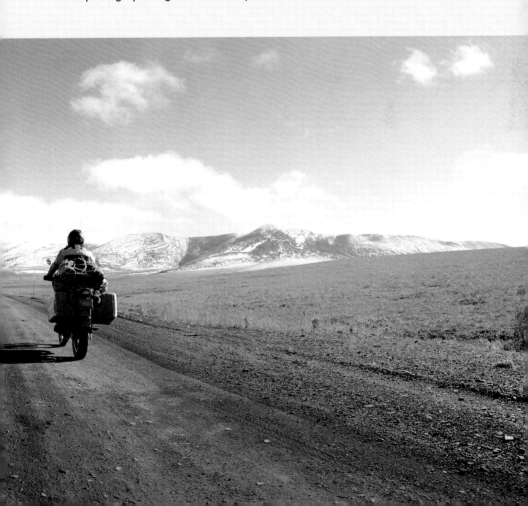

Think Ahead: What Do You Need?

Try the same exercise that I outlined in Chapter 8 about thinking through what equipment you'll need and the different levels of equipment. You obviously planned your vacation around getting to see things you wouldn't normally see. What are you hoping to photograph?

Your equipment really needs to be well thought out when you travel. Take too much and you won't want to carry it all; take too little and you'll spend the entire time wishing you had the one item you left behind.

For this exercise, let's imagine we are going to Europe for a typical tourist week in Paris.

Level 1 (for travel photography):

- Camera with a kit zoom lens (lens hood, filter, and so on)
- Tripod
- Small tabletop tripod
- Point-and-shoot pocket camera
- Infrared remote control for self-portraits
- 16 GB of memory or 30 rolls of 35 mm film
- Portable data storage drive or viewer (optional but highly recommended) or a laptop computer
- Gaffer tape (you'll find a new use for it every day)
- Pocket diffuser for pop-up flash

Level 2:

- Ultra wide-angle zoom lens, 10–22 mm (digital) or 20-35 mm (film), for interiors of churches, attractions, and panoramas
- Lightweight, variable-aperture zoom lens with a normal to long range (like a 50–200 mm)

- Fast, fixed-focal length prime lens, 20–28 mm, at least f/2.8 maximum aperture.

- Shoe-mounted flash unit

I probably wouldn't carry all of this equipment every day, and if I took these lenses I'd leave the kit lens at home. Anything beyond this is really tailored to a specific kind of vacation.

If it were a bicycle or backpacking trip, I'd want a carbon fiber tripod. I might also trade up the kit zoom for a pro zoom lens in the 17–40 mm f/4 range (better quality but still lightweight) and only take that lens.

For a photo safari trip to Africa, you'd obviously want a very long zoom lens in the 100–400 mm range. If I were going to the Bahamas, I might want to bring an underwater camera or an inexpensive housing for my point-and-shoot. These special trips actually make planning easier because you have a better idea of what to expect.

More and more point-and-shoot cameras are capable of underwater photography without an auxiliary housing.

A Travel Approach

When you travel with your family, it can become easy for photography to take over the trip. The kids really don't want to stand around while you try to find the one undiscovered angle of the Eiffel Tower.

One tactic is to simply set aside one hour a day to just wander and shoot—and the best time to do that is early in the morning before breakfast or late in the afternoon when everyone wants to rest and relax before dinner. One hour to yourself ... sounds kind of good, doesn't it?

Pro Tip

As a rule, most pros avoid the noonday sun because the light is boring and ordinary. Dawn and dusk are the "magic hours" when the light from the sun is almost equal to the light from artificial sources.

Wandering a new city before dawn is amazing. The streets are quiet, and there are no other tourists out. Another big plus is that when you are alone with a camera, the locals will often engage you in a way they never would if you were part of a group. It's a chance to see the culture without the insulating bubble of tourism—as well as to make memorable photographs.

Also I often see a location I'm interested in and think, "This will be great at sunset, at dawn, with a person, or completely deserted."

Don't be satisfied with your one and only photo of the Eiffel Tower. Keep working at it and thinking—adding new levels of complexity and meaning.

An Assignment

Try to make a photograph every 15 minutes (or every 30 minutes) during that hour to yourself. It doesn't matter where you are. Find something worthwhile to make a photograph of. A little process like this keeps you from zoning out and keeps you alert and observant. It also means that you will relax and enjoy yourself when you aren't "on."

Case Study:
The Carrera Pan Americana

One of my favorite travel stories is this one from the Carrera Pan Americana, a 2,500-mile road race with vintage cars that takes place in Mexico.

While it's a serious car race, it takes place on open roads that travel through many of the original Spanish colonial towns and is shot as a travel story. The race is a source of national pride for the Mexicans, and every village holds a fiesta to honor the racers as they pass through.

This photograph is made with a special panoramic camera. This story was really about traveling more than car racing. The panoramic format allowed me to show the cars while retaining the context of the Mexican countryside and architecture.

Find a view that no else is seeing.

The race takes place at speeds of up to 200 mph (the police close off the roads). Keeping up while competing and shooting takes lots of planning ahead.

This is the view from our racecar and a portrait of my co-driver, Sue Callaway, in the mirror.

When you are traveling, shoot the people you meet. This is the famous German rally champion Heidi Hetzer signing autographs in the beautiful colonial town of Zacatecas.

Travel FAQs

Whenever I shoot with flash at night, the foreground is all blown out and the background is dark.

Remember that when you are shooting with flash, the camera is still using a light meter to read and evaluate the light from the flash. If not enough light is reflecting back from the subject, then the flash just adds more and more although your spouse is getting overexposed.

When your subject is small in the frame, most of the light from the flash is just flying off into the darkness and not reflecting back to the camera.

By now, you should know that the only real solution is to set the camera on Manual and try to find a reasonable exposure for the background lights (a tripod really helps), then set the flash to underexpose by at least one stop.

The stained glass is too bright; I can't see its colors. (Or, the church is too dark.)

Most old churches were designed with the windows as the primary illumination. That's what makes them so special. If the window is supplying all of the light, then the meter in the camera is fooled into trying to make them "gray"—which results in underexposure of the window. This might be good for the window but bad for the rest of the church.

If the glass is blowing out and overexposing, then chances are that the window is small in the frame and the camera is reading a lot of the dark shadow areas of the church. Set the exposure compensation to underexpose (the church will go darker as well).

You have to remember that there's a limit to the total contrast range the camera can handle. If your camera has an auto-bracketing feature (most do), this can often help you find a compromise setting that works well.

If you are trying to get the entire interior to be as well lit as the windows, you are probably going to need extra flash. Your pop-up flash can't light the entire interior of Notre Dame de Paris. But in a smaller space, it might do a pretty decent job of just "filling in" and opening up some of the shadows. Leave your pocket diffuser off; it has no appreciable effect in large spaces and will just make the flash less effective.

Painting with Light

If you really want to get tricky with that interior church shot, then you can "paint" the interior with your separate shoe-mounted flash (like I painted the two cars in Chapter 6).

Set the camera on a tripod. (If you aren't allowed to use the big tripod, then use the tabletop tripod in your bag.)

Keep the flash unit in your hand. Set your camera on Manual exposure and select a small f-stop and the lowest ISO. Now, find a shutter speed that will underexpose the scene by about one to two stops. You want an extremely long shutter speed (in the 15-second to 45-second range). The ideal exposure might be something like f/16 at 30 seconds. This gives you enough time to move around with the flash.

Set your flash to quarter power. You want it to recycle quickly.

Use your remote control to open the shutter. Now, walk quickly down the aisle (as long as you keep moving, you won't be visible in the shot) and pop the flash around the room—at the ceiling, and the end of the aisle. Keeping walking away from the camera and keep setting off the flash as fast as it can recycle. Make sure you don't point the flash back toward the camera, though.

This takes a little experimentation, but the shot can look amazing.

Shooting at Night

Your camera—and the view on the playback screen—can be deceptive. Cranking the camera up to ISO 3,200 and just shooting might lead you to believe that you don't need a tripod for night photos. The view on the camera's playback screen might look fine, but it will probably be a noisy mess when you look at it on the computer and try to make prints.

Remember, large dark areas in the frame can fool your camera's meter. This will often result in highlights being blown out. Your clipping indicator (the playback option I described in Chapter 3 that has a blinking indicator for overexposed areas) will help you find an exposure that retains good highlight detail.

In this photo, the meter is fooled by the dark sky. It tries to turn night into day.

Changing to Manual exposure and underexposing almost three stops resulted in a photo that looked pretty decent on the camera's screen.

But excessive noise from the high ISO makes it useless.

Long night exposures are not the strong suit of digital cameras. Try to shoot with the lowest ISO possible and use a tripod. Many cameras also have a noise reduction setting for long exposures. If you are shooting JPEGs, I'd recommend using this feature. When you shoot RAW files, you will have more control over the noise during postprocessing. But you still can't shoot at ridiculously high ISO settings without consequences.

Shooting RAW

While RAW files might be too slow for sports, a vacation is a perfect time to try your camera's RAW format. You still have to get the exposure right, but RAW files will offer a lot more flexibility in controlling the contrast and color of your final photographs.

Try shooting both JPEG and RAW simultaneously. Shooting really good travel photographs means that you are trying to get 10 to 20 great photos instead of 300. Shooting in RAW will allow you to tweak the best photos when you get home.

Case Study: Lightning

I spotted this view of Las Vegas a few days earlier during the daytime, but the light was awful. When I saw this lightning storm start two days later, I jumped in the car and drove back—hoping to get the exact photo you see here.

The trick to capturing lightning is to set the camera to a very small aperture and long exposure (or bulb) so that the shutter is open when the lightning strikes. Lightning is very bright, so it will easily record at f/11–22. After the lightning flash, leave the camera open until the overall exposure is correct. Setting a low ISO will help avoid overexposure.

The light in the foreground (on the sign) was "painted" by popping a handheld flash about 10 times while I walked around during the two- to three-minute exposure. There were multiple lightning strikes during this time.

See what Cartier-Bresson meant about anecdotes? It's like a magician explaining a trick. The photo isn't nearly as mysterious and cool once you know how easy it was.

Mindful Travel with Cameras and Gear

You are a target when you walk through a strange city with camera gear—especially when you have your kids with you, because they are a great distraction for a pickpocket to take advantage of. It's important to note some safeguards for your camera and gear when you are traveling.

Look purposeful. Carry your camera in your hand with the strap looped around your wrist. Keep your bag(s) zipped or buckled. I like additional Velcro closures because they make noise when they are opened. Backpacks might be a comfortable way to carry your equipment, but they are easier for someone to unzip and reach into on a subway.

Photosensitive

Never hang a camera bag over the back of a chair in a restaurant! I have personally witnessed at least five occasions when camera bags or purses have been stolen this way. Put it between your feet, and loop the strap over your knee.

Leave expensive equipment you aren't using in a plain suitcase with the hotel concièrge. Domestic hotel staff are generally very trustworthy, but beware that there are professional thieves who work hotels and know how to access rooms.

The Least You Need to Know

- Use the lowest ISO you can at night, and use a tripod.
- Set aside time (especially time alone) for photography during vacations.
- Revisit key locations whenever possible.
- Strive to make 10 great photographs that tell the whole story instead of 200 that are each little pieces of it. Shoot freely, edit tightly.

In This Chapter

- How to approach inanimate objects

- Different light sources for still lifes

- The use of light to help tell a still-life story

Chapter 10

Shooting Still Lifes: The Secret Life of Things

Eminent photography historian and curator John Szarkowski once noted that while a picture might be worth 1,000 words, most of those words are nouns and adjectives. This is true for all photographs—but especially so for still lifes.

Thinking About Still Lifes

Photographing inanimate objects, like all photography, begins with the idea that we want to communicate something about the object we're photographing. Every object has a story; it was created by a person or by a force of nature.

Every photograph we make of an object has a purpose. We want someone else to pay attention to it. We want them to desire it, to buy it, to appreciate it, or to be awed or appalled by it. Photographs of inanimate objects—shooting still lifes—begins with the object's story and end with the photographer's execution of his or her intention.

The best still-life photographers are masters of the craft. They have a clear understanding of the thing in front of the lens and what they want the photograph to convey. They know how to use the camera and light effectively to reveal an object's secret life.

One of the great things about shooting still lifes is that you usually have all the time in the world. You can think, study, reinterpret, and reinvent the thing you are photographing. It's not unusual for many still-life photographers to leave something set up for days—returning to the same still life with a new interpretation, a new way of looking at the object, or a "tweak" that somehow makes the lighting more meaningful.

In the course of shooting a still life, you learn things about the object. The history and life of the object is revealed to you as if you were peeling away the layers of an onion.

Case Study:
Thinking About "Things"

I don't actually shoot that many still lifes professionally, but I do shoot a lot of cars (which are really just big shiny objects). The same ideas apply; the scale is just a lot bigger. I also happen to know a little bit about cars, which always helps me find a meaningful approach to the subject.

This is a new concept car from Ford based on the original Shelby Cobras of the 1960s. It was unveiled at the Detroit Auto Show a few years ago.

The Cobra was a big, complicated shoot that involved building the entire black "set" around the car on location. There were probably 14 separate lights at work and 4 assistants helping me. There was no photo-editing software used; it was all done in the camera by just using lighting as well as I knew how.

The original Cobra was the brainchild of Carroll Shelby and is one of the most beautiful cars ever made, exuding a feline muscularity and grace. That quality was the guiding principle for both the design of this car and my approach to this photograph.

In contrast with the technical complexity of the Cobra shoot, this photograph of a BMW was ridiculously easy—but only after I had admitted failure.

What I knew about the design concept for BMW Z4 was that the designers had sculpted the body with "flaming surfaces"—body panels that were designed to catch the light in such a way as to emulate the flame paint jobs of hot rods in the 1950s and 1960s.

This BMW was shot as we were packing up after a long day of shooting and I was still not happy with what I had done. My photographs were fine. I'd satisfied the assignment and the art director was happy, but I knew I hadn't done anything I was really proud of. As I pulled my own car around to pack up the equipment, the headlights hit the surface of the BMW and the car came alive. This photograph is lit with nothing more than the headlights of my car and a small flash unit lighting the back wall.

Lighting for Still Lifes

If you are interested in really learning how to use lighting, then still lifes offer a unique learning experience that you will be able to apply to all of your photography. It allows you to experiment endlessly with a subject that has no appointments to keep and is endlessly patient.

As a tool for learning lighting, digital cameras are pretty unbeatable. In the past, professionals shot Polaroid film to preview the end result. It worked beautifully but at a cost of at least $1 per preview. It wasn't unusual for the Polaroid budget alone on professional shoots to be in the range of $500 to $1,000 or more. That's fine when a client is footing the bill but prohibitive for most amateurs.

As the photographers in the Strobist Flickr group have demonstrated, digital cameras combined with inexpensive wireless flash setups have put some very sophisticated tools in the hands of amateurs that rival the resources professional photographers used just a few years ago.

However, you can start with even less. What about the lights you already have but aren't made for photography?

Incandescent Light Bulbs

When I was a photo assistant many years ago, I worked for quite a few architectural photographers shooting interiors for magazines like *House and Garden* and *Architectural Digest*. Most of the time, we shot with the simple aluminum reflectors that are available from any hardware store. In the photo world, we sometimes call these simple lights "scoops." We would use special *incandescent light* bulbs (Photofloods) or quartz halogen lights, and we shot most of our assignments at night.

The beauty of the aluminum reflectors is that they are very inexpensive (less than $20), and you can see exactly what the light is doing. They are also lightweight and easy to transport.

Scoops are incredibly straightforward as a light source. Need more depth of field? Lower your shutter speed and close down the f-stop. It's that easy. Need one side to be brighter? Just move the light closer.

The disadvantage of scoops are that they are not daylight balanced and aren't strong enough to mix with daylight. They also can't stop motion the way flash can.

The other problem is that unless you are using incandescent bulbs or quartz lights that are designed for photography, the color temperature probably won't be perfectly correct for any of the standard settings in your camera's white balance menu. So you must create a custom white balance.

Incandescent light sources, like scoops and professional quartz halogen lights, are often called "hot lights" for very good reason—they can get really hot. Burning yourself is the obvious consequence, but melting the plastic object you are photographing, wilting food, or burning fabric are also real possibilities.

The worst story I have ever heard was on a student film shoot when a light was placed too close to sprinkler head. I'll let you imagine the disaster that followed.

Lighting with LEDs

As I mentioned in Chapter 6, LEDs are becoming a viable photographic light source—and a quick look at the websites of some of the major photography retailers show more and more LED lighting kits for still photography every day.

One of the cleverest LED lighting accessories I've seen are LED *ringlights* that screw onto the front of the lens. Because LEDs are a continuous source (unlike a flash unit) the effect and strength of the light is easy to see in the viewfinder as you move the light. The fact that LEDs are a continuous source also eliminates the red-eye problem of flash ringlights since the subjects eyes are able to adjust to the light.

This still life is from one of my personal fine-art projects documenting my son's toys. The red light in the back is from existing Christmas tree lights (it was the holiday season). The car is lit with an LED flashlight. The photo is shot on a 4×5 view camera with an exposure of about three minutes at f/22.

A **ringlight** is a light source (usually a special flash tube) that screws onto the front of the lens and surrounds the lens like a doughnut. Ringlights were originally invented for medical photography as a way to light a small area (like inside a mouth) without creating distracting shadows (because the light surrounds the lens it seems to come from all directions and casts little or no shadows).

These unique-almost-shadowless light sources were quickly discovered by fashion photographers in the late 70s to early 80s and were a signature element in the work of photographers like Chris Von Wagenheim, Guy Bourdin and more recently rediscovered by contemporary photographers like David LaChapelle.

Flash

If you think you may do a lot of still life photography, then an investment in a wireless flash system (see Chapter 6) makes a lot of sense because you can also use it for other things. You can start a system with one flash and a remote control unit that attaches to the top of the camera.

If you don't need the *through the lens* (TTL) auto exposure option of a dedicated system, then you can set up a pretty complete still life lighting system with a couple of cheap light stands, a very inexpensive flash (like the Vivitar 285), and a remote triggering device for less than $200. There's a very inexpensive remote strobe trigger widely known as the "eBay trigger" (type "eBay trigger" into a search engine and you'll find it) that has a legion of loyal fans. I use the Canon system because I use the TTL auto exposure option for fluid and fast-moving photojournalism assignments, but the TTL option really isn't necessary for still life photography.

Pro Tip

Pros use a vast array of tools to modify the size, color, and shape of light sources. Two of the most popular are umbrellas and softboxes. Umbrellas are inexpensive and set up quickly. Softboxes are better for shiny surfaces because they create a more natural-looking reflection in the surface of the object.

Controlling the Quality of Light

Controlling the exposure of individual light sources is specific to the make and model of the light (you'll have to refer to your camera's instruction manual), but controlling the quality of the light is a universal concept. The rules that govern the quality of light apply equally, whether you are using simple scoops or a full, professional lighting system.

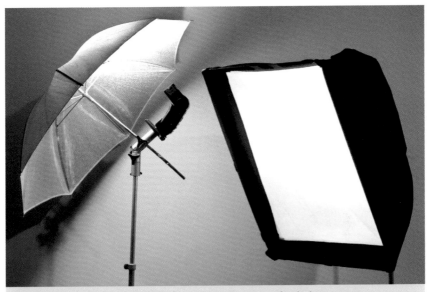

Two of the most popular ways to modify the size of a light source are umbrellas (left) and softboxes (right). Umbrellas can range in size from two feet to over 10 feet in diameter. Softboxes can range from the little four to six inch units that fit on a flash unit to 40 feet long for automotive photography.

Throughout this book, I have spoken about the relative size of a light source and its effect on the quality of light. This is a good time to look at this idea in a little more depth.

Whether a light source is soft and shadow-less or hard- edged and contrasty has to do with the size of the light source *relative to the size and distance to the object it is lighting.*

If you look at light traveling to a source, the penumbra of the shadow is hard-edged and sharply defined as the light rays striking the object become more closely parallel. As a light is moved

away from an object, less light hits the object—but the rays that do reach it are more parallel to each other.

If you look at a diagram of light leaving a light source, this concept becomes pretty easy to understand.

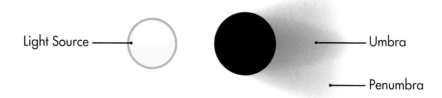

When a light is close to an object, the rays scatter and seem to "wrap around" the object resulting in shadows that have a soft edge.

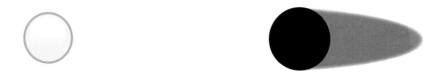

As light leaves a light source it scatters in all directions. But as the light source is moved farther away from an object the rays that hit the object are more closely parallel to each other. The result is shadows with a harder edge.

Up to this point, we have been concerned primarily with photographing people's faces—but still-life photography involves objects that can be very small or very large. So it becomes more important to understand the idea of relative sizes. If I am photographing a peanut, then a small flash unit close to the object is a relatively large light source. This is why the little pocket diffuser for a pop-up flash can look pretty good at a distance of four feet and becomes useless at greater distances. Conversely, if I am photographing a car with a 4×6 foot softbox positioned 30 feet away, the light will be comparatively hard-edged and contrasty although the light source seems very "large."

This concept is easier to visualize with some examples.

Case Study: Light and Shadow

This photo was shot with a small flash unit about 18 inches from the object. The front of the light source measures about 1×2 inches. At this distance, the light source is actually quite large relative to the small object, but it still produces a fairly hard shadow.

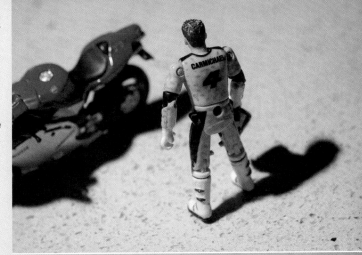

This photo was shot with a very small softbox over the flash unit (still about 18 inches from the object). The front of the light source measures about 6×9 inches. At this distance, the light source is very large and produces an indistinct shadow.

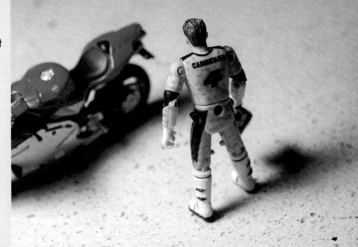

This photo was shot with the same small softbox, but the light is about six feet from the subject. The quality of the light and edge of the shadow is very similar to the first example.

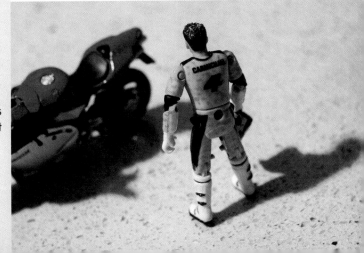

If you view light as a simple "bigger is softer-edged" or "smaller is harder-edged" equation, it makes the problems a lot easier to visualize and solve. When we shoot very large objects like cars, a huge softbox that measures 20×30 feet can suddenly seem pretty puny in comparison.

Still-Life FAQs

How many lights do I need?

There is no real answer to this but I suggest you keep it simple. Irving Penn (who I think can truly be characterized as the greatest still life photographer of all time) often uses one simple light.

In my advanced lighting class, I require an assignment using just one single light. The key is to be resourceful, creative, and imaginative with that one light: Use a broken mirror to reflect the light. Shoot it through something to create shadows or to change its relative size, move it during the exposure, use aluminum foil to bounce light into the shadows. Play around. Try to master one light before you add any more.

Any other good advice?

I tend to leave still lifes set up for as long as I can. Shooting inanimate objects beautifully is a mix of both experimentation (playing) and refinement (thinking, shaping and blending lights perfectly to the subject at hand). Leaving a still life set up allows you to look at the results, mull things over, and refine the results more critically.

A Simple Lighting Setup for Soft Light

I am often asked how photographers get the soft, shadowless lighting you see in magazine product shots. This is kind of like the old Henny Youngman joke about a pianist asking directions on how to get to Carnegie Hall. The real answer is, "Practice."

However, there is a very simple, down-and-dirty solution from David Hobby and Strobist that is so easy and effective for lighting

"eBay"-type photographs that I just had to include it in this book. But I did put a little of my own spin on his original concept.

Get a large box from an appliance store. The size depends on the object you anticipate shooting. Paint the inside of the box white or line it with white paper. Cut three large holes in the box (the top and two sides). The bigger the holes, the better the results will be. Cover the holes with tracing paper, then put a large piece of white poster board in the box so it forms a seamless "sweep" inside the box.

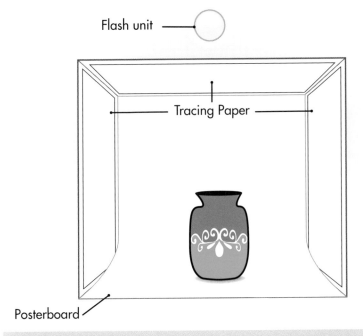

Flash unit

Tracing Paper

Posterboard

Each of the three holes becomes a little softbox window. Depending on which of the windows you point the light into, the object will be lit from the side or the top. The light will then bounce and reflect all over the inside of the box and "fill in" from the other sides. The following two photos were shot using only one flash unit, yet you can add more lights for different effects.

Pro Tip

Still lifes are a great way to learn how to control artificial light, but sometimes the best solution is simply to use available light well. I know two very successful food photographers who have built their styles around only using available sunlight for all of their shoots. The still lifes are set up on rolling tables that are moved with the changing sunlight.

This simple one-light solution is incredibly effective for describing an object.

With different-colored paper, some spray paint for clouds, and the help of a five-year-old's imagination, the "studio in a box" can also become a stage for re-enacting the Battle of Britain.

Lighting with Purpose

While we have the photo of that Leica fresh in our minds, let's take a minute to think about what the nouns and adjectives in the photograph seem to say.

It's a photo of a "camera" (noun), and it seems to be about a very specific and unique camera (a proper noun).

It's a rather "beat-up" (adjective) camera; the light is designed to let us look at the thing and examine it. We could describe the light as "clinical" (adjective). It *seems* to have no inflection or meaning, but of course it does. It is impossible to describe something without also implying something in the way you describe it.

On the next page we see the same camera, but the battle-scarred surface of the camera is less apparent. The photograph seems to be less about the specifics of this particular camera and more about the idea of the camera.

A very different interpretation of the same camera.

Simple ... maybe too simple. This photo is shot with a 4×5 camera by available moonlight. Exposure is about 20 minutes at f/22.

I wouldn't use this photograph to interest a potential buyer on eBay. But, I might use is it to illustrate a biography of a photojournalist.

The light is obviously manipulated, but it's a straight photo (no photo-editing software was used; it's all done with light. The photograph is heavily inflected with meaning (draw your own conclusions). The intention of the photographer is much more obvious and heavy-handed.

You probably don't see light like this in your everyday life unless you happen to live in an alternate universe ruled by Steven Spielberg.

The Least You Need to Know

- Every object, no matter what it is, has a story that can be told through photography.

- The quality of a shadow is dependent on both the size and distance of the light source.

- Complex lighting isn't always better lighting. Master photographers often use one light, and a simple box with some holes cut out of it provides endless lighting possibilities.

- Shooting still lifes will benefit all of your photography skills.

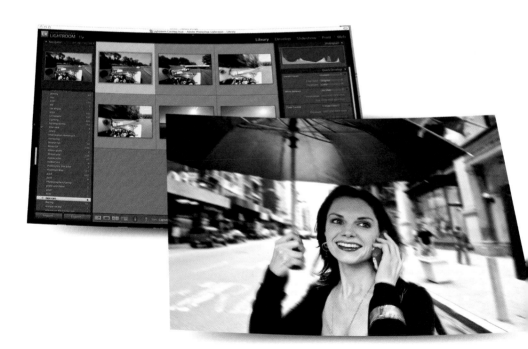

Chapter 11

Digital Imaging, Archiving, and Printing

In my office at the moment, I have six Photoshop manuals, three books on maintaining a digital archive, three books on RAW format, three more on color management, and six books on digital photography in general. Each of the books is probably 500-plus pages. This chapter cannot possibly teach you the complexities of postprocessing digital images in a comprehensive way. I'm going to throw you a life preserver here, not teach you how to build a boat.

I also need to confess up front that I am a confirmed Macintosh user. The entire photography and design industry is Mac-centric; all of our computers in the New York University Photo and Imaging Department are Macs. The few times I have had to use a PC (even to write an e-mail), I feel like someone who has driven an automatic transmission his or her entire life and is suddenly confronted with a stick shift and a clutch pedal.

This is not to say that PCs don't work for photography or that you shouldn't use PCs; just be aware that there are marked differences between Macs and PCs when it comes to working with graphics.

Computer Equipment: Who Said Digital Was Cheap?

Here's the good news. If your computer (Mac or PC) has 100 GB of hard drive storage and 1 GB of RAM, you are probably fine for now (at least, in my opinion).

The big problem with digital photographs is storage space—especially if you are shooting RAW files. Even if you are shooting JPEGs, you should invest in a separate hard drive as a way to back up your archive—but the hard drive can be a lot smaller and less expensive. I'd recommend an auxiliary 100 GB (separate from the computer) to anyone who is shooting JPEGs and 500 GB for RAW shooters (this also assumes that photographers who shoot RAW probably also shoot more photos).

Pro Tip

Backing up your work is imperative in case of a catastrophic crash, but fire and theft are other possibilities. Online storage services like PhotoShelter.com offer secure off-site storage that allows you to access your entire archive from any computer, anywhere, anytime. Also a service like this can be very inexpensive.

Monitors

Monitors can be quite pricey depending on how fussy you are. Like many photographers, I have two monitors for my desktop Apple G5 computer. The two-screen system is nice for digital imaging because it allows you to keep the photograph you are working on in one screen while the other can hold the palettes and tools for Photoshop. (The extra screen space is a real convenience, too.) One monitor is the Apple Cinema Display that costs about $600. I use this for word processing and other utility programs.

I can't control individual colors on the Apple screen, and the color calibration tool that Apple provides is a fairly rudimentary program in the system preferences menu. But my other screen is an expensive LaCie monitor (about $1,500) that can be calibrated and allows me to control the individual RGB balance (red, green, and blue). I have a calibration device (about $150) that I use weekly to ensure precise color calibration.

The difference between the two monitors is subtle but quite noticeable to me. If I weren't a professional, I'd probably be able to get along fine with the cheaper monitor and never know what I was missing. You should be fine with whatever monitor you are using; just be aware that as you progress with your photography, so will your standards for your monitor.

Printers

There are so many possibilities on the printing end that it is impossible to recommend a single great solution. Much of it comes down to one simple question. How big do you want to go?

If you never need to print bigger than 8×10, then there are a huge number of printers available to you for less than $200 from Hewlett-Packard, Canon, Epson, and many more. The better printers designed specifically for printing photos in this category will use six colors of ink to give a

> **Gamut** refers to the number and range of colors that can be seen or reproduced within a given color space or system. The eye can see a very large gamut of color, about 10 million distinctly different colors.

wider range, or *gamut*, of colors. Many printers in this category—like the Epson 380, for example—offer conveniences like a small monitor to preview the image and a memory card slot for direct printing (this enables them to work even if they aren't plugged into a computer). The results can be surprising and impressive for the price.

Bigger, tabloid-style printers are really made for photography and usually boast eight separate inks for a greater color gamut and richer blacks. These printers require a computer in order to function and can make prints up to 13 inches wide. Typical prices run from about $400 to $800, and many of these printers—like the Epson 2400—can really be considered "small" pro-level printers.

Using the Right Printer Paper

Using printers has gotten a lot easier in the last year or two, but working with a new printer is always a little frustrating. It can require a fair amount of experimentation in order to get everything working well. Read the instruction manual for your printer carefully. Pick one photograph and keep printing that one image until you get it right. Keep notes of your print settings as you make prints so that you can reproduce your results.

At New York University, all of our monitors are calibrated weekly—and we ensure that all of the color spaces for printers, screens, and programs are set to the same color space. Yet, students will often come in with a print that "looked great on the screen" but looks lousy when printed.

Often, the cause is a cheaper, off-brand paper. Printers need to be matched exactly to the paper you will be printing on. If you are printing on a generic paper from a large discount store, the results can be hit or miss because the printer won't have a specific setting or profile for the paper.

Pro Tip

In the same way that your eyes adjust to light of different color temperatures, they also adapt to the color of the screen when you are color correcting an image on the computer.

Before you hit the print button, look away from the screen for 10 to 15 seconds to give your eyes a chance to refresh. If the image still looks good when you look back at the screen, then go ahead and print.

Kiosks and the Internet

Wait ... do I even need a printer? Maybe not. I prefer ordering snapshot prints online or going to the local digital printing kiosk at the drugstore. It's much cheaper (ink and paper are expensive); the prints are water resistant and printed on photographic paper (with better archival properties than lower-end inkjet prints); and they have a wider gamut (range) of colors.

There are digital printing kiosks in many retail establishments, including drugstores, large discount stores, warehouse clubs, and grocery stores. The benefit of getting your prints this way is that you can have them the same day—sometimes within minutes. (Plus, you can lose yourself in your photography while the family is off shopping.)

The Internet is loaded with options for printing your digital photos. Just keep in mind you'll have to wait a few days to get them back in the mail. Places like Shutterfly.com and Snapfish.com will print and mail your prints to you. Many retail stores offer online photo processing services as well, and you can often go to the store closest to you to pick up your prints.

Making final prints of your work is integral to your growth as a photographer—even if they are only 4×6 drugstore prints. They expose technical problems that you won't see on the screen or in the camera. Prints also make the process concrete and complete. They are tremendously satisfying. It is still the best way to preserve your best work, learn from it, and share it with your audience. Don't condemn your best photographs to a life in cyberspace! Get them on paper, hold them in your hands, and put them in a frame.

Archiving Your Work

When was the last time your computer crashed? I currently have more than 16,000 photographs on my computer. If my work wasn't backed up, it would be devastating to me both financially and emotionally. You must back up your photographic archive periodically onto a separate hard drive. You should also copy every important memory card or shoot onto a DVD or CD as well.

Then comes the big question: Where do you put it all, and how do you keep track of it all?

iPhoto

Macs come with a nifty little program called iPhoto which automatically launches every time the computer senses a camera or a memory card has been plugged in. I don't use it, but lots of people love iPhoto. It makes the entire process of downloading, viewing, storing, printing, and sharing photos pretty idiot proof. The controls for manipulating or changing your photos are very rudimentary, but you can always open the files in a more sophisticated program like Photoshop Elements and the changes will be reflected once they're made and the photo is saved in your iPhoto library.

Screen shot of iPhoto.

iPhoto allows you to attach keywords (for example, "vacation," "Italy," or "Birthday 2008") to a photo or group of photos, which makes finding things a lot easier in the future. It also allows you to create virtual albums in the same way you create play lists for your iPod. Best of all, it allows you to create printed and bound books of your work (more on that in the next chapter).

If you're a casual snap shooter and happen to have a Mac, then iPhoto isn't a bad way to keep track of your work. Just make sure you copy your iPhoto library onto a separate hard drive every once in a while.

Adobe Photoshop Elements

I bought a copy of Photoshop Elements to try out because I figured the full Adobe Photoshop program (at $600+) was probably too complicated and too extensive for most people reading this book. I had never used it before and assumed it would be completely stripped down with none of the important tools.

Screen shot of Photoshop Elements.

The great news is that Elements has everything you are likely to need at about $100 (even less if you are a teacher or a student). At this price, it's a completely indispensable program for any serious amateur photographer.

In many ways, Elements is even better than the full version of Photoshop because it assumes you are a beginner and has more helpful hints right in the main menu bar.

Adobe Photoshop Lightroom

This program changed my life. I loved it within the first 15 minutes I tried it, and it just keeps getting better. I swear I am not on Adobe's payroll (although I was one of the beta testers for the program).

Lightroom is used to make global adjustments to an entire image and eases the photographer's workflow by filing and processing multiple images. It's really a digital darkroom for photographers who work in a traditional photographic manner.

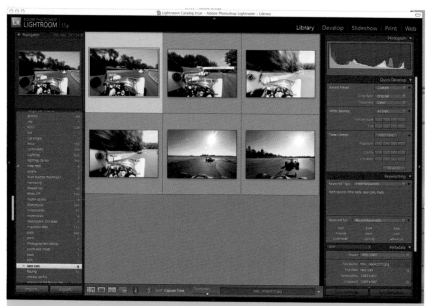

Screen shot of Photoshop Lightroom.

Lightroom doesn't completely replace Photoshop; you can't alter an image pixel by pixel, and you can't cut and paste images for collage-like effects. Lightroom is designed to be companion software to Photoshop.

The great thing about Lightroom is that it's really built for photographers shooting the RAW/DNG format, so it makes working and archiving with RAW files as easy as shooting JPEGs.

If I had to work professionally with only Lightroom and Photoshop Elements, I could probably get along fine. At about $300, it's a very versatile program for serious photographers working in RAW format.

The Least You Need to Know

- Set up a system for archiving your photos early on.

- Back up your archive on a hard drive that is separate from your computer. Back up important shoots on CDs or DVDs as well.

- Photoshop Elements is the single most essential program you can own.

- Making final prints is an integral part of the artistic process and is essential to making your work as strong as it can be.

In This Chapter

- Tools and resources for sharing your photos

- The rewards of maintaining a portfolio

- Online photography resources and communities

- The benefits of continuing education

Chapter 12

Be On Your Way Now

It might seem as though the natural thing for me to say at this point is that I hope this book has made photography a little easier for you. Well, actually I hope that this book has made it a little harder—because that would mean you will be expecting more from your photographs (and yourself) than when you first picked it up.

Taking Next Steps

Historically, one of the best things about photography is its ability to reward and serve any level of ambition. Whether you dream of a solo exhibition at the Museum of Modern Art or you just want to take better photos of your kids, it doesn't matter. Photography is equally accommodating, rewarding, and challenging at any level.

If you just take pictures, you'll get better. If you practice every day, you'll get very good very quickly—and it will seem effortless.

Early in my career, I decided to move to New York City because I wanted to be surrounded by photography at the highest level. Anyone who has ever participated in a competitive sport will know what I mean; it's not about winning (because there is really nothing to be won), but it is about competing because you respect, admire, and even love your competitors. It's fun to have something to strive for. The competition and camaraderie of a world-class photographic community is intense and inspiring. It keeps you hungry, and hunger is good.

The beauty of the Internet is that it has caused geographical limitations to largely disappear. In the twenty-first century, the term "world-class" really means what it says. You have an equal opportunity to play, learn, or compete on a global stage with your photography if that is your desire—whether you live in New York City or Karachi, Pakistan. The world is your oyster. It is also your classroom and your community.

Using Photo-Sharing Websites

Like many pros, I was a little dismayed by Flickr (www.flickr.com) the first time I saw it. It seemed to devalue imagery with a mountain of lousy photography, and the potential for corporations and art buyers to abuse unsuspecting amateur photographers by purchasing images at bargain-basement prices was—and is—a real concern.

I still worry about the potential negative effects of Flickr and other photosharing sites, but I also think the potential educational benefits will ultimately outweigh any negative effects.

Photosensitive

I get at least three phone calls a year from students who have been approached by major ad campaigns about using a photo the student has posted on their Flickr account. Most offer less than 10 percent of what a reputable stock agency would charge for the same use. Someone offering $500 to buy your photo for an ad might seem like a good idea until you realize that a photo agency would charge—and get—$10,000 for the same use. The internet is fraught with dangers when you post photographs, but internet sites like editorialphoto.com are also valuable resources for helping to research strategies for both pricing and fighting copyright use/abuse. Just remember that no one else can legally use your photos without your permission.

At first, Flickr was little more than bad vacation photos of people doing self-portraits in front of tourist attractions. However, more and more online photo groups like Strobist (www.strobist.com) and other virtual communities based around mutual interests are starting to generate quality work. More important, they are also starting to generate more constructive and tougher criticism. Some of the more advanced user groups and forums are developing into thoughtful discussions about photography.

I like online photo-sharing sites because they provide ways for you to expose your best work to other photographers. Even a simple, "Nice shot!" comment can make your day and help you realize that your work has merit. It's a way for you to invent and simulate some of the pressure of an art school critique no matter where you live and no matter how seriously you take photography. Flickr, Picasa (www.picasa.google.com), and other sites like them force you to edit your work carefully and question its value. Editing is the most important part of "getting past good."

Making Custom Photo Books

Creating photo books and albums is one of the most educational and constructive activities any photographer can engage in. It is also one of the best ways to preserve and share your work. When you set out to create a photo book, even if it's a simple family album or a record of your vacation, it sharpens your critical skills. You will realize quickly that you can't (and shouldn't) include

everything, and you will have to make choices. You will also real-
ize what you missed when you were shooting, and that knowledge
will help you in the future.

Using the iPhoto program from Apple as a way to archive or edit
your work is convenient, but I think that iPhoto's outstanding fea-
ture is its capability to easily create and lay out affordable photo
books. Creating books and albums is incredibly rewarding and
fun. It also gets your photographs off your hard drive and into
your hands. Programs and services like iPhoto have revived and
modernized the lost art of scrapbooking. A book like this is one of
the most thoughtful gifts you can ever give to a host, a grandpar-
ent, or a friend, and creating one (or several) will make you a bet-
ter photographer in more ways than you can imagine.

Model releases are a legal document that allow you to use a photo-
graph of someone else that you have taken for commercial purposes.
Many uses for your photographs (like an exhibition of your work) don't
require model releases, however using someone's likeness in a commer-
cial use (like an ad) exposes you to some nasty legal consequences. Get
model releases whenever it is possible and appropriate. Sample model
releases are available online and in packages at photo-stores.

You can also go way beyond iPhoto books, and there are options
for PC users as well. Higher-end album/book services like
Fastbackbooks.com and LuLu.com offer online books you can
make that are true coffee table books. These can look as beautiful
as something you'd buy at a fine bookstore, except that they are
full of *your* photographs. The reproduction on these higher-end
books makes the typical price ($10 to $100 depending on size and
page count) seem like a bargain.

Maintaining Your Portfolio

As a professional photographer, I have about 10 portfolios. These
need to be changed constantly in order to add new work or tailor
them to a specific client. A portfolio is really just a collection of
related images, but putting them in an easily viewable case pro-
tects the prints and makes it easier for people to view your work.

The case or portfolio book can be something as simple as a $20 plastic binder from the local art store or a custom-bound case. Custom portfolios like the ones available from HouseofPortfolios.com or Lost-Luggage.com allow for flexibility and constant updating and look impressive as all get-out.

However, my point isn't that you should spend $400 having a custom portfolio made; it's more that the ongoing process of creating and maintaining a portfolio is good for your work. It forces you to question and define who you are as a photographer.

If you have real aspirations to become a pro, or even to assist a working photographer, having and maintaining a portfolio is really a necessity. Opportunity seldom comes knocking with three weeks warning. It's important to be ready when someone says, "Really, you're a photographer? I'm looking for an assistant, or curating a show, do you have some work I can see?"

Websites are another way of maintaining a portfolio and defining your artistic identity. The great thing about websites is that they can be non-linear. Photo books are sequential by nature while websites can allow you to direct an audience or allow people to pick their way through your work. Of course, there's also the potential for more people to see your work.

Online Photography Resources

It goes without saying that the Internet is an amazing resource, but there are a few standout websites for learning about photography that I just have to plug.

Some of these require a nominal membership fee, and some of the pro sites might even require a portfolio submission if you want to participate in forums. This is often a plus. It keeps the forums under control and often makes the discussions more thoughtful.

Photoworkshop.com: This is a site featuring training and video tutorials on a huge variety of products including Canon cameras, wireless flash, a virtual studio, links to the Adobe Training Arena, guidance on advanced color management, and portfolios by master photographers. There are also online workshops. The biggest

problem with this site is that it is so large you can get lost for hours.

Adobe, www.adobe.com: Adobe rocks in user support of its products. Its website offers great downloadable video tutorials and 30-day trial uses of its programs, including Lightroom and full versions of Photoshop.

Sports Shooter, www.sportsshooter.com: A great resource for equipment reviews as well as tips and insights from pro-level photographers. Great forums.

Digital Photo Review, www.dpreview.com: This is basically an online magazine reviewing photographic equipment. Great discussion forums; an excellent technical resource.

Editorial Photographers, www.editorialphoto.com: This is more for professionals and emerging photographers. This website will help guide you through the beginnings of a professional career. It's invaluable for tips on copyright and other legal issues.

Strobist, www.strobist.com: Amateur photographers banding together to make better photos. Just great for ambitious amateurs. This is what the Internet was made for.

Digital Photography School, www.digital-photography-school.com: Great tips on learning your digital camera.

Photojojo, www.photojojo.com: This site is full of very accessible information with useful tips for any level of photographer. Great photo craft ideas, especially if you have kids who are interested in photography.

SeeSaw, www.seesawmagazine.com: Created by photographer Aaron Schuman, this website is dedicated to showing the works of emerging fine-art photographers. Schuman is a wonderful photographer, but he's also emerging as one of the best up-and-coming photo critics and writers out there. (Need I confess that he's an ex-student of mine?)

Capricious, www.becapricious.com: Created by Sophie Morner, this is both a website and a printed magazine that shows work by young avant-garde photographers. (Okay, she's also an ex-student, but they are both great sites with unique philosophies toward photography.)

Young Photographers United, www.ypu.org: This is both a website and an ad hoc group of recent photo school grads from around the world. Their aim is to promote photography and help ease the (painful) transition from student to working professional. Acceptance into the group is by portfolio review, but anyone can log in and simply be inspired by the work they are creating.

Luminous Landscape, www.luminous-landscape.com: Primarily devoted to landscape photography, this website has lots of downloadable video tutorials, discussion groups, and links to workshops.

Cambridge in Colour, www.cambridgeincolour.com: This website was created by a chemistry student named Sean McHugh while he was studying for his doctorate at Cambridge University. As both a scientist and artist, McHugh has some fantastic tutorials on digital photography, optics, the physics of light and color, and Photoshop. His photos are also really good.

Photocrew.com, www.photocrew.com: This is a national database for photographers, assistants, hair and makeup artists, and so on. One thing that sets Photocrew apart from other sites is the internship section. Here, you can offer to assist a professional photographer for free and possibly get some hands-on experience at a very high level.

Of course, one of the best resources on the Internet is simply the ability to search for a photographer by name and view his or her portfolio online.

Internships and Assisting

Even a student who has completed a rigorous four-year or post-graduate program in photography is ill-prepared to simply go out and become a professional photographer. For most the next step is assisting an established professional.

Even if you don't have aspirations to become a professional, offering to carry a working photographers bags for free, or just getting coffee on a photo-shoot is a worthwhile experience. Whenever I can I try to find a spot for at least one unpaid student to come

along on my shoots. The ones who have done well (arrive on time, keep quiet, listen, and watch) often become my paid assistants, and all of my assistants have gone on to successful careers as photographers.

Assisting and interning are great ways to plug into your local photographic community.

Workshops and Classes

The "how to" educational benefits of classes is obvious. Continuing education programs at your local colleges, universities, and arts/community centers are a great place to start. Taking classes locally is also a great way to connect with others in your community and develop a support network around your photography.

If and when you're interested in taking your instruction to the next level, there are some well-known photography workshops across the country, including The Maine Photographic Workshops (www.theworkshops.com), The Santa Fe Photography Workshops (www.santafeworkshops.com) The International Center for Photography (www.icp.org) in New York City, and the highly competitive and prestigious Eddie Adams Workshops in upstate New York (www.eddieadamsworkshop.com). These big workshops offer you the opportunity to spend a few days with a master photographer, which can be an inspiring experience.

Pro Tip

Don't be proud. After I was already well established as working photographer I worked as an unpaid second assistant cameraman on quite a few film/motion picture projects. I was easily 15 years older than anyone else on the set, but I learned a lot from being a "fetch it."

But the real advantages of classes and programs, anywhere you take them, are the class critiques and the interaction you have with other photographers like yourself. You will learn from others as they will learn from you.

Now go ... take some photos, and then take some more.

The Least You Need to Know

- Taking photos everyday and utilizing the world around you is the best way to become a better photographer.

- The options available today for sharing your photography are plentiful, from making photo books to posting pictures on the Internet.

- From Internet sites to classes and workshops, there are a multitude of resources available to help you become a better photographer.

Appendix

Glossary

angle of coverage The maximum angle that a lens can project as a circular image. The rectangle that the recording medium (film or digital) selects from this circular projection determines the actual angle of view.

angle of view The area seen by a given focal length/format combination.

aperture The opening of the lens through which light passes. This word is often used interchangeably with the term "f-stop."

Aperture Priority An automatic exposure mode in which the photographer chooses the preferred aperture and the camera automatically sets a corresponding shutter speed. This mode is often abbreviated as AV, or "Aperture Value."

archival The chemical, software, and storage properties that allow photographs to be preserved for future generations. Photographic prints that are pH neutral, printed on stable media (such as paper), and use long-lasting inks are said to be archival under proper storage conditions.

archive A collection or database of photographs.

autofocus An internal camera function that selects an area of the frame to be perfectly focused. This can be accomplished by either analyzing the contrast of the area (passive autofocus) or reading a reflected light beam that has been transmitted by the camera (active autofocus).

Automatic Exposure (AE) Any exposure mode in which the camera's light meter is choosing some combination of shutter/aperture or both.

AV Stands for Aperture Value; *see* Aperture Priority.

available/ambient light The light that exists in a scene prior to the photographer introducing an additional light source. Also referred to as "existing light."

banding Occurs when a smoothly stepped or graduated grayscale has been altered, resulting in a series of visible steps. This term is used interchangeably with posterization.

barrel distortion Occurs when a lens renders straight lines (usually at the edge of the frame) as slightly curved outward like parentheses (). Some lenses, like fisheye lenses, have barrel distortion as part of the lens's aesthetic.

bit The smallest amount of information a computer can process; represented as "0" or "1" (binary format).

bit depth The number of bits used in a digital image to determine the gray value of any single pixel. The 8-bit images have 256 steps from absolute black (no shadow detail) to absolute white (no highlight detail). The 12-bit RAW files can represent 4,096 steps from absolute black to absolute white. These additional steps can help alleviate the posterization that can occur when postprocessing an image before converting it to an 8-bit (per color channel) file for printing or electronic transmission.

bounced light Any light that is reflected off another surface.

built-in meter A meter that measures the light reflected from an object or scene as it passes through the actual lens of the camera. Also referred to as *Through the Lens* (TTL) metering.

bulb This shutter setting opens the shutter for as long as the shutter release is depressed.

camera obscura Latin for "dark chamber." This term means any darkened room with a small hole to allow light to enter and project an image (inside the room) of the scene outside the room. All cameras are essentially just tiny rooms with the addition of a lens (to help gather light) and a recording medium (film or sensor) to preserve the image.

CCD Stands for Charge-Coupled Device. This is one form of digital sensor.

chrome Shorthand term for a photograph shot with transparency or slide film.

circles of confusion As a lens focuses individual rays of light, the ray forms a point on the focal plane. Areas that are out of focus show up as indistinct blobs, or "circles of confusion." As the lens is either focused or the aperture is made smaller, the circles become smaller and smaller until they can be regarded as "sharp."

CMOS Stands for complementary metal-oxide-semiconductor. This is a type of sensor used in digital cameras.

color management The synchronization of color spaces combined with a calibration of displays so that all devices (like monitors and printers) display the same range and gamut of color.

color temperature A numerical description of the color spectrum of light, usually expressed in degrees Kelvin.

compression A way of reducing the (stored) file size for a digital image or file. Compression has advantages for faster electronic transmission and simplified storage. Compression may be "lossless" or "lossy." Lossless techniques reduce the stored file size without loss of original data (RAW files use lossless compression). Lossy techniques, like JPEGs, actually discard some information in order to achieve very highly compressed and small files sizes that transmit quickly and take up less storage space.

daylight film Color film that is balanced for and designed to be exposed in sunlight.

dedicated flash A flash unit that is made to interact with a specific camera and allows the flash's output to be controlled automatically by the camera's internal meter for optimum exposure. Also known as TTL flash.

depth of field The distance, or range, between two points (far and near) that will be rendered as sharp in the final image.

diaphragm A mechanical iris that controls how large the lens opening or aperture is and how much light is allowed to enter the camera.

diffuse Light that is scattered and emitted from many different angles, resulting in softer-edged shadows.

dpi Stands for dots per inch; the resolution of a printer.

dynamic range The ability of any given capture medium to record extremes of highlight/shadow detail within a particular scene. Some media, such as color negative film, are able to record scenes with extreme dynamic range. Other media, like color transparency film and digital sensors, are extremely limited in the range of highlight and shadow detail that they can record in a single image.

electronic flash A tube filled with gas that creates a powerful and short-duration burst of light when it is electrified. This term is interchangeable with "strobe."

emulsion A light-sensitive and flexible coating of gelatin with silver halide particles in suspension that is applied to acetate-based film.

exposure latitude The amount of overexposure or underexposure that a given capture type (film or digital) can tolerate without a significant loss of quality.

Exposure Value (EV) A shorthand number that can indicate the complete range or combination of shutter speeds, ISO, and f-stops available within a given lighting scenario. Many older cameras like Rolleis and Hasselblads used an EV setting that "linked" the shutter speed and aperture to a given EV setting, allowing the photographer to simply turn one knob in order to access any of the shutter/aperture combinations available. While few photographers or cameras use EV in this way anymore, it is still used as a way to describe a certain light level with one simple number. For example, an EV of 6 translates to $\frac{1}{15}$th of a second at f/2.0 at ISO 100 or one second at f/11 at ISO 200.

fast Refers to:

1. Film or sensor speed: ISO 1000 is "faster" than ISO 100.
2. Aperture: f/1.4 is a bigger lens opening; therefore, it is "faster" than f/8.0.
3. Shutter speed: $\frac{1}{1000}$th of a second is "faster" than $\frac{1}{15}$th of a second.

fill A diffuse light source (no distinct shadows) that reduces the contrast of a scene by lightening the shadow areas.

film speed A numerical designation to describe film's sensitivity to light. The universal designation is now "ISO" (International Standards Organization); however, older cameras and light meters may use ASA (American Standards Association) or DIN (Duetsches Institut fur Normung) as a designation.

filter A piece of glass, plastic, acetate, or gelatin that is placed over the lens (or lights) in order to selectively absorb or transmit a selected part of the light or spectrum.

flare Light that reflects or scatters inside the camera or lens, resulting in either loss of contrast or undesirable pinpoints or streaks of light.

focal plane The plane at which a lens focuses light inside the camera.

f-stop A ratio that equals the focal length of the lens divided by the diameter of the lens aperture (or opening). In theory—and practically speaking—any lens set to the same f-number transmits the same amount of light as any other lens set to the same f-stop regardless of focal length. This term is often used interchangeably with "f-number" and "aperture setting."

focal length The distance from the lens to the focal plane when the lens is focused to infinity. Long focal lengths result in greater magnification (telephoto lenses), and

short focal lengths result in less magnification (wide-angle lenses).

focus The point at which light rays converge to form a sharp image. Also the act of adjusting the lens in order to form a sharp image.

gamut The range of colors capable of being recorded or reproduced within a medium.

gigabyte (GB) One billion bytes.

gray card A device used by photographers to measure the luminance and/or color temperature of a scene. Photographic gray cards reflect 18 percent of the light falling on them and correspond to a theoretical scene with equal amounts of lights and darks.

ground glass On older cameras, this was an actual piece of glass that had a texture on one side allowing the photographer to focus on the glass. Newer cameras use plastic screens, but the term is still used interchangeably to refer to the image viewed "on the ground—glass." All SLR type cameras use a ground glass as a focusing/viewing device. When the lens projects an image onto a ground glass (as opposed to viewing through another type of optical viewfinder) the photographer can clearly see the effects of focus and depth of field. Other types of optical finders project everything as sharp and crisp (though they might not be in the final photo).

highlight Bright or light areas of an image.

histogram A graph that shows the distribution of tones in a digital image ranging from black to white. While it looks like a smooth scale most of the time, it is actually a representation of each of the 256 steps from absolute black to absolute white (in an 8-bit JPEG). When a histogram has gaps (like a comb with broken teeth), it is an indication that tonal information has been lost and will likely result in a print or file with visible banding or posterization.

hot shoe A slot with built-in electronic contacts on the top of the camera that allows accessories like flash units to be mounted to the top.

hyperfocal distance A way to extend the useful depth of field for a given lens and f-stop combination. It is the distance setting that produces the greatest depth of field for any given aperture setting.

incandescent light Light created by a substance that has been electrically heated to create light. Technically, any black body light source is incandescent, but the term is most commonly used to describe ordinary household light bulbs.

incident light meter A light meter that measures the light falling on the surface, rather than the light reflecting off the surface of an object.

infinity The distance at which all reflected light rays from an object become (effectively) parallel for a given focal length of lens. Also, the farthest focus setting on a lens.

ISO A numerical designation that indicates the relative sensitivity of a film or sensor to light.

Kelvin temperature In photography, Kelvin temperature is used to refer to the spectrum of light emitted by various light sources.

key light The primary light in a three-point light scheme.

light meter A device with a photoelectric cell that is capable of measuring the amount or color of light in a situation.

long lens Any lens whose focal length exceeds the diagonal of the capture format, resulting in a narrower field of view and a magnification of the image. Commonly referred to as "telephoto" (135 mm as one example).

macro lens A lens that is capable of extremely close focus. Sometimes referred to as a "micro lens."

manual exposure An exposure mode in which the photographer chooses both the shutter speed and f-stop.

megabyte (MB) One million bytes.

megapixel (MP) One million pixels. Megapixels are a common form of referring to the absolute resolution that a digital camera is capable of. However, megapixels are just one of the factors that determine overall image quality.

midtone An area of medium brightness.

normal lens A lens whose focal length is approximately the same as the diagonal of the capture format. This results in an angle of view that approximates the human eye. For example, a 50 mm lens on a 35 mm film camera or a 33 mm lens on a typical digital camera with a 1.5 conversion factor.

open up To increase the exposure of a photo by lowering the shutter speed, enlarging the aperture, or increasing the ISO. Also, to decrease the overall contrast of a scene by introducing "fill."

palette A range of colors that an artist/photographer uses consistently in his or her work. Also, a panel or box that appears in imaging software that contains tools.

pan Following motion with the camera to record the relative movement of an object.

photoflood A form of incandescent bulb that is made specifically for photographic use and has a color temperature of exactly 3,200 degrees Kelvin.

photo montage A new composite image created by combining individual photographs, or parts of individual photos.

photosite The individual photoreceptors that together make a digital sensor.

pincushion distortion A lens defect that causes parallel lines in an image to pinch toward the middle, like backward parentheses:)(. Most commonly found in zoom lenses at the long end of the zoom range.

pinhole A very tiny opening that can allow light rays to form an image without a lens in a camera obscura.

pixel A picture element. Digital photographs are actually composed of millions of picture elements, each displaying a distinct tone or color. When viewed at normal distances and magnifications, these individual elements merge to form the illusion of a smooth and continuous tone image.

pixels per inch (PPI) The pixel resolution of an image. It is important to remember that pixels have no real "size" until a size is assigned to a digital image (although your camera and imaging program might assign one by default).

plane of focus When a camera is focused on a given object a "plane of focus" is created. Most of the time the plane of focus is flat and perpendicular to the axis of the lens. If you point a camera at a wall (with the lens perpendicular to it and the back parallel) the entire wall will be sharp, even though the edges of the wall are physically farther away than the center. Some cameras (view cameras) and/or lenses (tilt and shift lenses) are capable of tilting or swinging the plane of focus, resulting in an effect of greater or less depth of field than would otherwise be possible.

plug-in An upgrade or addition to a software program that gives it additional capabilities.

polarizing filter This filter absorbs reflected rays of light from nonmetallic surfaces that are vibrating at certain select angles to the filter. The effect is that the amount of reflection can be controlled and selected by the photographer.

posterization *See* banding.

primary colors The three colors that can be combined to create all other colors. In the additive color system, three different colors of light (red, green, and blue) are combined to create all other colors (including white). In the subtractive color system, three different colors of pigment or ink (cyan, magenta, and yellow) are combined to create all other colors (including black).

prime lens A fixed focal-length lens that cannot zoom or change its angle of view (for example, a 24 mm or 135 mm lens).

profile A color space profile is the data that accompanies an image

or file and informs a digital device how to display the color gamut for the image. A paper profile is data that accompanies a certain paper type and allows the printer to perform optimally with that particular paper.

reciprocity law The relationship between the shutter speed and f-stop, which states that if one is increased it must be balanced by a decrease in the other. For example, $1/15$th of a second at f/2.0 is functionally the same exposure as $1/30$th of a second at f/1.4. Both settings allow the same amount of light to reach the film/sensor.

reciprocity law failure This occurs when the reciprocal relationship between lens opening and shutter speed no longer applies, such as very long exposures and/or very short exposures. An exposure of $1/30$th of a second at f/1.4 is the equivalent of $1/15$th of a second at f/2.0. In theory, the reciprocal law should hold that a one-minute exposure at f/64 is still the equivalent exposure. However, when shooting exposures longer than one second on traditional photographic film, the reciprocal law starts to break down and the exposure is not equivalent. This is called reciprocity law failure, often incorrectly referred to as reciprocity. A rule of thumb is that at exposures longer than one second, you should increase your exposure by one–half a stop. Exposures longer than 30 seconds should

be increased by one entire stop. However, this does vary with different films. Reciprocity law failure can also cause color to be rendered inaccurately with certain films.

reflected light meter Reflected meters measure the light that a scene is actually reflecting. The light meters in cameras are all reflected light meters.

resolution The ability to render and differentiate fine details; the degree of detail available in a photographic image. Also, the number of data points within a given linear measurement of a digital image (for example, 300 ppi). In digital images, this is the total number of pixels available to represent a photograph. Resolution commonly refers to the photosites available in a camera's digital sensor (such as six megapixels); however, this is misleading because the quality and size of individual photosites— together with lens quality—is ultimately as, or more, important in the resulting visible optical resolution than simply the total number of pixels.

reversal The process of making a negative into a positive. The word is commonly used to refer to slide film (reversal film).

short lens A lens whose focal length is shorter than the diagonal of the rectangle of the capture format, resulting in a wide field of view (a wide-angle lens, like a 20 mm).

shutter A mechanism to control exactly how long the film or sensor is exposed to light.

Shutter Priority (TV) An auto-exposure mode in which the photographer selects the shutter speed and the camera sets the appropriate f-stop to produce a correct exposure. Many cameras use the abbreviation TV for this setting (Time Value).

slave An optical electric sensor that can trigger an electronic flash when it detects a burst of light from another unit.

slow Can refer to film or sensor speed (ISO 100 is slower than ISO 400), aperture (f/5.6 is a smaller lens opening, therefore, it is slower than a lens set to f/1.4), or shutter speeds ($\frac{1}{15}$th of a second is slower than $\frac{1}{60}$th because the duration is longer).

spot meter A reflected light meter with a very small angle of view.

stop The aperture setting of a lens. Also, the change in exposure by a factor of two. A one-stop increase in exposure doubles the amount of light hitting the film/sensor. A one-stop decrease halves the amount of light hitting the film/sensor.

stop down To reduce the size of the aperture (a larger f-stop number; for example, stopping down from f/2.8 to f/8), thereby reducing the amount of light hitting the film/sensor.

strobe *See* electronic flash.

surrogate focus A technique used in candid photography to help remain inconspicuous and minimize the amount of time the lens is pointed at the subject. The photographer focuses on another object that is approximately the same distance away, then recomposes quickly on the actual scene to be photographed.

synchronize or "sync" To electronically connect the camera's shutter to a flash unit so that the shutter is fully open when the flash fires. Focal plane shutters cannot sync at very high speeds, so it is important to know the highest sync speed of your particular camera.

telephoto Photographers use this term to refer to any long lens. Technically speaking, a telephoto lens is a specific lens design that allows the effective focal length to be longer than its actual size, resulting in a more compact package than would be possible otherwise.

Through the Lens (TTL) meter Usually used to describe a type of light meter that reads the actual light being transmitted through the lens of a camera.

transparency An image on a transparent base that allows the image to be viewed by transmitted light rather than reflected light. This term is used interchangeably with "slide" and "chrome."

TTL flash A flash unit in which the duration and power of the flash unit is controlled by a meter in the camera to ensure proper exposure.

tungsten Technically, this is simply a metal that is heated to create incandescent light, but the term is commonly used to refer to photofloods or quartz halogen lamps yielding a precise color temperature of 3,200 K. Tungsten or "Type B" films are made to be exposed under lighting that has a color temperature of 3,200 K. This is also a preset color temperature in the white balance menu of digital cameras.

TV Time Value (*see* Shutter Priority).

variable maximum aperture A lens in which the ratio between the maximum f-stop and the focal length of the lens changes as the focal length changes.

vignette Underexposure at the corners of the rectangle resulting in the image having an almost circular quality in extreme examples. Vignetting is a common problem with inexpensive zoom lenses, especially at short focal lengths; however, many photographers like the effect.

white balance The setting on a digital camera that corrects and balances the camera to a particular light source, ensuring that white objects will be rendered without a color cast.

zone focus Setting the camera to a preselected distance and depth of field in anticipation of a photograph.

zoom lens A variable focal length lens (for example, 18 to 55 mm).

An Overview of Photoshop Editing Tools

Photoshop is a very deep and complex program. When I give Photoshop demonstrations at school, half of the class is bewildered. The other half is yawning in boredom because they know the program better than I do. There is always one whiz kid in every class who teaches us all something new.

The goal for this section is very modest: learning a few color-correction skills and the most basic tools of Photoshop.

I've chosen to talk about Photoshop Elements instead of the full professional version of Photoshop for two reasons. The first was cost; a fully enabled pro version of Photoshop is about $600. I also think Elements is a better program for beginners. The first time you click most tools, a tutorial will open. You will learn more about this program from just playing with it for an hour than from what I can possibly teach you here.

Layers and Levels

Photoshop offers a few different tools for correcting both the tone and color of photographs—a multitude of ways to skin the same cat, so to speak. They all have advantages and disadvantages, and it not unusual to use a few different tools on the same image in order to take advantage of these different characteristics.

One basic rule of working in Photoshop is that you want to retain the ability to go back to your original image at any given time.

For this reason, you should always work on a copy of the original photograph. You should also always work on an adjustment *layer* rather than on the image itself. The advantage is that if you find later that you have made a mistake, you can simply discard the individual layer instead of starting from scratch. Just click the layer and then click the little trashcan icon in the Layers palette to discard an individual layer.

This photo is flat and dull; there are no true blacks or whites.

Layers in Photoshop are like acetate overlays that are being applied to an image. They change the way the photo looks, but you can always discard them. Once you are happy with the final image, go to the Layer menu in Elements and choose "Flatten Image." This will merge all of the layers into their final form.

Levels are another adjustment tool allowing you to control the overall tone and color of an image. It's a great tool, but it can also let you make very large changes that can lead to posterization. Because of this potential danger, I try to use it early in the process when I am working with a fresh file. I also try to use it sparingly, just to get the overall tone and contrast right (although you can use it to control color balance as well).

Levels refer to the steps between pure black and pure white. The Levels tool allows you to alter what values in your image you want to be pure black, and what values should be pure white.

Within the Levels window under the histogram, you will find three sliders. Moving the right slider will brighten the highlights, the left will darken shadows, and the middle will change the overall brightness of the image.

Pro Tip

If you hold down the Option key on Macs or Alt on PCs when you select the black and white sliders in the Levels window, the screen will show you where your highlights and shadows are "clipping." Clipped light or dark areas will result in either a pure white or a pure black with no texture or detail.

The great thing about Levels is that the tools you use are sliders on an actual histogram, so it's very easy to see both the tone of the image and any destructive changes.

In general, you usually want photos to clip a tiny bit because this will ensure that something in the photo will be a true black (as black as the ink can go) and that something will be a true white (as white as the paper can be). However it's important to remember that not all photographs will have a true black or white (imagine a gray cat on a gray sidewalk on a foggy day. There would be no blacks or whites).

By clicking the Channel tab in Levels, you can also control the individual color channels to control the overall color balance of the image

Brightness and Contrast

This tool is very similar to the Levels tool, but you don't have the option of seeing exactly where the blacks and whites are clipping—and you can't control the individual color channels.

However, this tool is a lot more intuitive if you are confused by the levels adjustment.

Variations

If you are confused about what a photo needs, the variations tool can be a great help. It will present you with a variety of options and "looks" both in terms of color balance and tone.

Clicking one of the thumbnails brings an image with the selected colors setting into the "after" window. This can be a real help when you have shot a photo under mixed lighting conditions and you are having trouble diagnosing exactly what is wrong.

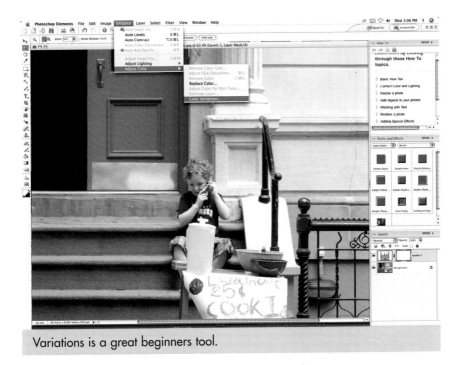

Variations is a great beginners tool.

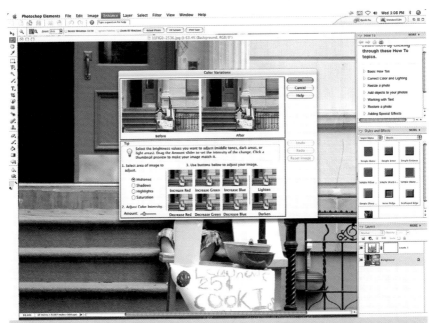

The options in the Variations menu will also allow you to see either very large or very small variants of the image you are working with.

Hue and Saturation

Because this photo was shot on a rather cloudy day, I also created another adjustment layer to modify the hue and saturation of the image.

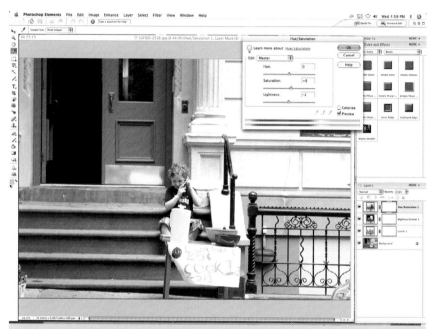

Hue and saturation allow you to control the hue and color of either the whole image or just one particular color.

Selection Tools

On the left side of the screen, you will see the Photoshop Elements toolbar. Toward the top, there are four selection tools:

I've highlighted the primary selection tools with a red overlay.

The Healing Tool

The healing tool (the Band-Aid icon in the toolbar) will fix facial blemishes. It can also be useful for minimizing black spots from dust on your camera's sensor.

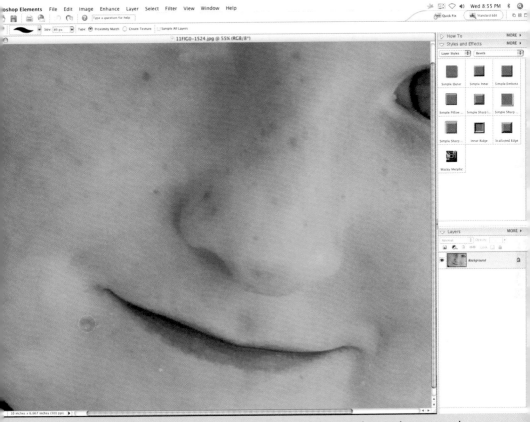

The healing tool works by looking at the spot and then analyzing the surrounding area. It then matches the two areas seamlessly.

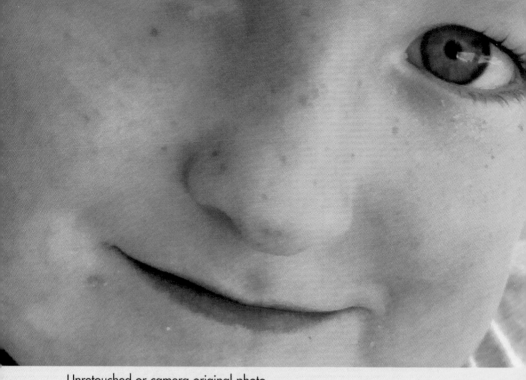

Unretouched or camera original photo.

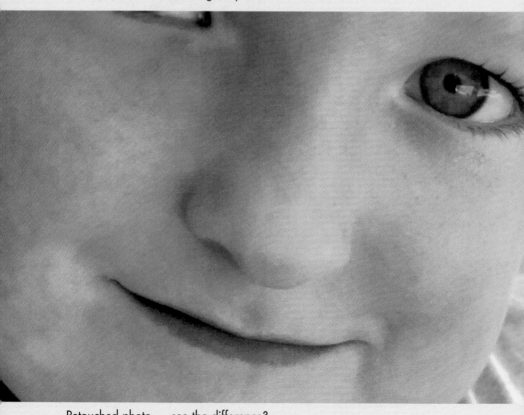

Retouched photo ... see the difference?

The Clone Stamp

Right underneath the healing brush, you'll find the clone stamp. It works in a very similar way, but the clone stamp allows you to choose what the spot or object you are eliminating will be replaced with. It's very useful for eliminating things like telephone wires because it allows you to sample a piece of the adjacent area (like the surrounding sky) to replace something else in the image.

Other Essential Tools

There are other tools you can use to modify your images. Some of the best ones are explained as follows.

■ The rectangular marquee tool allows you to draw a rectangle around something (useful for) quickly isolating an area). You can also use it to crop photos (although there is also a separate cropping tool).

■ The magnetic lasso tool allows you to draw a series of straight lines around something. The magnets will attempt to "stick" to the edge of the item you are selecting.

■ The magic wand tool can help you select something as well. Simply click the object, and the magic wand will analyze the color, contrast, and edges of the object and attempt to discern what you want it to select.

■ The magic selection brush allows you to draw or scribble on part of a photograph, and Photoshop will then attempt to discern what you are trying to select.

In this photo, I've used the magic wand tool to select the yellow paint.

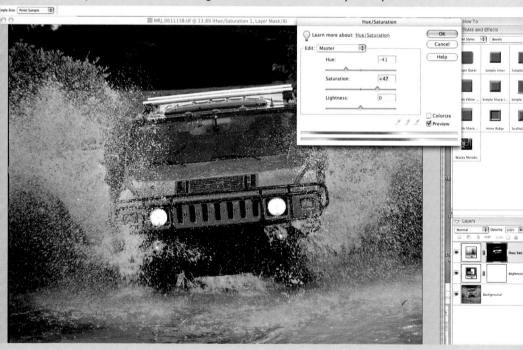

Then, I used the selection to create a new adjustment layer and changed the color of only that layer. However, I could have just as easily used the same selection tool to completely cut the vehicle out and then paste it into another photo.

To Touch Up or Not to Touch Up

It bears mentioning that Photoshop carries some big ethical issues. The ethics of photography and the way each photographer deals with ethical issues are part and parcel of our individual artistic identities. Most of us deal with it on a case-by-case basis. I would never alter a photo that was shot for a photojournalism assignment, but I won't hesitate to break out every trick in the book for a fashion shoot. This seems reasonable, but of course this still feeds the fashion machine that makes teenage girls feel inadequate for not looking like supermodels (who have all been retouched). Where do you draw the line?

In the earlier photo of the child, the food on his face was transitory; I'd certainly have wiped it off if I had noticed it at the time. Is the removal justified? After all, he's a kid—and kids can be messy. I prettied the picture up, but I also compromised its integrity. It might seem like nothing, but staff photographers for newspapers can get fired for stepping over this rather nebulous line.

In your own life, you have to ask the question: Do I want to enhance the photo, or do I want to preserve the integrity and history of the photographic document? Your teenage acne might have been a source of angst, but it is also part of your personal history. Do you really want to tamper with it?

Index

golden rectangle, 100
lasso technique, 106-107
negative/positive space concept, 105
rule of thirds, 101
spiral convention, 102
watching the background, 110

computer equipment (digital imaging)
monitors, 238
printer paper, 240
printers, 239

context (portraits), 165-167

conventions of composition, 100
diagonals, zigzags, and s-curves, 103
dirty frame, 109
Dutch angle, 106-107
dynamic symmetry, 104
frame within a frame, 109
golden rectangle, 100
lasso technique, 106-107
negative/positive space concept, 105
rule of thirds, 101
spiral convention, 102
watching the background, 110

curvilinear distortion, 30

custom photo books
creating, 249-250

D

depth of field (lens)
angle of view and, 39-40
distance and, 39
focal length and, 37-40
mechanics, 34-36
usage, 36

diagonals (conventions of composition), 103

digital imaging
archiving work, 241-245
Adobe Bridge, 243
Adobe Photoshop Elements, 243
Adobe Photoshop Lightroom, 244-245
iPhoto, 242-243

color balancing
auto white balance, 132-133
custom white balance, 134
computer equipment, 238
monitors, 238
printer paper, 240
printers, 239
printing options, 240-241

digital photography
color balancing
auto white balance, 132-133
custom white balance, 134

Digital Photography School website, 252

Digital Photo Review website, 252

digital sensors
ISO settings and digital noise, 79-81
JPEGs, 83-84
overview, 81-83
megapixels, 78
RAW files
overview, 84-87
pros and cons, 87

digital storage devices, 24

diopter, 10

direction
lighting, 141-143

dirty frame convention, 109

distance
depth of field and, 39

Dutch angle device (conventions of composition), 106-107

dynamic symmetry (conventions of composition), 104

E

Editorial Photographers website, 252

environmental portrait, 166-169

W

X-Y-Z

Explore your creative side with these *Complete Idiot's Guides*®!

ISBN: 978-1-59257-615-9

ISBN: 978-1-59257-613-5

ISBN: 978-1-59257-390-5

ISBN: 978-1-59257-504-6

ISBN: 978-1-59257-547-3

ISBN: 978-1-59257-606-7

idiotsguides.com